# Practical HDRI

## High Dynamic Range Imaging for Photographers

### 2nd Edition

**Jack Howard**

rockynook

Jack Howard, practicalhdri@gmail.com

Editor: Joan Dixon
Copyeditor: Judy Flynn
Layout and Type: Terri Wright Design, www.terriwright.com
Cover Design: Helmut Kraus, www.exclam.de
Printer: Tara TPS Co., Ltd. through Four Colour Print Group
Printed in Korea

ISBN 978-1-933952-63-5

2nd Edition
© 2010 by John M. Howard (aka Jack Howard)
Rocky Nook Inc.
26 West Mission Street Ste 3
Santa Barbara, CA 93101
www.rockynook.com

Library of Congress Cataloging-in-Publication Data
Howard, Jack, 1972–
Practical HDRI : high dynamic range imaging for photographers / Jack Howard. — 2nd ed.
    p. cm.
Includes bibliographical references and index.
 ISBN 978-1-933952-63-5 (alk. paper)
1.  Photography--Digital techniques.  2.  Image processing--Digital techniques.
3.  Single-lens reflex cameras.  4.  High dynamic range imaging.  I. Title.
TR267.H688 2010
775--dc22
                        2010014679

Distributed by O'Reilly Media
1005 Gravenstein Highway North
Sebastopol, CA 95472

*For the one and only Corey Leigh—my wife, best friend, confidant,*
*and partner in all things. I stand by her and she stands by me and we now walk*
*this world together with our beautiful daughter, Avery Rose.*

*Our journey continues.*

# Table of Contents

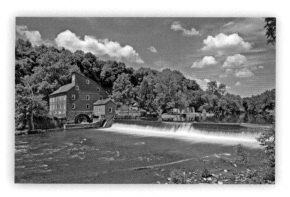

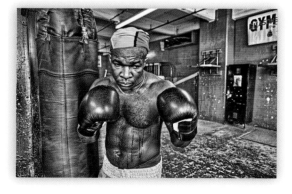

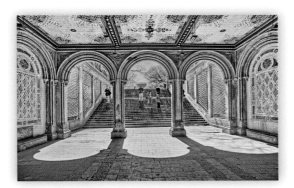

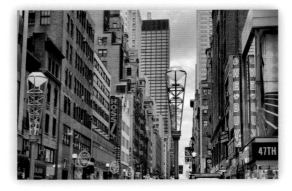

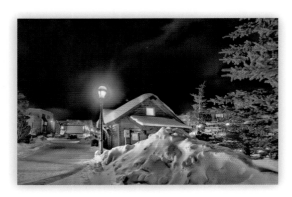

## 136   CHAPTER **8**   Tone Mapping High Dynamic Range Images

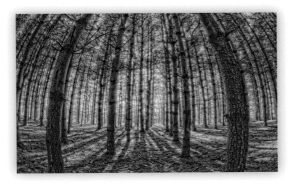

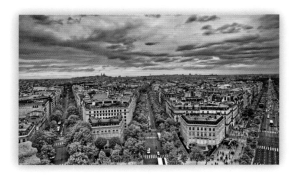

**184  CHAPTER 9    Post Tone Mapping Image Optimization**

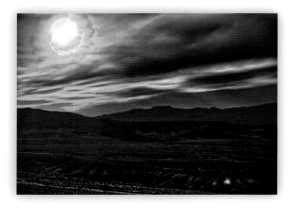

**222  Epilogue**

**227  Index**

# Preface

Since the first edition of *Practical HDRI* hit the bookshelves in September 2008, much has happened in the world of high dynamic range imaging (HDRI). HDRI is now, in certain quarters, a four-letter word, so to speak, due to an overwhelming association of the term HDR with (and exclusively with) a certain style of hyper-saturated, ultra-detailed tone mapping. But high dynamic range imaging encompasses so much more than this single style of tone mapping. In this book, we'll holistically explore the HDRI process, including tone mapping, giving you the skills and know-how to make your images photorealistic, surrealistic, or somewhere in between.

Maybe you've already been experimenting with HDRI techniques, or maybe you simply recognize it as the next big thing and want to ramp up on this cool imaging technology as soon as possible. By the time you read this book cover-to-cover, you'll have the foundation for making HDRI work for you.

High dynamic range imaging with a digital single lens reflex (DSLR) camera is a slightly more complicated process than simple single-shot capture and processing. There are new terms to grasp, new software workflows to master, and a host of image-degrading challenges to overcome at every step along the way. Sounds a bit scary, doesn't it?

Don't worry. Once you get comfortable with the HDR workflow and mindset, it'll become second nature. You'll find your HDR-eye. And

that, quite simply put, is the purpose of this book. I'm going to stay as far away from the mind-boggling mathematics running in the background as is humanly possible. I focus on real-world advice, both in the field and in the digital darkroom. There are times when I will have to get ultra-geeky to explain this concept or that operation, but I promise I'll try to keep it to a minimum. This is a specialized photography how-to book, not a college math text! [1]

This book is not meant to be a comprehensive introduction to all aspects of digital SLR photography. The focus is on what you need to know and what works for HDRI photography. So, for example, there's virtually nothing in this book about autofocus tracking of fast-moving subjects, but I do touch on when to use single-shot autofocus and when manual focus is better since this is critical to HDRI workflows.

I presuppose a basic understanding of still photography with a DSLR or advanced compact camera. I'm not suggesting you need to be a grizzled pro with decades of imaging experience to grasp the advice and workflows in this book, but I expect most readers to have more than an inkling of how to take some creative control of their camera. Yes, I know all too well that camera manuals aren't exciting by any stretch of the imagination, but if you take

---

[1] If you do want to do a deep-dive into the numbers, math, and science behind HDRI, I highly recommend *The HDRI Handbook: High Dynamic Range Imaging for Photographers and CG Artists* by my friend Christian Bloch, also published by Rocky Nook.

the time to really get to know your camera, you will get a lot more out of your shooting experiences, both with HDRI and traditional single-shot imaging.

This book is DSLR-intensive. There are a handful of advanced compact interchangeable lens and integrated lens electronic viewfinder cameras that can produce high-quality source files for high dynamic range imaging, and most of the advice and tips given can be translated to the handful of non-SLR digicams with just some minor adjustments. Even today's exceptionally affordable entry-level DSLRs and interchangeable lens compacts offer great image quality (especially at their lowest ISOs) and the base set of camera controls necessary to get started in top-notch high dynamic range imaging.

Get ready to cover a lot of ground in the following pages! The first chapters cover in-the-field shooting techniques, tips, and tricks for successful HDR source image capture as well as lens, gear, and gadget tips geared toward the HDRI experience. We'll also take a look at file-management issues specific to HDRI, in a section of chapter 4 that is much expanded upon from the first edition. Then we'll jump into HDR merging of the source files to high-bit high dynamic range images for both basic and challenging situations.

What was a small section of chapter 6 in the first edition is now a full chapter in the second edition that focuses on image editing in 32-bit space with Adobe Photoshop CS5 and HDR PhotoStudio, either prior to, or instead of, the bit-dropping tone-map processes we'll explore later in the book.

HDR PhotoStudio is an exciting new player in the field of HDR photography, and it's the only new software title to be included in the second edition of this book. The HDRI workflows of Adobe Photoshop CS5 have been significantly upgraded for the first time since CS2, and many amazingly useful 32-bit features that were previously available only in the Extended version of Photoshop have now migrated to the non-Extended version for the first time. The powerful imaging engines behind Adobe Photoshop now have a much-improved user interface with a deghosting option during merge. It is a marked improvement to the user experience, both in terms of the expanded feature set and interfaces. This is great news for HDR photographers!

Next in the book we'll explore tone mapping. This is where all the information in the HDR image is translated back down to traditional bit spaces for display on conventional computer monitors, for sharing on the Web, and printing for display. We'll explore the full scope of tone mapping for various results ranging from subtle to surreal.

Finally, we'll look at using the tools available in Adobe Camera RAW and Adobe Photoshop CS5 to optimize your HDR images after tone mapping for both Web and print.

I touch briefly on Adobe's popular Lightroom for HDR merge initiation and file management, but, it should be noted, Lightroom isn't currently set up to thumbnail most 32-bit files, and it simply passes off files to other programs for the heavy lifting involved in HDRI, so it isn't really a major player in HDRI.

All the software explored in depth in this edition of *Practical HDRI* is cross-platform software, and user experiences are virtually identical whether you're running the software on a Mac or a Windows PC. There may be some slight cosmetic variations between the platforms, but this isn't anything to worry about. It is quite interesting to see how Mediachance has made

Dynamic Photo HDR cross platform: It ships the Mac version inside a stand-alone PC emulator!

We haven't included software downloads on a disk because the smaller software companies update and upgrade at such frequent rates that there will likely be a newer version available online before this book is shipped to you. But I do provide links to each program's free trial download site so you can try before you buy—and you'll be absolutely certain that you're installing the freshest version of each program.

Also, I have always believed that the majority of photographers are most invested in their own images, so I'm not including downloadable image samples in this book. Instead, I encourage you to go out and create your own images following the advice in the early chapters—and reap the rewards by practicing with your own amazingly worked-up HDR images that you're ready to share with the world!

It is my goal to get you ramped up on HDRI as quickly and as painlessly as possible. If you've already been experimenting with HDRI, the tips, tricks, and new ideas found in this book will help you improve and refine your craft. If HDRI is new to you, you will have established a solid foundation by the time you work through the chapters.

This book focuses on pragmatic workflows, a healthy dose of tips and tricks, and real-world advice from my own trials, errors, and successes, all with the intention of helping to make your once-impossible photos look as amazing as possible.

I have revisited every work path and screen shot in the first edition and updated them as necessary. When there has been no meaningful change to a given operation since the first edition was published, you may catch some shots of older versions of programs. I have clarified some passages that may have been a bit unclear and have also made a number of small typographic corrections for the second edition. In short, I have built on the strengths of the first edition to make an even stronger second edition.

I truly hope you find this book informative, useful, and enlightening.

— Jack Howard
June 2010

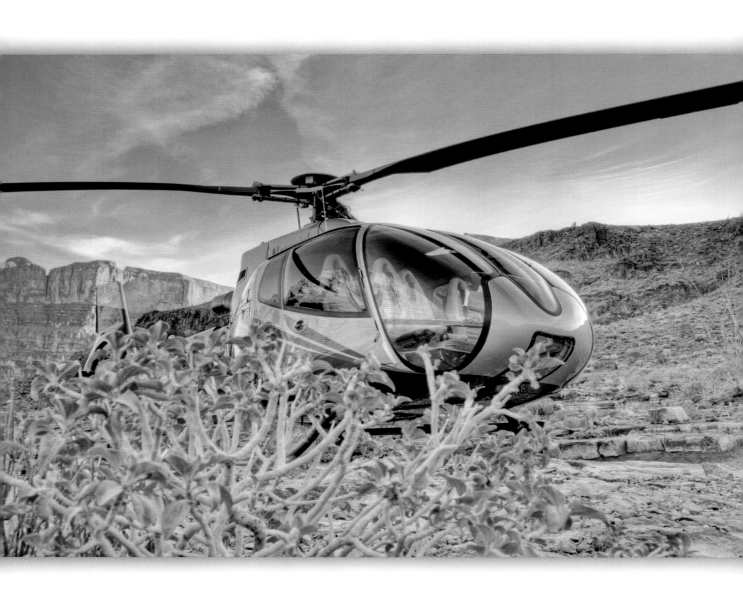

# Introduction

## The Big Lie about High Dynamic Range Images

There is not a single high dynamic range (HDR) image published in this book, despite the title. Not a one. Sure, there are screen shots of 32-bit high dynamic range images, but these were grabbed from traditional monitors, which cannot display the full luminance and tonality of an HDR image in all its glory.

You are looking at either 8-bit per channel screen grabs from LCD computer screens or 16-bit per channel TIFFs of image files that were sent to prepress and converted into CMYK halftones optimized for display on this paper stock.

Every brightest white you see in the images in this book has an equal RGB value of 255, 255, 255; a LAB value of 100, 0, 0; and a CMYK value of 3%, 2%, 1%, 0% (for a very light, neutral ink laydown just a touch below the paper stock's brightness rating of about 92). And every darkest shadow has an RGB value of 0, 0, 0, a LAB value of 0, 0, 0, and a CMYK value of 80%, 69%, 69%, 92% (dot gain makes this amount of ink appear a true enough black without overinking). In truth, these two extremes represent clippings of the luminance values—either due to the limitations of the digital camera's sensor to capture light across a broad exposure range or as a deliberate effect applied in post-production.

In either event, high-key (highlight-clipped) and silhouetted (shadow-clipped) images can have impact. High-key imagery is very popular in fashion, food, and advertising photography to draw the viewer's eye directly to the photographer's chosen focus point—and who hasn't snapped a shot of the shadowed outline of a distinctive object such as a cactus, palm tree, or architecturally significant structure against a dramatic sky? Both of these styles of photography take deliberate advantage of the limitations of the camera's sensor and employ white clip and black clip as an aesthetic consideration. But outside of certain situations where a conscious decision is made to exploit the capture chip's limited sensitivity, the dynamic range of a sensor can be a vision-stealing hurdle between you and your dream shot.

**A BIT MORE ABOUT "BITS"**    Technically, I'm talking about the number of bits per channel, so when I say 8-bit, 16-bit, and 32-bit throughout this book, I am "shorthanding" for x bits per channel, which would generally be 24, 48, and 96 bits total per format. But in practice, some of the bits are used for things other than color information (or not used at all). And some HDR formats use half-type data, so they don't actually employ 32 bits for storage and compression. The original 8-bit color format was truly only eight colors, with 3 bits that could be on or off: 0,0,0; 0,0,1; 0,1,1; 0,1,0; 1,0,0; 1,1,0; 1,0,1; 1,1,1. Eight bits per channel space, meanwhile, has over 16 million color values. And the number of possible color and brightness values in some 32-bit spaces boggles the mind. ∎

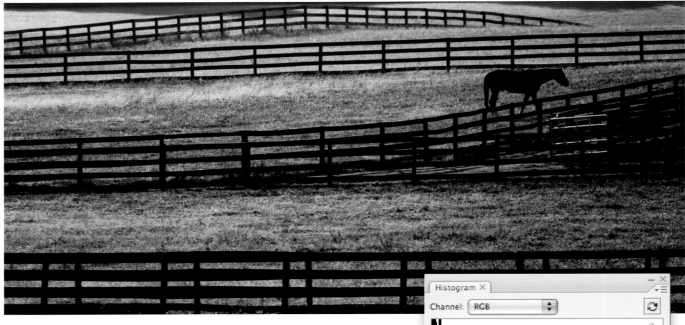

I envisioned this shot as a silhouette from the very start. I even underexposed by a full stop to ensure that the horse and fence would be complete shadows to emphasize the outline of both in contrast to the late afternoon directional sun streaming across the green grass of the paddocks. Here's where the limitations of the imaging sensor were deliberately exploited for an intended aesthetic effect. Even without detail in the animal, you recognize this as a horse from its contour lines alone. Notice the shape of the histogram, indicating major shadow clipping.

Here I let much of the image go to pure whites in the high-key style. Your eye is naturally drawn exactly where I intend: to the three blobs of paint at the mouths of the tubes of watercolor paint. Notice the shape of the histogram, indicating major highlight clipping.

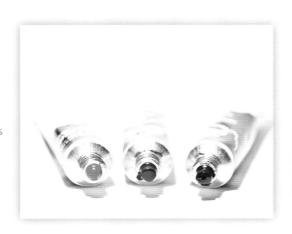

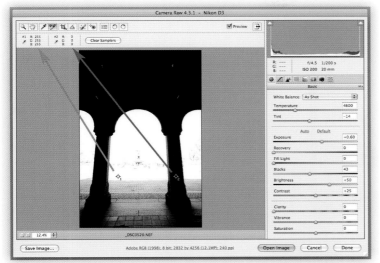

This is a middle shot from a burst to capture high dynamic range source images. I tweaked the exposure a touch to give pure blacks and pure whites in this frame. Notice how the two control points correspond to white clipped and black clipped areas of the image.

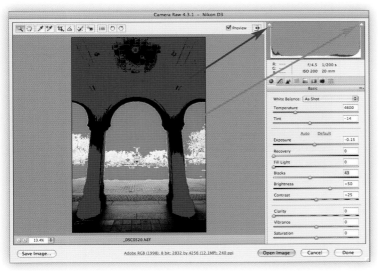

When you click the arrows atop the histogram in Adobe Camera Raw, it will show the white and black clipped pixels in your image. You can choose one or the other, or both.

Got that so far? Any pure white (RGB: 255, 255, 255) or pure black (RGB: 0, 0, 0) in a standard low dynamic range (LDR) digital photograph effectively contains no additional useful color or luminance information.

Whether your image is formatted as an 8-bit per channel JPEG, a 14-bit-per-channel RAW, or a 16-bit per channel TIFF, and no matter how much you push or pull the exposure in an image-editing program, you cannot retrieve any significant detail from these areas. Sure, you can squeeze these away from the ends of the histogram, but all you'll get are patches of detail lacking gray instead. Messing around with individual channels to get away from a true neutral (equal RGB values: 255, 255, 255 or 162, 162, 162, for example) will build some color information into the bald patches, but these are just paint chip samples. Let's call a light greenish gray Saratoga Spring (RGB: 205, 233, 205), a

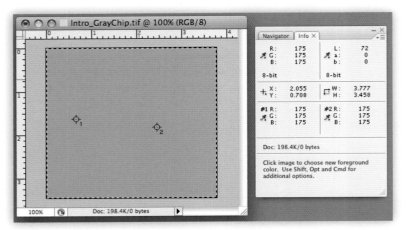

Here's a perfectly gray square with equal values in all three channels: 175, 175, 175. You can make darker or lighter grays from 0, 0, 0 all the way up to 255, 255, 255 as long as you keep all three channels equal.

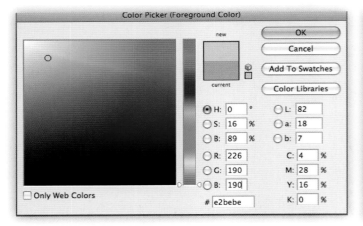

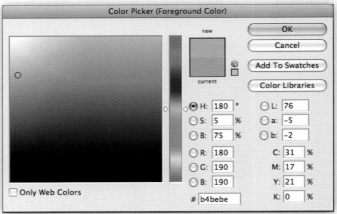

By changing one of the color channels to a nonequal value (or all nonequal values, for that matter), you get away from neutrals and into colors. But there's still no way to rebuild detail information when the captured pixels are beyond the dynamic range of the sensor. You can forget about Havana Mauve and Baltimore Blue, but we'll be revisiting Saratoga Spring in a few pages.

mauvish gray Havana Sunset (226, 190, 190), and a cool blue gray Baltimore Blue (180, 190, 190). Perhaps I don't have a future career as a paint color namer, but you get the point. And, making unequal neutrals can introduce color casting to an image—either unintentionally, or for a purposeful addition of warmth or coolness to the overall feel.

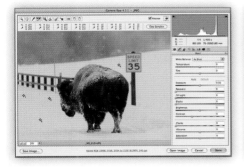
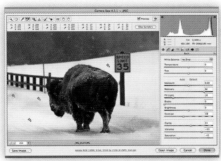
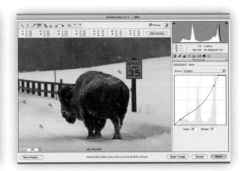

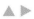

Here is a pretty extreme example of exposure range compression at capture. This image was made during a blizzard in Yellowstone National Park, Wyoming, USA, and the deepest blacks and hottest whites all fall within a couple of exposure values (EVs). In fact, this image needs to be spread across the entire histogram to give it normalized contrast and pop. Notice the large number of control points to make sure I don't accidentally introduce white or black clip during my global tweaks in Adobe Camera Raw. On a bright, sunny day, this image would have had major clipping issues at one end or the other, or potentially both, depending on the exposure settings.

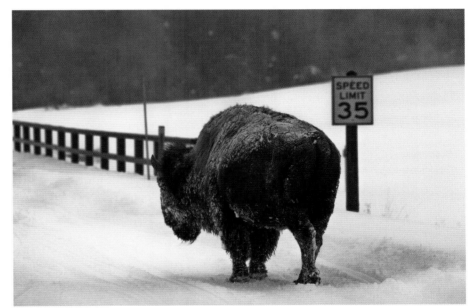

When the deepest shadows and hottest whites hit the walls of the histogram in a traditional LDR image, there's no detail information that can be retrieved whatsoever. With traditional single-image photography, dealing with black and white clip can be handled to certain degrees of success by adding some combination of fill-flash, graduated neutral density filters, or waiting patiently for a certain time of day or weather pattern that manages to compress the overall exposure range of the scene into luminance values that are smaller than the camera sensor's dynamic range. And this is what most people would call a proper exposure for the given image—good detail throughout the tonal range with an emphasis on the primary subject of interest without excessive blocked shadows and blown highlights distracting the aesthetic eye away from the main thrust of the image. Sure, it might need some minor tweaking in the digital darkroom for optimization, but it doesn't need major surgery before sharing.

But there are times, no matter how skilled a photographer you may be, and regardless of what you've got in your bag of tricks, when it is simply impossible to capture all of the

brightness values in a scene presented before you in a single exposure. Here's where high dynamic range imaging can come to the rescue. By taking a bracketed sequence of frames of the scene, ranging from severe underexposure to severe overexposure (based upon the median meter reading), and merging these images into a single 32-bit per channel high dynamic range image, it is possible to cover a much broader exposure range because this 32-bit space is much larger than 8- and 16-bit spaces and can therefore hold much more information. Think of it this way: If 8-bit space is a page in this book and 16-bit space is a couple of chapters, 32-bit space is an entire floor-to-ceiling bookshelf. One 32-bit format is so robust that it can represent a series of luminance values that exceeds the tonal range of the entire known visible universe a couple of times over! Another HDR file format has a billion colors for each luminance level over a 25 EV range, which is quite practical enough here on this little earth. I'm talking huge, awe-inspiring color spaces here.

If you think of every single low-bit RGB combination as a tube of watercolor paint squeezed straight from the tube, that's a pretty big set of paints, right off the bat. But the 32-bit high dynamic range space adds the ability to dilute each tube with water to make a lighter tint or add an ultrablack neutral to make a darker hue. And it can do this in floating-point numbers—meaning each additional drop of tint or hue from an eyedropper has its own distinct value. Add one microliter of water to a gram of ultramarine paint (mix well!) and it's got its own 32-bit floating-point value. Add 1 gram of ultramarine to a liter of water and it's got a different 32-bit floating-point value. Add equal parts ultramarine and "ultrablack" and it will have a different 32-bit floating-point value, although all three of these will have the same low-bit RGB numbers, if that makes any sense. I'm talking a huge quantity of numbers representing colors and brightnesses here, if I haven't yet beaten that point into the ground! (And yes, from a very technical perspective, paints are a subtractive color model, while the HDR space is an additive color model, but it does get the point across, yes?)

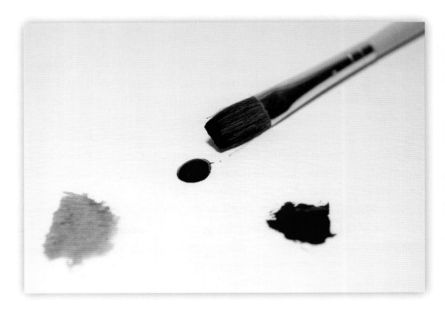

The pigment in each of these three spots of ultramarine watercolor paint is the same, but one is full strength, one is slightly thinned, and one is dramatically thinned. In 32-bit space, each of these three "colors" of ultramarine would have its own floating-point values but the same RGB values, as shown on the following three screen shots of the color "Saratoga Spring" show.

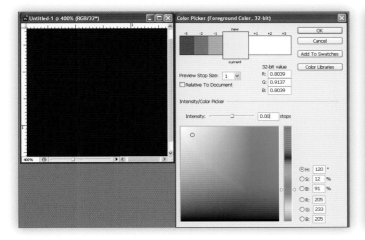

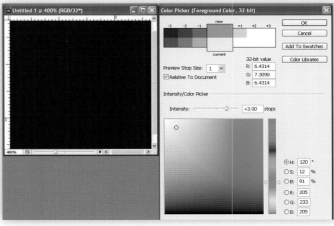

## The Little Lie about Low Dynamic Range Images

Every single 8- and 16-bit image is built from the same bits of the same relative brightness and chromaticity. Slice and dice it as Lab color, or RGB if you want, but there is a definite upper and lower limit. No pixel can have a value less than 0, 0, 0 or greater than 255, 255, 255. It is a closed set, and every traditionally captured image represents its values with these 256 by 3 channels values—and that's where black and white clip come from. There's no -27, -27, -27 for the "ultrablack" shadows deeper in that cave or 314, 276, 320 for a flabberghastingly bright "infra-lavender" you discovered in a field in Burgundy after several glasses of wine when the sun was shining just so on that magical spring afternoon. Nope. Every color, shade, and tone must be no less than 0, 0, 0 and no more than 255, 255, 255 or they're kicked off the histogram for not coloring within the lines.

In the low-bit world of digital imaging, all 18% gray in an image is the same 18% gray—never mind the real-world luminance values. Think about a piece of flagstone for a

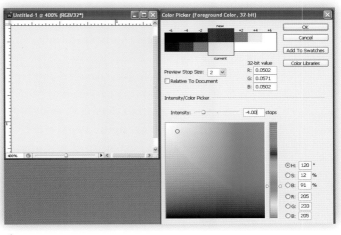

Here's a paint chip of Saratoga Spring, jumped up into 32-bit space. Notice that the RGB values are the same for all three but that there are different 32-bit values. Notice the position of the slider underneath the images. In the last one, I have shifted the exposure value preview brighter, although it is the identical color in all three images. Yes, 32-bit space is a lot to wrap your head around!

moment, a very good gray card proxy. It's a piece of flagstone no matter the ambient lighting conditions. And this flagstone lives in a ring around a tree by a little decorative bench in the photographs shown here, captured in bright, midday sunlight and by crescent moonlight with stray diffuse tungsten lights.

The flagstone is the flagstone, and it has the same reflectance characteristics (right around

18%) no matter how it is illuminated. But you'll need dramatically different exposures to capture the scene under these two lighting conditions. In afternoon sunlight, I used an exposure of 1/13 second @ f/16 at ISO 100 to yield a frame with minimal clipping. After the sun went down, I needed an exposure of 9:24 @ f/4 at ISO 100 to make a normal exposure of the same scene (without any clipping—I had to spread the histogram a bit to normalize this low-contrast version of this scene). Shooting the nighttime scene at 1/13 @ f/16 would yield a frame of nothing but blacks: 0, 0, 0. And shooting the bright sunny day scene at over nine minutes would yield a completely burnt frame of nothing but whites: 255, 255, 255.

Nonetheless, it is the same flagstone, and in each image you'll want its RGB values to be right around 175, 175, 175, which is a Lab value of 72%, 0, 0 to be a true neutral and a gray card proxy for balancing the exposure in post-processing. Any neutral brighter than the flagstone will have a greater lightness percentage: 84%, 0, 0 or 92%, 0, 0, for example. Darker neutrals will have a lower lightness percentage: 52%, 0, 0 and so on. Colors, of course, have nonequal values in at least one color channel in the RGB model and in the "a" and "b" axes in the Lab model.

In both low-bit photographs under these different lighting conditions, the brightest details in the scene that aren't clipped will be in the 245 to 254 range, and the deepest shadows that aren't completely blocked will be in the 2 to 15 range for each RGB channel. And this works reasonably well in representing the scene on a normal computer monitor and for print output. We expect the image to have contrast and a pleasing tonal range spread across the histogram. Even if we look at the two photographs side by side, we accept the 0, 0, 0 to 255, 255, 255 representation of the scene and perceive and posit different light sources and different times of day. We perceive the ink laydown through the contextual clues of the image and combine this with an understanding of the lighting in the natural world, and we accept that one image is nighttime and one is daytime. But the maximum and minimum ink laydown on a print, or RGB numbers on a monitor, are within the same small range of values in both cases. However, in the physical world, even the darkest shadow values that aren't clipped in the daylight photograph are actually much, much brighter than the hottest nonclipped highlights in the nighttime photo.

▼

This same scene requires very different exposures when shot in the afternoon and on a nearly moonless night. But in both cases, I'm going to white-balance off a section of flagstone that stands in nicely for an 18% gray card. And in both cases, all the color values live within that 0, 0, 0 to 255, 255, 255 range.

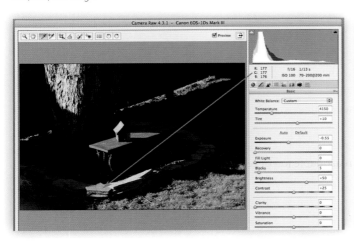

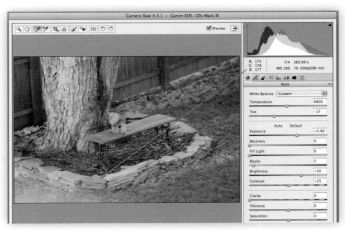

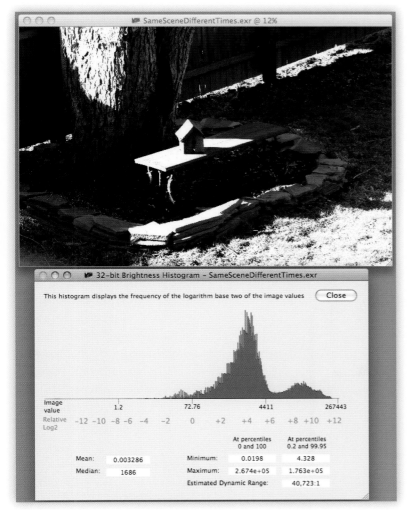

When I take these shots and merge them into a single high dynamic range image, the histogram in Photomatix Pro looks quite different. Notice that the estimated dynamic range is more than 40,000:1!

The same base set of numbers representing different color and tonal values works in both these cases, and in all low dynamic range images, be they 8-bit per channel JPEGs, 16-bit per channel TIFFs from 14-bit per channel RAW files, or any of the other standard 8- and 16-bit file formats. Based upon our perception and understanding, we accept this small set of numbers to represent the differing luminosity values of pretty much all images we display on our computer monitors and as photographic prints. It's a working fallacy that we accept a small set of monitor colors and an even smaller set of ink colors to represent so many different lighting conditions and brightness values. From a technical perspective, these monitors and the printers (and the inks, and by extension, the prints) are called "device-referred". We know there is no set of inks that can truly display all the colors and brightness levels in the world, but we can conveniently crunch them into a set that does a reasonable job of representing much of the world.

But in the real world, that same scene of the bench under nighttime or daytime conditions has distinctively different overall luminosities. And it's not just the same scene under different lighting situations that can have dramatically different luminance values. There is many a time when the range of light and shadow through the viewfinder simply exceeds the dynamic range of even today's top-of-the-line digital cameras. And that's where high dynamic range imaging comes into play. By making a series of images across a range of exposures to capture the entire luminance range of a scene, we can use the magic of insanely complicated mathematics to create a single image that can hold all of this color and luminance information—no more blown highlights or blocked shadows. Yippee!

True high dynamic range images live in a much bigger space than the single-shot 8- and 16-bit low dynamic range images you are familiar with. The 32 bits per channel HDR format allows for such a ridiculously huge set of numbers representing different color and luminance values that it can preserve a truer representation of the real-world relative brightness over a much larger range—it can describe candlelight and the blazing desert sun in the same image without clipping, for example. Briefly revisiting our bench and flagstone, these two images live in very different places on the HDR brightness scale and histogram—which makes sense, since these were captured at very different exposures, and the whole point of HDR imaging is to better represent the real-world lighting conditions. There are a number of different 32-bit formats, with a ton of crazy math employed to make each one work, but from a practical photographic perspective,

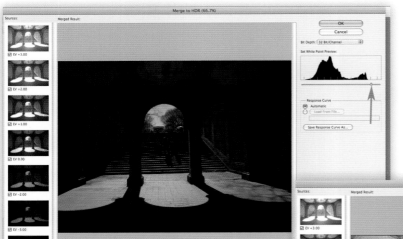

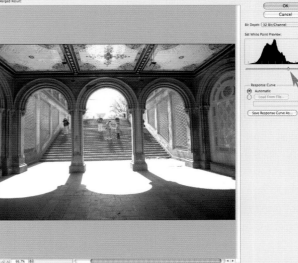

Both of these screen shots from Adobe Photoshop CS3 show the same high dynamic range image at different exposure value levels. You can see the seven low dynamic range source images in the left column. The Set White Point Preview slider in the right column sets the exposure level for the high dynamic range image. Anything that pushes past 0, 0, 0 or 255, 255, 255 based on the white point preview level goes to black or white on your monitor, but all that information is held in the HDR image. By adjusting the white point preview under the histogram, we can reveal detail at various luminance levels.

you need to understand this as much as you need to understand how the Healing Brush in Adobe Photoshop is like a thermal transference function—in other words, pretty much not at all.

For HDR images, the two formats we are most interested in from a practical perspective are OpenEXR (.exr) and Radiance (.hdr) for cross-program compatibility. These formats are not truly infinite, but there is not much of a color or an exposure value in the universe that can't be held within one of them. I will revisit this later, but for now, just take away that both of these formats have some really cool street cred—Radiance was invented by Greg Ward, HDR pioneer par excellence, and OpenEXR is an open-source format courtesy of Industrial Light & Magic—you know, the folks who made *Star Wars*! We'll also touch on HDR PhotoStudio's new BEF format and PSDs for saving layered HDR images in Adobe Photoshop.

From a technical perspective, high dynamic range images are "scene-referred", as their luminance values are not output device dependent.

Of course, not many of us have the exorbitantly expensive monitors necessary to fully appreciate a high dynamic range image in all its luminous glory. So why bother if we don't have monitors capable of displaying HDR images or printers capable of reproducing them?

## Crunching All the Brightness into a Much Smaller Space

Normal computer monitors cannot display the full range of exposure of a true high dynamic range image, nor can our printers output the full luminosity range of an HDR image, so we must crunch that 32-bit photograph back down into smaller bit space. There are a number of ways this is accomplished, and I will use the umbrella term *tone mapping* in this book when speaking generically about dropping bit depth from 32 to either 8 or 16 bits per channel. (I'll also use *crunch*, *compress*, and a couple of other terms to break up the monotony.)

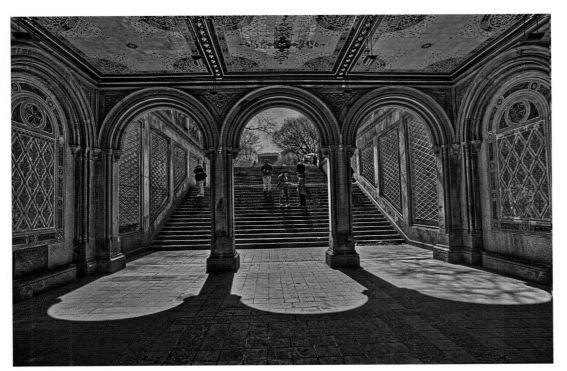

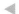
This tone-mapped image resulting from seven source files preserves much more of the overall luminosity of the scene than any single captured image. After being merged to a 32-bit high dynamic range image, it was converted back to 16-bit space using the Compressor Tonemapper tool in the FDRTools Advanced software program.

▷
This tone-mapped high dynamic range image showing both the subdued interior and bright daytime view through the picture windows of this room on a top floor of the Flamingo Hotel in Las Vegas may not have the same immediate visual impact as the fountain in the following image, but for architectural, real estate, and commercial photographers needing purely representative, documentary images, HDRI can make quick work of challenging lighting conditions such as this.

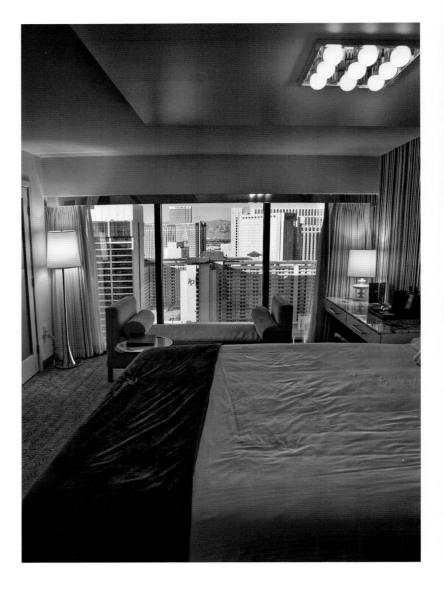

Some photographers are pushing the envelope of high dynamic range imaging to surrealistic extremes with aggressive tone mapping, while others prefer this specialized capture and digital developing process to be seamless, invisible, and utterly photorealistic. Neither approach is right or wrong within the broadest scope of creative expression, although the marketplaces for surrealism and photorealism may very well be quite distinct. Art is art, and that is that. And while this hyperrealistic/surrealistic style is wildly popular at the moment, don't underestimate the practical applications of the "invisible" HDR process, which has a serious future for commercial, advertising, scientific, and documentation applications, just to name a few.

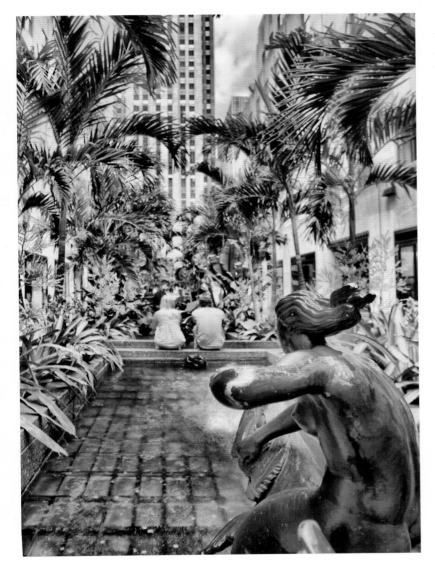

This tone-mapped high dynamic range image takes reality and pushes it to a hypercolored, ultradetailed impression of the scene, which I found to be more exciting than a single shot with a subdued palette.

Neither approach is right or wrong—it just depends on the intent of the image.

It all seems kind of roundabout, doesn't it? Bracket several shots, run these through a complicated workflow of many low-bit low dynamic range images to a single high-bit HDR image that can't really be viewed correctly on your monitor, then make a crunched low-bit file that attempts to preserve and interpret all that extra luminance information. And in many ways *it is* very roundabout; but it works, and that's the most important thing.

And now, let's get started!

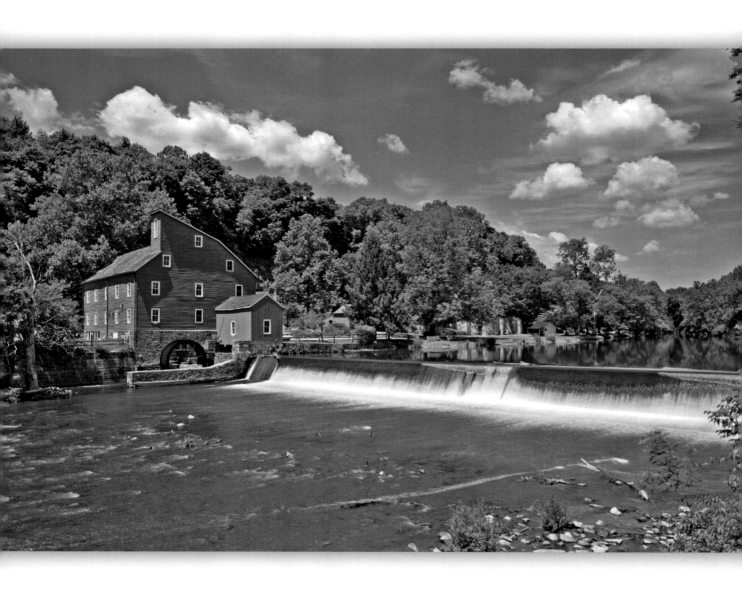

# 1
## Cameras and Gear for High Dynamic Range Imaging

t is possible to jump into high dynamic range imaging (HDRI) with an advanced compact digital camera, but you will achieve much better results with a digital single-lens reflex (DSLR) camera. You don't have to run out right now and buy a top-of-the-line pro model costing several thousand dollars to begin—even economical DSLRs offer the right set of basic controls to begin exploring high dynamic range imaging.

## A Little Bit of Good News, a Little Bit of Bad News, and Some Serious Gear Envy

**THE GOOD NEWS:**  You can jump right into high dynamic range imaging with your current DSLR camera and lenses. Whatever you've got in your arsenal can be used for HDRI, whether it's a wide-angle zoom, a tilt/shift perspective control lens, a normal macro, a telephoto prime, or even a Lensbaby. At its core, HDR photography is simply photography—and it offers endless possibilities to the creative shooter.

**THE BAD NEWS:**  High dynamic range imaging isn't a magic bullet that will instantly improve your creative and aesthetic eye. You've got to know the basics of composing, framing, and exposing an image first, otherwise your HDR shots will simply be weak photographs with a massive amount of detail throughout the brightness and tonal range. And you can buy all the top-of-the-line gear we talk about here, but no amount of gear or cash output or software tweaking can improve your photographic eye. Becoming a stronger photographer only comes from practice, perseverance, and experimentation. New gear will never be a miracle shortcut skirting hard work and practice. In any event, I'll touch on framing, composing, and exposure basics in a later chapter for the ambitious beginners.

**GEAR AND GADGET ENVY:**  The DSLR and lens combination you currently own will absolutely work to get started with high dynamic range imaging. In fact, there's not a DSLR on the shelves that can't be used to make high dynamic range images. The bare-bones system requirements for a DSLR for high dynamic range photography is a tripod socket and the ability to control the shutter and f-stop concurrently (also known as manual exposure mode). If you can find a DSLR that doesn't have this minimum feature set, please let me know!

*So,* the good news is that as soon as you finish this book you can jump right in and start experimenting with whatever gear you've got. *But,* I am going to tempt you with lots of gear and gadgets that can make high dynamic range photography easier, more effective, more fun, or some combination of these. I've conveniently added a check list at the end of this chapter to jog your memory when you go online later to order half the camera shop!

## Two DSLR Features for Easier HDR Shooting: Auto Exposure Bracketing and Burst Mode

Two DSLR performance features that can really make a camera a winner for HDRI are Auto Exposure Bracketing (AEB) and burst mode. These two features help a lot with HDRI because the less you have to touch (and possibly move) the camera between exposures, the better aligned the photos will be when they are merged; and the quicker the burst is captured, the less chance there will be moving objects in the scene, which present a challenge in HDR processing. (With some really high-end DSLRs, a fast burst rate of more than six frames per second combined with a wide bracketing sequence opens up the door for gambling with

This three-rectangle graphic is used almost universally to represent Auto Exposure Bracketing. In fact, if you look at the logos for both Photomatix Pro and FDRTools Advanced, you'll see stylized variations of this symbol.

handheld bracketed bursts—I'll revisit this later.)

When it comes to burst rate, pay attention to both frames per second (fps) and number of shots before the onboard processor clogs up. Pay particular attention to the RAW burst rate, which may be significantly lower than the JPEG burst rate, depending on the make and model. At bare minimum, the camera should be able to match its Auto Exposure Bracketing number with its RAW burst. In other words, if a camera can AEB five shots, it should be able to capture five RAW photos without a buffer slowdown.

Annoyingly, most economical DSLRs skimp on the Auto Exposure Bracketing settings. Since this is a simple firmware setting, I'm not really sure why, except to think that it's a brilliant gear-envy marketing scheme to get you to buy

In many (if not most) cases 19 EVs in a seven-shot burst may be overkill, but this is the maxi-

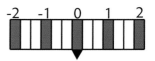

Through your viewfinder or on your LCD, some variation of this theme will indicate Auto Exposure Bracketing.

mum range, and it can always be decreased in half- or third-stop increments (but there may be times when this could come in handy in extreme situations—candles and blazing sun in the same frame, for instance). On the other hand, 2 EVs at ±1 isn't really enough for many common situations in which HDR photography has a serious advantage over single-shot imaging. There is a neat little workaround to gain more ground with any Auto Exposure Bracketing range, which I'll cover in the next chapter, so don't fret too much about your AEB spacing just yet.

---

**BURST MODE** (Also known as *continuous mode*): A digital camera mode that fires a series of images quickly when the shutter is pressed. This feature is useful for studying events that happen quickly and in such areas as sports photography. The camera will continue taking photographs, as long as the shutter release is pressed, until its buffer is filled. This is why the specifications on digital cameras indicate the speed in frames per second for a set number of frames (i.e., burst rate). ■

---

the higher level cameras! Pay attention to both the number of possible shots (which is usually an odd number, such as 3, 5, 7, or 9) and the maximum exposure value (EV) spacing between frames. It could be as little as 1/3 (.3) stop or as much as 3 full stops. The wider the exposure range, the better. For example, a camera that can capture three frames at ±1 will give you a bracket burst spanning 3 EVs: -1, 0, and +1. A camera that can capture five frames at ±2 will give you a bracket burst that spans up to 9 EVs: -4, -2, 0, +2, +4. A camera that can capture seven frames at ±3 can span up to 19 EVs: -9, -6, -3, 0, +3, +6, and +9.

---

**EV SPAN FOR AEB BURSTS AND YOUR CAMERA SENSOR'S DYNAMIC RANGE**  The dynamic range of your camera's sensor and the exposure value range possible in an Auto Exposure Bracketing sequence are two distinct things. But they work together to determine the overall EV range/constrast ratio possible in a bracketed series of shots. Add the EV span of your camera's AEB sequence to the dynamic range of your SLR on www.DxOMark.com's image quality database to determine the bracketed dynamic range coverage. For example, the Pentax K10D can AEB five shots at up to 2 EVs covering this range of exposures: -4, -2, 0, +2, +4. Add this 9 EV span to DxOMark's 10.61 EV dynamic range results at ISO 100 and that's a 19.6 EV range captured in a bracket burst by this camera. Makes perfect sense, right? ■

---

The big price tag cameras with big, wide AEB bursts can really help a lot in some extreme situations, but if you're on a tight budget, don't worry. You'll be just fine with the gear you've already got almost all of the time. It just means a tripod is all the more important.

## A Trusty Tripod Is a Good Thing!

The greatest percentage of your HDR images will be shot with the assistance of a tripod. If you are serious about photography—and HDR photography in particular—spend your money on the best tripod you can afford, whether it is an ultralight carbon-fiber compact model or a big tubular steel behemoth.

Trust your tripod. Love your tripod. Keep it with you at all times. The first most important thing to know about your tripod is its safe load weight: make sure you invest in a tripod that can support your heaviest lens and camera combination. The second most important thing is to know its balance points. Nothing ruins a photo expedition like watching a great lens and camera go smash, and if you overload or unbalance even the best tripod, *this type of disaster really can happen*. And it's not pretty.

The third most important thing is ease of use. If you think your tripod is a pain, you're likely to skip it and gamble with handholding, whether it is HDRI or simply long-shutter speed photography. You want a stable, easy-to-use shooting platform, and that's your 'pod's most important job. If it isn't up to the task, send it out to pasture and upgrade. As a photographer, there's absolutely no reason to not love your tripod—even more so as an HDR photographer!

In addition to tripods, there are monopods, beanpods, superclamps, gorillapods, and other less-bulky stabilizing platforms. As with your trusty tripod, get to know them: know and

**MY TRIPOD—MY HDRI COMPANION**   I recently upgraded to a carbon-fiber Gitzo Traveler tripod with a heavy-duty compact ballhead. It comes with me almost everywhere these days, specifically because it's so small yet so strong. Its 8.9-pound safe weight load is enough to hold all but my biggest supertele-photo bazooka lenses. (I never use these lenses for HDR anyway. These lenses are for high-speed single-shot photography such as sports and active wildlife imagery.) I cannot make the point strongly enough to love and trust your tripod. A tripod that stays in the closet does you no good when a great HDR shooting opportunity presents itself! ■

respect their quirks and limitations. It's really tough to keep a camera perfectly steady on a monopod or other lightweight platform for much more than a single burst. If you've got to physically touch the camera to change settings during a bracketing sequence, a sturdy tripod is your best bet. But for a quick Auto Exposure Bracketing sequence, those other little gadgets can be very useful.

## Let's Not Forget about Memory

You'll also need a big, fast memory card (or six) that can hold at least a couple of images in RAW format, and preferably a lot of them. Your best HDR source images will be shot in camera RAW format, and these files will range from big to huge, depending on your camera. For instance, a 2 gigabyte CompactFlash card will hold approximately 120 Canon CR2 RAW plus Large JPEG files from the 10-megapixel Canon EOS 40D, 100 from the 10-megapixel Canon EOS 1D Mark III, and only 48 from the 21-megapixel Canon EOS 1Ds Mark III. And divide the number of files a card can hold by three (or five, seven, or nine) shots in each bracket sequence and you'll soon realize that big, fast memory cards are a must. Running out of card space in the middle of an amazing shoot is always a disappointment, so it behooves you to stock up

on as much memory as you can before heading out to shoot HDR style. And don't forget about speed: A few HDR bursts in a row can quickly clog up cheap, slow cards.

### Lens Envy

It doesn't matter who you are as a photographer. You will always crave new lenses, whether they be wider, faster (in aperture terms), longer, sharper, faster (in autofocusing speed), smaller, and on and on. I would tell you to get over it, but you won't.

More than a camera body, lenses help fine-tune personal vision. Deal with it, make compromises with it, make do with what you've got, but it doesn't matter who you are as a photographer, you'll always have some degree of lens envy. We'll talk more about the nuances and characteristics of shooting with different popular lenses for HDRI in the next chapter, but now is probably a pretty good time to start squirreling those extra pennies away for the all the lenses you'll see used and discussed throughout this book.

### Filters

Even in the age of digital imaging, certain optical filters still play an important part in image capture. There's not a software solution that can match the glare- and reflection- cutting characteristics of a polarizing filter. Polarizers can make skies and clouds much more dramatic in the captured images—and great source files will yield great high dynamic range images. Continuous-tone filters can add a sense of warmth or coolness to an image at the RAW stage. I'm not sure about graduated density filters for HDRI

because in many ways the HDRI process is the ultimate split density filter—and HDRI doesn't have to follow a straight line like most split filters. But if there's one filter every photographer should have in their bag, it's a circular polarizer. Buy the circular polarizer to fit the threads of your largest lens and pick up step-up rings to match it to all your other lenses. A bunch of step rings are a heck of a lot cheaper than a quiver full of circular polarizers any day of the week!

### Cable Releases, Tethered Shooting, and Wireless Remotes

Almost every DSLR can be fired remotely via a cable release, with a computer interface via USB 2.0, or with wireless remotes. Check with both your manufacturer and third-party companies such as Quantum and Pocket Wizards to see what's available to fire your shutter without ever having to touch the camera. Pay special attention to what modes can and cannot be used in conjunction with remote release. Any remote release option that can't work in conjunction with Auto Exposure Bracketing isn't worth considering for high dynamic range imaging.

Canon shooters can also use Chris Breeze's DSLR Remote Pro to Auto Exposure Bracket up to 15 exposures at up to 2 EV spacings! This $95 program is compatible with almost every digital EOS camera made in the past five years—and it's a much cheaper way to gain a massive bracketing sequence than swapping up to a $4,999 Canon EOS 1D Mark IV. (Of course, this does mean lugging your laptop with you!)

The Promote Control (www.promotesystems. com) is an interesting new third-party remote that can be used to capture bracketed source shots from many Nikon and Canon cameras. In addition to HDR capture brackets, the Promote

can be used for time lapse. Performance and available functions vary from model to model, but this has serious potential for HDR triggering. It is a smart device, and firmware updates can expand its functionality.

## Equipment Essentials

### The "Must Have" Checklist

- Basic DSLR camera and lens
- Basic tripod
- A big, fast memory card that can hold some RAW images

### The "Really Want" Checklist

- Pro-level DSLR with fast burst rate and wide AEB sequence
- Circular polarizer fitted for biggest lens, and step rings for the others
- Cable release or wireless trigger
- Ultralight compact carbon fiber tripod
- Heaps of big, fast memory cards for shooting lots of RAW images
- Manfrotto Super Clamps
- Gorillapod
- Beanpod
- Lenses
  - Ultrawide rectilinear zoom
  - Full-frame fish-eye
  - Circular fish-eye
  - 1:1 normal macro
  - Wide-angle tilt/shift lens
  - Lensbaby Composer
  - 50–150 mm or 70–200 mm f/2.8 zoom
  - Your dream lens here: _____

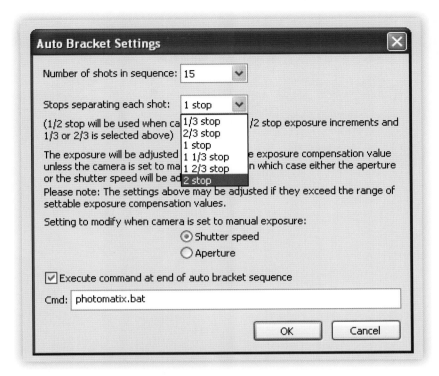

DSLR Remote Pro offers Canon shooters an amazing 15-shot bracket sequence at up to 2 EV spacings when tethered to a Mac or Windows laptop.

- Laptop with big hard drive loaded with all your HDR-friendly applications:
  - Adobe Photoshop CS5/CS5 Extended
  - Photomatix Pro 3.2.7
  - FDRTools 2.3
  - Dynamic Photo HDR 4.6
  - HDR PhotoStudio 2
  - Any remote-control program that shipped with your camera
  - Breeze's DSLR Remote Pro for AEB sequences up to 15 shots (Canon only)
  - Promote Control

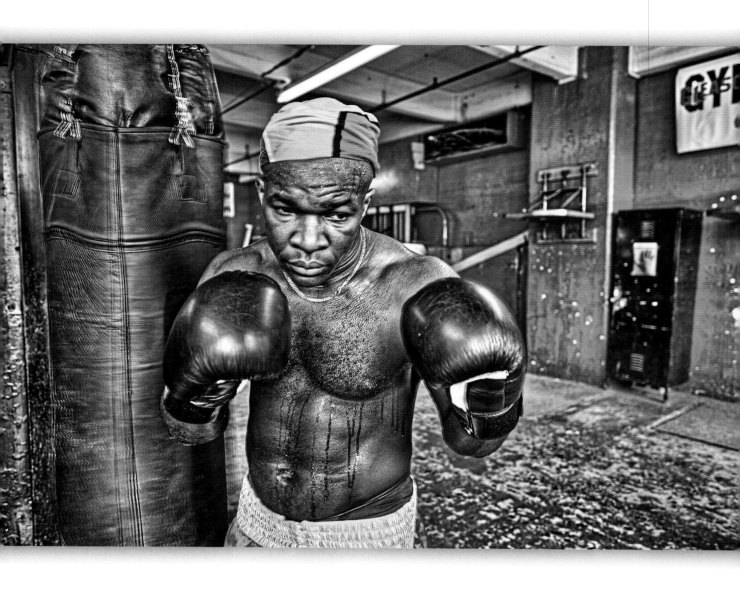

# 2
## Composition, Framing, and Exposure Basics

The basic rules for successful photographic composition hold true for high dynamic range imaging just as they do for traditional single-shot photography. Don't think that the high dynamic range (HDR) process will miraculously turn a boring, ill-composed scene into a masterpiece simply by capturing multiple frames and tweaking it with the HDR workflow. In fact, because high dynamic range imaging can hold detail information across a much wider exposure value range than traditional imaging, composition and framing are more important than ever. In this chapter, we're going to explore some basic photographic composition tips and focus on maximizing the strengths of the various lenses.

## The Rule of Thirds

There's a rule out there that it is not possible to publish a photography technique book without at least a passing mention of the rule of thirds. The simple reason for this is because this rule generally works. Take a look at many of your favorite photographs—whether they be your own compositions or photos that really speak to you. Odds are the greater percentage of successful images will prove to fall under the sway of the rule of thirds. If you overlay these images with a tic-tac-toe grid, the primary point(s) of focus will fall on or very near the intersections of the vertical and horizontal dividers. In fact, many cameras with live view LCDs have built-in rule of thirds grids for compositional assistance.

There is a pleasing balance to the asymmetry of many images that follows the rule of thirds.

Certain schools of thought hold that such images strike the eye and mind as aesthetically satisfying in an innate way that predates words and superconscious philosophizing—but we're not going to go too far down that rabbit hole.

When possible, try to frame images that subscribe to the rule of thirds. Don't get superobsessive about completely nailing the primary eye point dead on the intersections; in the closely surrounding neighborhood is fine. Outside of photo how-to books and art classes, you don't often see people running around with rulers and overlay grids assessing the exact placement to the micrometer of the focus points of the artwork before them!

**RULE OF THIRDS**   The rule of thirds is a compositional rule of thumb in photography and other visual arts. It states that an image can be divided into three equal parts vertically and three equal parts horizontally, thus creating nine sections (like a tic-tac-toe grid). The four points formed by the intersecting lines can be used to align features in the photograph. The theory is that if you place points of interest at the intersections or along the lines, your photo becomes more balanced and more aesthetically pleasing. ■

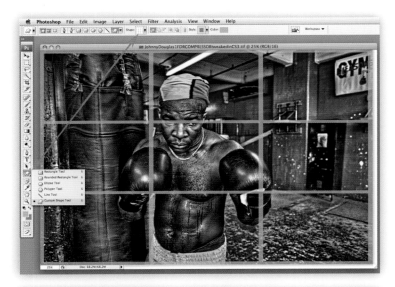

In Adobe Photoshop CS5 there are two easy ways to check for rule of thirds compositions. Select the Custom Shape tool, and pick the grid box from the drop-down menu. In this example, I made a new layer and dropped opacity down to 75% for transparency. Here, both of the boxer's gloves intersect rule of thirds points, and his eyes are on a horizontal line, just a touch off from another intersection. Even easier is the addition of the new "rule of thirds" lines on the Crop tool. Just select it from the drop-down menu for the Crop tool to check your image. If you want to crop, click the check mark, press the Enter key, or double-click. Click the circled x icon or hit the Esc key to remove the Crop tool overlay without applying the crop.

All that having been said about the rule of thirds, there are times when a centered composition—particularly with closeup portraits—offers more engagement and stronger impact. One of the best photographic rules to remember is to know the rules and know when to disregard them. This only comes with practice, experimentation, and heaps of trial and error.

## Lines, Layers, and Textures

Leading lines can be used to define divisions of space and to draw the viewer's eye into the image. A roadway or footpath toward the bottom edge of the frame suggests a breakdown from being a passive viewer to an active participant in the image. Conversely, the span of a bridge leading out of the sides of the frame suggests height and distance. The world is your canvas, and strong leading lines can be utilized to draw the viewer's attention to your chosen point of focus.

Look for layers of intrigue—different planes of interest add to the dimensional experience of viewing a photograph. Maybe it's a foreground rock formation, a creek, and distant hills or—as with the following figure—dock pilings, a bridge spanning the river, and the skyline across the way.

Indoors, look for a foreground element that is a key to the visual story. Is it a steaming teacup on the edge of table in an ornate room? Is it a tease of just a few lines of a handwritten letter and a telling scene behind? Don't be afraid to think creatively. Look at everything with a photographic eye and think how you can tell a story with what you see in front of you.

Search for different textures and different colors to define contrast in high dynamic range

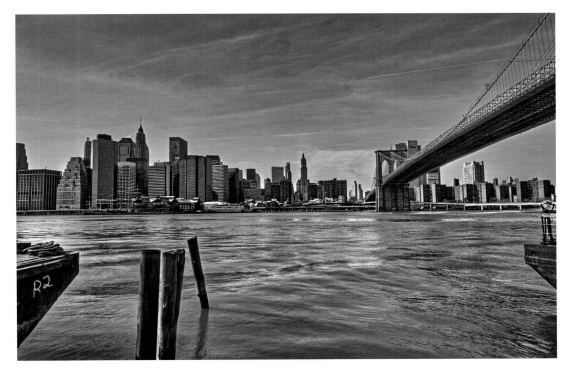

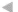
Foreground, middle ground, and background elements make for a layered image with more viewer engagement. Here there are pilings and hints of boats framing the foreground, a bridge spanning the middle ground, and the Manhattan skyline as the background.

imaging. This is important because in many an HDR image, two major types of contrast perception play a diminished role. First is the role of light and shadow as perception clues, and the second is atmospheric perspective. Our eyes have a greater dynamic range than a single low dynamic range (LDR) photograph, but we have become so familiar with the visual language of LDR photographs that HDR images throw us a slight curveball.

Atmospheric perspective (aka aerial perspective) is a visual clue of distance and scale when actually observing a scene before us as well as in photographs. In single-shot LDR images, atmospheric perspective may be exaggerated due to the limits of the medium. Conversely it may be managed with split density filters, although not to the dramatic extremes possible with HDRI.

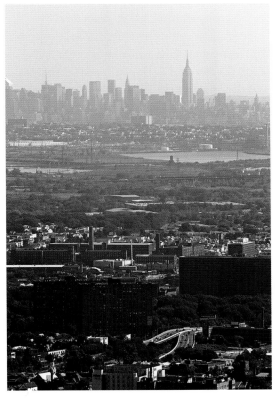

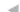
This shot shows both types of aerial perspective. Shot from a moving blimp, this image shows the atmospheric/aerial perspective effect of the distant objects appearing blue and gray and hazy. HDR photography can sometimes overcome the atmospheric effects.

But, always look to build contrast by pairing varied textures—both manmade and natural—with strong color variances to build contrast elements within your high dynamic range images.

# The Three Intertwined Exposure-Setting Functions of your DSLR

## Aperture and Depth of Field

As a general rule, the wider and faster the aperture, the more shallow the depth of field will be. Depth of field indicates the distance in front of and behind the focal distance that will appear acceptably sharp in the captured image. Focal length, distance to subject, and hyperfocal distance also play a role in depth of field, and you'll have to experiment with your personal lenses to determine exactly how deep or shallow focus is at a given aperture and at given focal distances. As you stop down to smaller f-stops in full increments (aperture numbers get higher: f/5.6 is a full stop slower and smaller than f/4), depth of field will increase, and your shutter speed must be halved to make an equivalent exposure. At a given ISO, 1/100 second at f/4 is equal to 1/50 second at f/5.6 in terms of light gathering for equal exposures. Pinpoint focus with a wide aperture, as well as expansive foreground-to-background sharpness when stopped down to small apertures, can both be employed effectively for high dynamic range imaging. However, as a change in aperture does alter the focal depth and relative sharpness, it is not recommended to alter aperture/depth of field during capture of a high dynamic range source image bracket sequence. Change shutter speed instead—which will affect the exposures without changing the focus.

## ISO Sensor Sensitivities and Sensibilities

Digital camera sensors actually possess only one native ISO speed rating. Every other ISO on a digital camera is an interpretation of that capture data based on complex algorithms and signal boosts. And as ISO numbers increase, the signal-to-noise ratio diminishes, leading to two possible issues at higher ISOs: significant increases in noise, which may or may not be coupled with aggressive blur filtering to minimize noise—which can sap resolution and fine detail from your higher-ISO images. The good news is that noise management is getting better with every product cycle, meaning higher ISO images are becoming cleaner without significant detail loss, which is a very good thing for a number of reasons.

However, it is not advisable to switch ISOs to alter exposure during HDR capture because the pixel symmetry and noise patterns can change significantly from one ISO to the next and this may present image-degrading artifacting and ugly blotchy noise in your tone-mapped images. It is a good idea to always use the lowest ISO speed you can get away with to achieve exposures that will work with your aperture and shutter speed choices.

# Shutter Speed: How to Change Exposure with the Least Impact for Your HDRs

The third camera setting that can be tweaked to alter exposure is shutter speed. This is the preferred method for capturing the same scene at different exposure values for high dynamic range imaging because it generally and usually has the least impact in significantly altering the framing and composition both at the macro (aperture: depth of field) and micro (ISO selection:

noise and pixel/grain patterns) levels. Of course, this rule holds most true for completely static scenes with zero moving or potentially moving elements. It tends to fall apart when the scene contains moving elements, such as water features, pedestrians, vehicles, active wildlife, and such. This is the big reason high dynamic range imaging is easiest with completely static compositions.

Here's the big thing about high dynamic range imaging: You are not simply picking a single shutter speed. You are selecting a range of shutter speeds based on the particulars of the scene. We call this a bracketed exposure sequence, and it is at the heart of high dynamic range imaging with your DSLR. And with compositions with extreme variations in exposure values, the range of bracketed shutter speeds may span action-freezing thousandths of a second to motion-blurring long seconds. Again, this is why scenes with zero moving elements are the easiest to capture HDR-style.

That's all a bit confusing, isn't it? Why not just leave it in full auto and hope for the best?

In some ways, yes, it is easiest to leave your camera in auto everything and just set your Automatic Exposure Bracketing (AEB) setting to maximum spacing and hope for the best, but where's the fun in that? DSLRs are creative tools, and these creative tools are best used when the eye behind the lens takes as much control of the image-making as possible.

> With high dynamic range imaging, you are not simply picking a single shutter speed. You are selecting a range of shutter speeds based on the particulars of the scene. We call this a "bracketed exposure sequence", and it is at the heart of high dynamic range imaging with your DSLR. ∎

**IN-CAMERA HDR AND DYNAMIC RANGE EXPANDERS?**     Things have gotten interesting and complicated in-camera since the first edition of this book. Pentax's K-7 launched the era of true in-camera HDR capture and tone mapping. The Pentax K-7 and the K-x SLRs capture three images in a burst at 3 EV spacing to capture about 17 or 18 EVs at lowest ISOs. These shots are then merged and tone mapped in-camera along a "standard" or "strong" formula and a single JPEG image is written to the SD card. The photographer never gains access to a true HDR file in this process. Pentax's in-camera mapper works best with scenes that truly require an HDR workflow. You may notice some halo issues with low-contrast scenes. Meanwhile, Sony has been promoting a two-shots at 3 EV offset in-camera plus auto image alignment "HDR" mode that should yield decent results for many scenes with just too wide a range of brightness for a single image.

My advice for most in-camera HDR options versus a bracketed sequence of RAW files mirrors my "RAW vs. JPEG vs. RAW plus JPEG" advice in chapter 4: Shoot your scene both ways for maximum versatility and ease of quick sharing.

Meanwhile, every company has its own variation going of toe and shoulder tweaks on single-shot curves for gaining up shadows and burning in highlights—but whether it is called "D-Lighting", "Dynamic Range Optimization", or something else, it is not a true HDR workflow. Even the best SLRs cap out at less than 12 EVs in a single RAW frame at the lowest ISOs—not enough for true HDR imaging.

In many cases, these adjustments can help to maintain some nuanced detail in delicate highlights and shadows; but it does come with a price. Go back and look at your camera manual. Search for that footnote that states something like, "This mode may visibly increase noise, particularly in shadow areas". You see, it is simply cooking the linear data with a specialized curve to push the linear data away from the toe and shoulder of the curve and toward the middle range. This certainly has its uses in many applications, and for many a situation this may be all that is needed. But it does not truly, significantly increase the dynamic range of the image in the same way that a bracketed sequence of images merged into a single HDR image does. When you're shooting a bracketed sequence of source images that captures the full dynamic range of the scene for HDRI merging, these settings should be turned off.

Long Exposure Noise Reduction settings can have a noticeable impact on overall image quality for long frames in very low-light situations, but this will also significantly increase the time between captured frames in a bracket sequence, which creates its own set of challenges to deal with for HDR photography. ∎

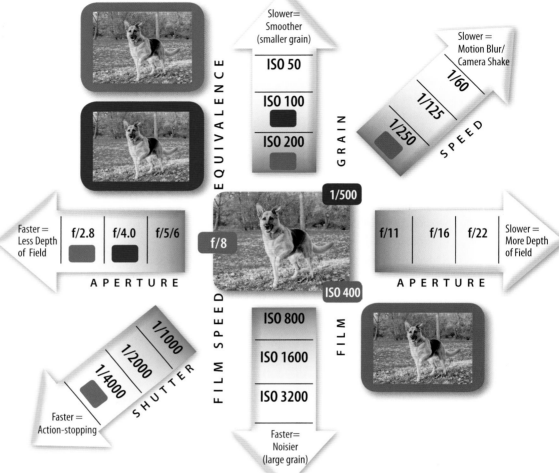

For any full-stop change along a given axis, an opposite full-stop change must be made along one (but not both) of the other axes to keep an equivalent exposure setting. But the red, green, and blue-bordered shutter, ISO, and aperture combinations would all vary in terms of depth of field, noise, and action-freezing/motion blur. Which version will have the shallowest depth of field? Which will have the least noise?

The first step to move from simply "taking pictures" to consciously "making pictures" is to understand and control the way light reaches the sensor and the triad of aperture, ISO, and shutter speed interdependencies. Changing any one of these three a full stop in one direction requires an equal reaction of one of the other two in the opposite direction to maintain an equivalent exposure.

When you change your shutter speed, you must also change either your ISO or your aperture. For example, if you double your shutter speed from 1/1000 to 1/500, you can make equivalent exposures in two ways: decrease your ISO sensitivity from 800 to 400, or dial down your lens a full stop, from f/4 to f/5.6. Likewise, if you stop down your lens a full EV—going from f/4 to f/5.6—and decrease your ISO a

full EV—from ISO 800 to 400—you will need to double your shutter speed twice for 2 full stops—1/1000 to 1/250—one for the aperture adjustment and one for the ISO adjustment. Got it?

Yes, it is very confusing that each of these three systems employs a different counting system, isn't it? There are reasons and logic behind each scale, but honestly, it's easier to simply memorize each scale in full stops, half stops, and third stops and remember to adjust accordingly rather than puzzle over why f-stops are described on a scale based on the square root of 2, ISOs double or halve, and shutter speeds represent actual time measurements. See our nifty graphic to help hammer all this info home!

## Relative and Absolute Exposure Values

If you've grasped the information on the intertwined relationship between shutter speed, aperture, and ISO, you've got the concept of exposure values down—kind of.

Switching a shutter speed one full stop is a change of one EV. Boosting ISO one full stop is a change of one EV. Stopping a lens down a full stop is a change of one EV. It seems easy enough, doesn't it?

Here are some examples on the absolute scale:

- EV 0 is equal to 1 second at f/1.0 at ISO 100.

- EV 1 is equal to both 1 second at f/1.4 and ½ second at f/1.0.

- EV 2 equals 1 second at f/2, ½ second at f/1.4, or ¼ second at f/1.0.

- EV 16 is equal to 1/1000 second at f/8.

- And so on, and so on. Yes, it is really simple and elementary in some ways, but it's massively confusing in others.

Don't worry. I'm going to keep this easy, and deal with a relative scale throughout this book, where EV -1 equals a full-stop change from your metered median exposure, which I will describe as EV 0. EV +2 is two full stops from your metered median exposure, and so on. And of course, the EVs shift shutter speed, right? Keep in mind, your HDR generation program may read EXIF data along with evaluating the relative luminance of your images, may have slightly different interpretations of the EV spacing and median image, and may describe a different image in the series as the EV 0 image. It's nothing to get too worked up about.

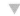

On the absolute scale, the higher the EV number, the brighter the scene. But a wide enough bracket sequence and HDR workflow can capture and interpret useful pixels across a very broad swath of EVs.

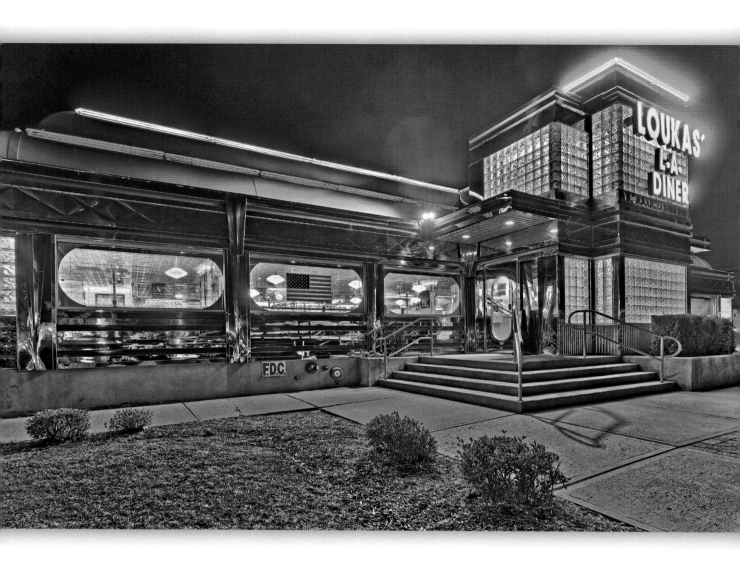

# 3
## Popular Breeds of Lenses for High Dynamic Range Imaging

The beauty of SLR photography is the ability to swap optics as often as you like for many different photographic feelings and situations. Certain lens types truly lend themselves to high dynamic range imaging. Here are some breed-specific tips for making the most of your glass for high dynamic range imaging.

## Rectilinear Wide-Angle Lenses

Rectilinear wide-angle lenses are very popular for landscape and cityscape photography, and the same holds true in high dynamic range imaging. The expansive field of view combined with the virtually unlimited depth of field when stopped down at hyperfocal distance can create sweeping vistas that envelop the viewer. Think about lines such as a country roadway, a meandering river, or the strong architectural details of a skyscraper, which can be employed to really pull the viewer into the details of the image.

The apparent magnification and close focusing can spotlight a particular foreground element in its environmental context, from wide to medium apertures. Whether it's a desert plant on a rolling hill or a chef in his kitchen, an off-center foreground-intensive composition can have big impact.

Rectilinear wide-angle lenses keep straight lines straight (or near straight), but the expansive angle of view gives the keystone/vanishing point effect to lines that are not parallel to the sensor plane. This is particularly effected and effective as a compositional element with manmade, right-angled constructions. Make sure that one of the axes is plumb with the sensor plane—for example, when shooting up at a skyscraper, make sure the horizontal lines of the ascending stories are parallel with the top and bottom of the frame. When shooting a long

Ultra-wide-angle lenses can capture expansive views and can keep a lot in focus from near to far, even at medium apertures. This source image was shot at f/5.6.

Stopping down to f/8 softens the rolling dunes behind this desert plant, but close focusing allows for the plant to be the main focus.

When you cannot eradicate keystoning, use it as an element to imply distance and scale. Be sure to keep one of the axes parallel with the edges of the frame! (There's a very real chance you may run into Seetharaman Narayanan on the 16th floor when he's in town!)

This 10 mm full-frame fisheye image shows the bowing effects of a fisheye lens along with warped keystoning. Notice how prominent the Fish and Chips sign is in the foreground; that's due to my proximity to the sign during capture.

construction, such as a train on a straightaway, make sure the vertical lines of the train are parallel with the sides of the frame.

## Two Flavors of Fisheyes

With fisheye lenses, the idea of rectilinear correction flies out the window. Straight lines are warped into bowed curves, with the effect becoming most extreme the farther you get from the center of the image. Full-frame fisheyes matched to a particular sensor size will take in up to 180 degrees along the wide axis. Circular fisheyes capture a round image in the center of the frame that usually covers 180 degrees. Some photographers enjoy the warped perspective of these extreme images as is, but there's a whole subculture of photographers remapping fisheye images into rectilinear projections and computer video virtual reality environments. VR

remapping, even when combined with HDR imaging, is a little outside the scope of this book, but HDRI plus VR mapping can offer a richness of detail and a luminance experience lacking in single-shot VR movies.

Both fisheye flavors can usually close-focus to within a couple of inches (if not closer) and have very deep depth of field even at wider apertures—meaning almost everything from near to far in the immense angle of view can be acceptably sharp when focused properly. Use your camera's depth of field preview (or simply take a test shot) to determine depth of field range. Be aware of the extreme "dog nose" effect with fisheyes, which can be used creatively to amplify the importance of objects very near the lens but can also be very unflattering to human subjects.

## Swinging, Bending Optics

### Big, Expensive, Perspective-Fixing Lenses

There are only a handful of these perspective-controlling optics available for DSLRs, and they are universally expensive. These bulky lenses usually communicate with the camera to set aperture and support in-camera metering, but they are shifted and focused manually. The primary purpose of this breed of specialized lens is to allow for focal plane shifts off parallel from the sensor plane to correct for keystoning and other quirks of optical physics that manifest in captured images when it is not possible to take the picture from a location that would present a more truly utilitarian, representational rendition of the scene.

In plain English: Tilt/shift lenses not only keep straight lines straight, they can be employed to keep right angles at or near right

Employing a 24 mm tilt/shift lens, I was able to correct for keystoning in the steeple of the same church as seen in the fisheye image. Notice how much less prominent the Fish and Chips sign is. I had to move my shooting position back several yards to take in the whole church with the longer, non-fisheye lens.

angles when photographing architecture under many conditions where keystoning will occur with a lens that cannot shift the focal plane. Architectural shots are usually captured at small apertures so there is sufficient depth of field to keep the entire structure in focus; however, opening a tilt/shift wide while skewing the focal plane gives a zone of sharp focus that can

wander across the image, from near to far. This can give an interesting perspective to rooftop photography, for example. And in the studio, this nonparallel focal plane can be exploited to pull the viewer's eye right to the most important details of a product.

▶

In this aerial view of Paris, a tilt/shift lens was used to both level the horizon and add a meandering focal plane across the middle ground.

The Lensbaby 3G has a curved "sweet spot" and a locking mechanism, allowing for creative blur effects.

## An Economical and Fun Way to Mess Around with Focal Plane Shift, Curved Field Lenses, and Fisheye Effects

Lensbabies are fun little lenses that can be pushed, pulled, bent, swung, and shifted around a curved-field "sweet spot". The introduction of the locking Lensbaby 3G opened up a whole new world of Lensbaby imaging, including HDRI. Lensbabies feature magnetic aperture disks that sit in front of the lens element, and in addition to the normal circles, they offer precut shapes such as stars and hearts (as well as blanks for your own custom shapes) that will turn specular highlights off the focal plane into those cool creative aperture shapes. These "toy" lenses are starting to have a major impact in the world of

photography and cinematography and can make some interesting HDR compositions. The new series of Lensbabies features an innovative Optic Swap System with three curved field lenses along with the new Fisheye, Pinhole, and Soft Focus lens options that offer a relatively economical way to experiment with different lens types for HDRI.

## Macros: Make the Little World as Big as All Get-Out!

If budget allows, invest in a prime macro with 1:1 magnification and a fast maximum aperture. If not, many zoom lenses offer a "macro" setting that will close focus and give decent magnification, maybe up to 1:2. If the macro bug really bites you, though, you'll want to upgrade to a prime 1:1 as soon as possible!

Bracketing several exposures of this tabletop composition of jewelry shows deep sparkle in the gems and very few hotspots on the shiny surfaces.

Magnification of 1:1 means that an object that is 1 cm wide will be recorded as 1 centimeter wide on the camera sensor—when the camera is focused at its 1:1 focal distance. Changing the focal distance of a macro lens also changes the magnification of the lens. So, to keep your magnification constant at 1:1 (or any magnification), move either the camera or the subject until focus is achieved.

Magnification of 1:2 means that a 1 cm wide object will be recorded as 1/2 cm on the sensor. Magnification of 1:3 will record a 1 cm object as 333 mm, and magnification of 5:1 will record that 1 cm object across 5 cms of the sensor. Even stopped down, depth of field is extremely

shallow in macro photography, and the slightest camera movements will be amplified. If you're thinking of combining HDRI and macro, a steady tripod is a must!

High dynamic range imaging techniques can be very useful for macro photography when specialized macro ringlights or dual-head strobes aren't feasible, practical, or within the budget. But when it comes to small, shiny objects, you're actually sometimes better off using a longer telephoto lens zoomed in as close as you can. Yes, you sacrifice some absolute magnification, but the reflections of the tripod and camera aren't nearly as prominent when the object is farther from the camera.

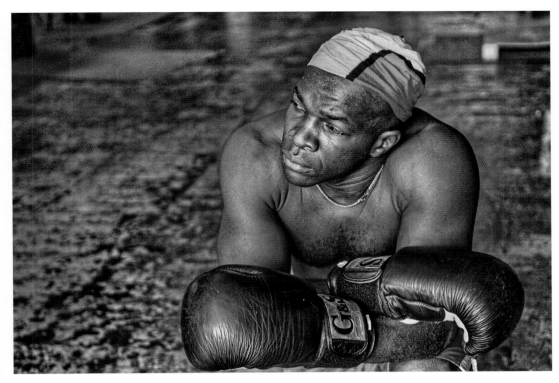

This image, shot with a normal zoom at its wide f/2.8 aperture, draws the eye to the subject and offers excellent background separation.

## Normal and Telephoto Lenses— Both Zooms and Primes

Midrange lenses and long lenses, both primes and zooms, can be used in the field for portraits, wildlife, and details of flowers or to gain more reach to capture distant buildings or landscape elements. At wide apertures, medium zooms and telephoto zooms offer shallow depth of field and wonderful background separation, which can really make a subject pop from the background. Conversely, longer telephoto lenses appear to compress distances when stopped down to smaller apertures. Longer lenses amplify camera movements, so a sturdy tripod is very much advised for any HDRI attempts with telephoto glass.

Now, let's actually make some photos!

# 4

## Capturing Images for High Dynamic Range Imaging

Unlike traditional single-frame photography, where the purpose is to find the single best exposure of the scene before you, the goal of high dynamic range imaging is to find and capture the best series of exposures to capture the scene before you in all its luminous glory. In this chapter, we're going to look at recognizing good high dynamic range imaging opportunities, metering methods, bracketing techniques, file types, and other HDR-specific shooting tips.

## RAW vs. JPEG vs. RAW *plus* JPEG (plus TIFFs!)

The dialogue about file format is usually positioned in an adversarial way: *RAW versus JPEG.* One must be better than the other in this dialectic positioning. This is silly—like so many of the online discussions about photographic absolutes. Both have their strengths, weaknesses, uses, and purposes. I always shoot RAW *plus* JPEG, and I highly recommend this for several reasons. Yes, RAW is linear data, and off-camera processing offers much more control than in-camera JPEG cooking. Even cameras with heaps of JPEG image quality adjustments can't match the pure number of dials, sliders, adjustments, tweaks, and settings of a good RAW converter program.

For HDR generation, there's a whole other set of variables to throw into the mix from a scientific and geeky perspective, and yes, you *should usually* get better output from HDRs generated straight from RAW files because your HDR-generating program doesn't have to attempt to reverse-engineer the gamma curve applied during JPEG transformation. You also may be stuck with remnants of the JPEG white

balancing (among other things). So, whenever possible, capture RAW files for low dynamic range (LDR) bracket sequence shots and use these RAW or minimally processed 16-bit TIFFs converted from RAWs for merging. So why shoot JPEG at all? Here are reasons for shooting both formats:

- There are many different RAW formats, and your HDR-generating program may not be able to read the RAW data from very new cameras on the market. JPEG is a standard format on every modern computer, so any computer anywhere can be borrowed for a quick preview of the images on a memory card. If a computer doesn't have image-editing software, you can always drag and drop a JPEG into any browser window for a 100% preview. If you see that the JPEG is unsalvageable, the RAW will likely not be much better. And then you can clear off some space on your memory card! Plus, there are many online image-editing programs that support JPEG format, including Google's Picasa and Adobe's Photoshop Express, for some quick image tweaks for sharing photos from anywhere with a web connection—such as an Internet café at some far-flung resort—saving the major image tweaking for home.

- Even if you know that all your HDR generation programs support your camera's RAW files, it's still wise to shoot small JPEGs along with the RAWs. This advice is particularly true for beginners to HDR photography. The processing time for HDR generation and tone mapping of large RAW files can be quite long, even with powerful computers. You can use the small JPEGs to

check for alignment and ghosting issues and get a feel for what tone mapping will look like on your RAW files in a matter of seconds as opposed to minutes. Then apply the same settings to your RAW files.

- In-camera JPEG processing is tuned by the camera engineers to the particular nuances of each camera. Particularly at higher ISOs,

with many recent cameras the JPEG images may actually be sharper with less noise than your custom-tweaked RAWs!

## Recognizing High Dynamic Range Photo Opportunities and Non-Opportunities

### See the Gull? This Is Not an HDRI Op

See this shot of a herring gull taking flight off Miami's South Beach? This is a good example of what is *not* an HDRI opportunity!

First, there's virtually no shadow or highlight clip in the RAW file (or the JPEG, either). And the clip in a few of the feathers is so negligible as to be a nonissue, making it an unlikely candidate for HDR treatment right from the start. Second, there is so much movement involved in the scene: The camera is moving to track the gull, the gull is taking flight, the water droplets are frozen in midair, and the rippled surface of the sea is moving in rhythmic yet chaotic wavelets. Looking at the frames before and after this shot

There are good reasons to always shoot RAW plus JPEG.

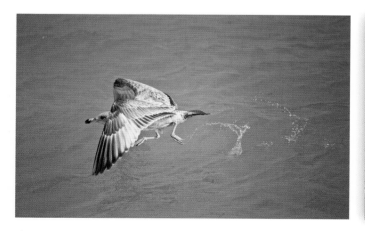

Not everything is an HDRI opportunity. A solid understanding of when to utilize HDR imaging will help you both with HDR and single-shot photography.

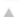
Looking at the burst of frames before and after the frame shown earlier shows just how dynamic this scene is, making it an unlikely candidate for HDR treatment.

shows that this scene is extremely dynamic in the "not-static" sense. This is a matter of right place, right time, right metering, and right light for a great single-shot capture.

If the lighting were different and the dynamic range of these same compositional elements didn't fit nearly perfectly into the dynamic range of the Canon EOS 5D that captured this wild moment, it still isn't an HDR opportunity because it is a moment in time that cannot be re-created to be virtually identical even a millisecond later—unlike a landscape formation, for example.

That's when you've got to make the high-key vs. silhouette decision, choosing which slice of the scene's dynamic range you will capture to your sensor. Remember, your camera can capture only about 8 to 10 consecutive EVs in a single frame, but it can capture a great range of different EV slices—from starlight to blazing sunshine—and that's what makes high dynamic range imaging possible with the right composition.

## Oh Grand! An HDRI Opportunity!

I recently had the opportunity to tour the Grand Canyon and Lake Mead by helicopter. This is a life experience for which the word *awestruck* can be utilized without irony or hyperbole. The chopper landed on a tiny plateau about 300 feet above the Colorado River on the Hualapai Indian Reservation. It was late in the afternoon on a gorgeous blue-sky day. But many of the gorges were in hard shadows due to the low angle of the winter sun. My eyes could take in the full dynamic range of the scene. I could effectively see the nuances of colors in the striations in the shadows and highlights simultaneously. (Human vision is so amazingly complex in its ability to gather

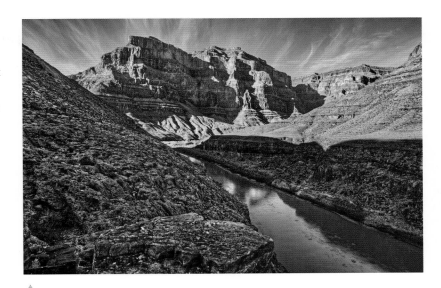

The relatively static nature of this Grand Canyon scene makes it an ideal candidate for HDR treatment.

information that it boggles and baffles the mind, hence the qualifier *effectively*.)

Unfortnately, it was more than even a top-of-the-line pro camera with a per-shot dynamic range of close to 11 stops in RAW at low ISOs could faithfully reproduce in a single frame. Luckily, this camera, the Canon EOS 1D Mark III, has a 10 frames per second burst rate and an Auto Exposure Bracketing setting that can capture up to 7 frames at up to 3 EV spacings. And even luckier (or wiser, I should say), I'd packed my compact Gitzo Traveler carbon-fiber tripod in my camera bag. All I needed to do was find a median exposure, select wide bracket spacing, and fire away.

Based on previous experiences as a photographer, particularly with late afternoon directional sunlight in the canyon-like conditions of midtown Manhattan, I knew that HDRI was the way to go to make images with the

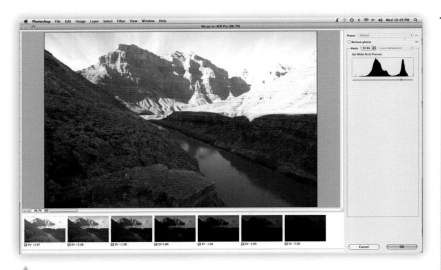

Capturing seven shots from -3 to +3 allows for amazing detail across the entire tonal range—from the deepest shadows to the wispy clouds.

most visual impact on my trip into the Canyon. Add that the scene was overwhelmingly static with virtually no moving elements during a 0.7 second seven-shot AEB burst and you've got a great formula for winning high dynamic range images.

But it's not just natural light and shadows in magnificent landscapes where HDR shines. We're all familiar with twilight and evening scenes when there are great point light sources illuminating architecture. And think of the number of "about to be abducted by aliens" blazingly blown windows you've seen in your dimly lit daytime interiors. Don't you wish you knew about HDR then?

Study your archived photos for shots where there's excessive black or white clip—when it wasn't a conscious aesthetic decision to go high-key or silhouette style. These will help you find your HDR eye. Say goodbye to utterly black shadows and/or bald skies in your sunny and shady landscapes. Say hello to HDR!

The most obvious reason to shoot HDR style is when the highlights and shadows clip off excessively. However, many contrasty scenes with just a little bit of clip at one end of the histogram or other may be improved via the HDR process. This is because the HDR-generating programs analyze the pixel point values from all the source images, which may minimize shadow noise in the low tones and channel clip in the high tones. Experimentation truly is the best way to learn photography and digital imaging.

## Metering for High Dynamic Range Imaging

### First Things First: Take Your Camera Out of "Easy" Mode!

With the exception of top-of-the-line professional models, most DSLRs feature a fully automatic shooting mode where the camera decides all exposure control settings: shutter speed, aperture, and ISO sensitivity. It may even pop

up the flash if the camera thinks it's necessary. Get out of this mode immediately! Even if your camera supports Auto Exposure Bracketing in full-auto mode, you have no way of knowing if it will boost the ISO, stop down the aperture, or increase the shutter speed during a capture sequence. One rock-solid rule for better high dynamic range imaging (and creative photography in general) is to take more control of your camera. It's not nearly as scary as it sounds, and your photos will be the better for it.

## Determining Exposure: In-Camera Metering is Your Friend but May Not Always Be Right

There are several types of in-camera metering: spot, partial, center-weighted, and evaluative, to name a few. Names may change slightly from brand to brand, but one thing remains constant: These metering systems measure some or all of the light coming through the lens and attempt to determine the proper exposure for the scene before the camera. This is how the Program modes work, whether it is Full Program (where the camera chooses both the aperture and shutter speed), Aperture-Priority (the photographer chooses an f-stop and the camera determines the proper shutter speed), or Shutter-Priority (the photographer selects the shutter speed and the camera chooses the proper aperture). Some cameras, in certain modes, may also choose to shift ISO during the program modes. Disable this option *right now*! You do not want ISO shifting during capture of an image sequence.

The Program modes are designed to help you nail the single best exposure for the scene before you, and in many cases, they do a good job at this task—even finding the best "compromise" exposure during high-contrast scenes with light values beyond the sensor's single-image capabilities at one end of the histogram or the other (or both). But oftentimes with dodgy lighting situations, the "compromise" exposure doesn't do justice to any of the image elements and you get a yuck frame that's bound for the trash bin in traditional single-shot imaging.

However, whether it's a weak compromise or a decent representation of the scene with okay exposure but some black and/or white clip, this single exposure can be a handy reference point for making exposure tweaks to find the proper centered exposure, or for the beginning of an auto bracketing sequence.

In HDRI, the goal is to expose the entire tonal range of the scene—from overexposed shadows to underexposed highlights—in a sequence of exposures. It's possible to not bracket enough, but it is also possible to bracket too much. Metering the scene properly and studying the histograms is the best way of ensuring a successful capture sequence covering the entire dynamic range of the scene. If the darkest frame in your

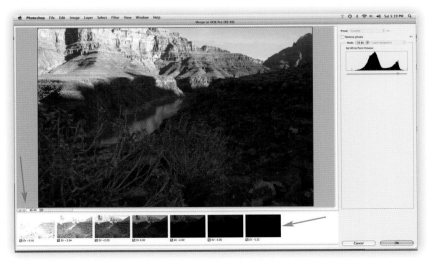

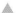 In this example, the darkest and brightest images are very close to being overbracketed. These images can be excluded without significantly impacting the overall luminosity range.

sequence is pure blacks and your brightest frame is pure whites, you've overbracketed.

The goal of the bracketing sequence is to slightly overexpose the darkest tones in the brightest image and to slightly underexpose the highlights in the darkest image. There should be a good bit of detail and histogram overlap between the frames, which helps the HDR generation programs average each pixel point for a high dynamic range color value. An added bonus of the HDR process is that by overexposing the shadow details, it has a noise-reducing effect due to the way captured data is handled in-camera in low-bit space. (This noise-smoothing side

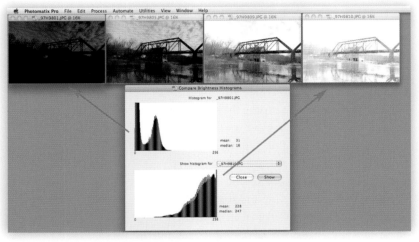

▲

The purpose of the bracketed capture sequence is to underexpose the highlights and overexpose the shadows. I am using the handy **Compare Histograms** function in Photomatix Pro under the **View** menu here. To ensure that the entire dynamic range has been captured, there should not be any white clip in the darkest image, nor should there be any black clip in the brightest.

**CHIMPING** A term that describes photographers using the LCD display screen on the back of their digital cameras to view the images they have just captured. They are so excited that they exclaim "Ooooh, ooooh, ooooh", making a sound like a chimp. The term is now generally used for reviewing the images during a photography session. An alternate folk etymology suggests the term is shorthand for "Check Image Preview", although that doesn't explain the grunts and groans! ■

**TURN ON THE CLIP WARNING AND CHIMP AWAY!** In some circles, reviewing images in the field is considered weak, churlish, amateurish, unprofessional, impure, heretical, and suchlike. For the most part, people who think this are fools. With DSLRs, you have the ability to check your exposures, study the light in the field, and adjust on the fly. What's so noble about learning after you get home that you messed up and it's too late to take another shot when you can mess up and experiment in real time?

Chimping is particularly useful for HDR photography because you want to ensure that you've captured a sufficient exposure range for merging in your bracket sequence. And this is accomplished by checking both the thumbnail images (for a quick-and-dirty visual assessment) and the histograms (for a more precise analysis of the capture data.)

There *are* certain exceptions: You should never take your eyes off field action at a sporting event during live play—missing a peak action shot is one thing, but not being aware of a player's helmet or high-speed projectile en route to your skull is another! The same thing holds true with wildlife. You don't want to take your eye off a big free-roaming creature—be it a bear or a bison! ■

benefit is more effective with Linear RAW data, but is also effective with JPEGs to a degree.)

## Evaluative and Center-Weighted Average Metering

Evaluative and center-weighted average metering modes are good choices for an "out from the middle" metering style. Since these metering modes evaluate the lighting across a broad swath of the sensor area, the meter reading should usually be pretty dead-on for a "normally" exposed single frame. In HDRI, we call this middle exposure with a zero EV offset the "median" exposure. This metered exposure will usually be the best bet as the center of an Auto Exposure Bracketing sequence.

## Spot and Partial Metering

Spot and partial metering modes measure a very small percentage of the frame—usually less than 15% for partial metering and down to as little as 2 or 3% for true spot metering. Check your camera manual for actual percentages of your viewed frame. If spot or partial metering can be linked to an active focus point, you can sometimes meter different segments and light values in a scene without having to change your composition to center the spot metering point on the darkest and lightest values in your composition. Spot and partial metering modes work well when you're manually bracketing a sequence across the exposure range—with a tripod of course!

**AUTOMETERED AUTOBRACKETING?** Right now, multisegment metering analyzes any number of small sections of the frame and averages these exposure values into a compromise exposure that should do well to hold detail through most of the image, and in most cases, this works just fine for single-shot imaging. But I've got a really cool idea for using this metering for high dynamic range purposes.

What if, instead of averaging the varying exposures, the camera determined the necessary bracket spacing for capturing the whole scene in a number of exposures for HDR merging? I *still* can't see why a few lines of code can't be added to the next product cycle's cameras to make this a reality, can you? ∎

## Exposure Bracketing

### First Things Burst

Whenever your camera is set to Automatic Exposure Bracketing (AEB), you should also set your camera to burst mode. There's no reason to not capture an AEB sequence as fast as your camera can shoot—whether you're using a tripod or gambling with handholding. When these two functions are both activated, most DSLRs will capture the AEB burst in a single squeeze of the shutter button and then stop when the AEB sequence is complete. And, a single depression of the shutter button for a number of shots will probably introduce less camera movement than a series of shutter presses. Of course, you can always use a cabled or wireless release—if this can be cofunctioned with AEB—which will minimize camera movement even more.

## Check Your Camera Manual for AEB Options

Buried somewhere in the middle pages of your camera manual will be the description of Automatic Exposure Bracketing (AEB). If you don't find it in the index under *A* for *automatic*, check *B* for *bracketing* or even *E* for *exposure bracketing*. On your camera, it may be a button labeled with the three-box icon, BKT, or AEB. On an LCD menu, it will usually be AEB or Bracket(ing). Regardless of how it is labeled, Auto Exposure Bracketing sets the camera to capture a series of exposures that vary by a user-selected exposure-value offset. If you set Auto Exposure Bracketing to ±2 for 3 shots, your camera will capture three shots in a row at two EV spacings based upon your meter reading.

AEB can be combined with Exposure Compensation to spread your auto-bracketing sequence even further—although it is a two-step (or more) process. Let's say your maximum EV compensation shift is ±2, with the ±2 three-shot burst given earlier. By first dialing EV comp back to -2, you'll get a sequence of shots that stand at -4, -2, and 0, based upon your median measured exposure. Then by dialing EV comp to +2, you'll get 0, +2, and +4 biased shots. Toss out one of the median exposures and you've now got a five-shot bracket sequence from -4 to +4! Of course, you'll need a tripod for this. But the moral of the story is that a limited AEB burst isn't the worst thing in the world.

If you can capture a series of histograms that meets the overexposed shadows to underexposed highlights requirements in an Auto Exposure Bracket burst, (or a combined EV compensation double AEB sequence), you're all set for HDR processing when we get to that chapter. If your brightest and darkest frames are too close to pure extremes—almost 0, 0, 0 or 255, 255, 255—you've overbracketed. Set a smaller AEB offset, reshoot the scene, and recheck the histograms.

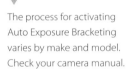

The process for activating Auto Exposure Bracketing varies by make and model. Check your camera manual.

Auto Exposure Bracketing is usually very effective; however, it does have its limits, especially when there are extreme point light sources or very hard shadows in the image and if a camera's AEB sequence isn't ridiculously robust—whether it's the sun, a floodlight past twilight on the hot side, or a dark stairway leading into a metro station on a bright sunny day in the city. In these cases, some variation on manual bracketing will usually yield better results. Some very hot point light sources, such as the sun or very bright floodlights, may still be partially clipped no matter how wide you bracket, but this is OK. Just don't try to overcompensate in tone mapping or you'll turn these hot points into gray haloed splotches!

*Underbracketing* is a far more common mistake than overbracketing. Three shots at ±1 usually isn't a large enough range to truly capture the nuances of a scene with a wide

**NOT ALL CAMERAS ARE CREATED EQUALLY**

Now would be a very good time to consult your camera manual since not all cameras bracket the same way all the time. Certain cameras will shift the shutter speed, the aperture, or both, depending on the program mode. But there should be at least one mode, usually aperture and/or manual mode, where the aperture remains constant, shifting only the shutter speed. Again, this varies from brand to brand and model to model, so the best advice is to know exactly how your camera behaves by checking the manufacturer's instructions. ■

dynamic range. Using aggressive tone mapping (i.e., overcompensating) in an attempt to give the "HDR feel" to an HDR shot generated from an underbracketed source sequence can look artificial and amateurish. If, despite your best efforts and workarounds, your AEB functions can't capture it all, then go manual.

◀

Underbracketing can lead to overcompensating during tone mapping to give an "HDR" feel to an image—and as seen here, the results can look horrid! And don't get me started on the ghosted people in the mid-ground!

## Full Manual Mode: Retro with a Modern Twist

Almost every photograph I've made with an SLR camera in the past decade has been captured in full manual exposure mode. If a shot is overexposed or underexposed, it is my doing, either intentionally or accidentally. Cameras are smart—but they are not creative.

And very often in-camera metering can be fooled, or may simply not realize your intent. There are times with single-shot photography when you will gladly give up the sky to favor the backlit shadowed faces of the soccer players. But in-camera metering, particularly the evaluative and average methods, just try to hold *some* detail in everything, and it's likely a yuck frame again.

Here's the good news. In-camera metering also measures the light during full manual exposure mode—but here you have total control over the shutter speed and aperture. Luckily, this allows us to radically under- and overexpose the scene with the assistance of the spot/partial meter. By spot metering the darkest shadows and then the brightest highlights, we can determine the fastest and slowest shutter speed we'll need to manually bracket the scene for high dynamic range imaging. Then it's a simple matter of spacing shots at even intervals (1 to 2 stops should be good) from about a stop below the darkest reading to a stop over the brightest reading. Just make sure there is a good degree of overlap between the frames. You don't need to capture every 1/3 stop over a 9 EV range, but you also shouldn't simply shoot one frame at -4, one frame at 0, and one frame at +4. Overlap isn't overkill!

Why add two more frames to either end of the metered readings? It's simple: It's always better to capture too many source images over a range than not enough. You can always throw out an extra frame or two, but you can't truly replicate a missing exposure with any post-processing tricks. The most important thing is to field-capture the sequence of exposures that ranges from an overexposed shadow-detail histogram to an underexposed highlight-detail histogram.

> **I'M IN MANUAL MODE, BUT EXPOSURE COMPENSATION ISN'T WORKING!**   Don't worry. You're in manual mode. You now have total control of the exposure compensation—well beyond the limited ± range of the button or dial that normally tweaks your exposure in the program modes. Want to underexpose from the meter reading by 3 stops, 5 stops, or even 10 stops? You've got the power. Count your full stop shutter speeds and adjust accordingly. Overexpose the darkest shadows or underexpose the hottest highlights—you've got the power in manual mode!. ∎

## Be Still, My Bracketing Camera

Here is a case of "do as I say, not as I do". Yes, I frequently gamble and handhold AEB bursts with certain high-end cameras that have ultra-fast burst rates. Sometimes it works well. But other times, it creates more computer work—if it works at all. And it can have an impact on the overall output image sharpness. Gamble if you want, but do realize that you are taking a chance. The worst thing that may happen is you'll get one exposure near the proper "single exposure" for your collection.

If you want to gamble with handholding high dynamic range source image sequences, here are a few tips to improve your odds:

- Wider lenses work best. You'll get less pixel drift between slightly unaligned frames with a 14 mm lens than a 50 mm. The longer

the lens, the more the camera movement is exaggerated between frames.

- Hold your breath, brace the camera firmly with a two-hand grip, and press the eyecup tightly to your brow. Be firm in your grip, but not tense—this can increase shake and misalignment.

- Jack's corollary to the 1/x focal length rule: No shot in a handheld Auto Exposure Bracketing sequence for high dynamic range imaging should be slower than the reciprocal of the focal length. For example, no shutter speed in the sequence should be longer than 1/15 second in an AEB burst with a 14 mm lens.

- Jack's special corollary to the 1/x focal length rule for HDR imaging: You can safely expect to gain one stop with a stabilizing element in the camera or lens. You may be able to get a slow frame acceptably sharp with a 14 mm lens down to about 1/10 to 1/8 second.

- The entire burst sequence should not exceed one second. This is dependent on shutter speeds over the EV spacing and on the frames-per-second rate of the camera. Again, this varies by camera, and with some top-end pro cameras, you can make a seven- or nine-shot bracket burst in less than a second. With many of the more economical DSLRs, you may be limited to three shots because of either the AEB bracket limits or the frames-per-second rate.

- Before attempting HDR merging, assess the individual frames of the source image capture sequence for sharpness, paying particular attention to the slowest frames.

- Be sure to enable alignment options (if user selectable) during HDR merge.

Good luck!

## Ready for Some More Gambling? Moving Objects, Deghosting, and More Risky Techniques!

Yes, the world is constantly in motion—from clouds and water features in landscapes to people, cars, and more in cityscapes. Moving objects create challenges for HDR imaging, and, after tone-mapping, can sometimes result in ugly "HDRtefacts". Don't be afraid to experiment, but do realize that you are gambling and you might not get a perfect result every time. Some HDR programs have deghosting schemes built into HDR generation, which we'll explore, and I'll also share my ultimate deghosting method later. Here are some real-world observations to help with your high-risk HDR opportunities:

- Objects that move between short-duration frames are a problem, but objects that are in constant motion during longer exposure frames are less problematic (e.g., drifting clouds, flowing water, and streams of headlights).

- The smaller the object is in the frame, the less harsh the HDRtefacting will be around the object. A little ghosting intrigue of moving cars, walkers, or scooters can add something to high-vantage point cityscapes.

- During HDR generation, experiment with different subsets of the capture sequence frames to see if the ghosts are minimized in one subset or another.

- The smaller the target size of the output image, the more wiggle room you've got. Small moving objects may not be noticeable on-screen, or even in a 4 x 6 print, but they grow more noticeable the larger a print gets.

- Photoshop's Smudge tool is a great way to smooth HDRtefacting. We'll cover this in post-production.

▶

When you first saw this image on page 32, did you even catch these tiny little ghosts? It's obvious at a 100% pixel level, but virtually seamless at 4 x 6 snapshot size.

## File Management, Storage, and Back-Up

File management isn't a lot of fun, but it is important for keeping track of your photographs for high dynamic range imaging. There are multiple versions of each captured scene, 32-bit true HDR images, and tone-mapped output images that will all be gobbling up hard drive space at an amazing pace. For example, the work folder for *Practical HDRI* is close to 137 gigabytes and will continue to grow as this book progresses.

**DEGHOSTING**   When you're taking a series of exposures for an HDR image, there are frequently moving objects (such as people) in the scene, causing each exposure to be inconsistent with the rest. This results in ghosting—the moving objects appear semitransparent. The process of removing the semitransparency is called deghosting.  ■

## A Little Bit of Organization Goes a Long Way

If you already have a file management system in place that works for you, you're ahead of the game, *for the most part*. Then it is simply a matter of incorporating your source image files, 32-bit HDR files, and tone-mapped output files in a way that will help you identify and track the images along the HDRI path. You'll need to pay particular attention to some challenges and known issues with 32-bit files, including inter- and intraprogram compatibility, potential keyword and EXIF loss during HDR generation, tone mapping in certain programs, and so on.

Adobe Photoshop Lightroom 3, Camera Bit's Photo Mechanic, and Apple's Aperture are all wildly popular among photographers for workflow and asset management, but none of these are as adept at handling *all* phases of the HDRI

process as Adobe Bridge CS5. You can easily adapt parts of this Bridge CS5 workflow to your chosen program, but keep in mind that most of those programs are not currently able to work with 32-bit HDR files.

## Bracketed Source Image Importing and Keywording

Establishing a routine to import and assign keywords to your bracketed source files will go a long ways toward keeping your workflow and disk space streamlined and organized. Here's how I use Adobe Bridge to bring my source shots from card to computer.

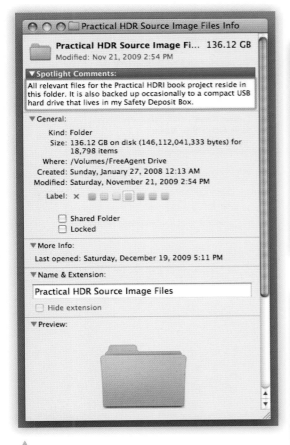

◀ **1**

In Adobe Bridge, select Preferences (or CMD+K) to auto-launch the Bridge Photo Downloader whenever a camera or memory card is mounted to your computer. Or you may select File > Get photos from Camera to launch Bridge's Photo Downloader utility.

◀ **2**

Click the Advanced Dialog button. The resulting screen has a few very useful options missing from the basic screen. But if you know you want to import each and every image on your card, it's okay to use this screen.

▲

I'm only about halfway through my work on updating *Practical HDRI* for the second edition, and between source files, HDR files, output images, screen shots, and written documents, I'm now at about 136 GB! If you are serious about high dynamic range imaging, invest in big hard drives. For example, I have more than 3 terabytes of hard drive storage hooked up to my iMac right now, and I have many important documents and folders, including this one, duplicated to a compact USB drive in my safety deposit box.

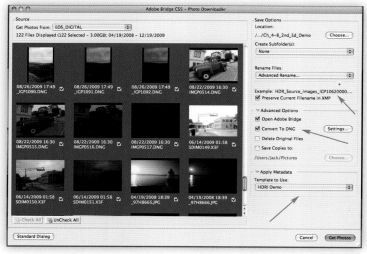

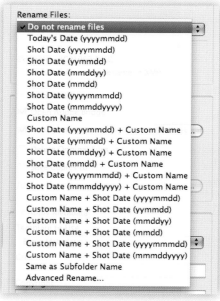

 **3**

I like the quick image browser for selecting which images to be imported. This is handy if there are test shots and other "out" images that don't need to be in your primary workflow area. There are a few things to pay special attention to in this window. **Rename Files** allows you to append or replace the in-camera names with a number of different options. Here I choose to prefix the in-camera source image names with **HDR_Source_Images_###** and suffix with a four-digit sequence as well. You also have the option to convert any proprietary RAW files to Adobe DNG format. And you can append or replace metadata as well in this process. But perhaps more important, notice what is not checked. Never check a **Delete Original Files** option in any import program! It is well worth the extra few seconds to confirm that all files copied correctly before clearing your cards yourself.

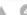 **4**

There are many preloaded file rename options, but if none of these work for you, you can also make your own set of renaming rules by selecting **Advanced Rename**.

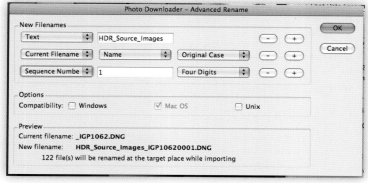

 **5**

Here I have chosen to add a prefix and suffix to the original file names.

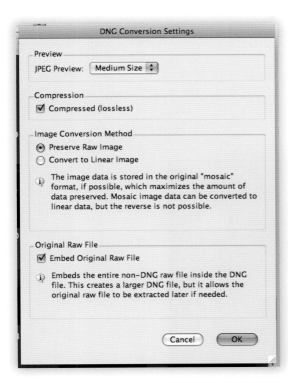

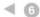

DNG conversion of proprietary RAW formats is a good idea to ensure cross-program compatibility. It may be redundant to have both **Preserve Raw Image** and **Embed Original Raw File** checked, but this keeps your source data in the most untouched state. However, if you find an HDR program is having trouble with your DNG files, consider making copies of your source files by checking **Convert to Linear Image**.

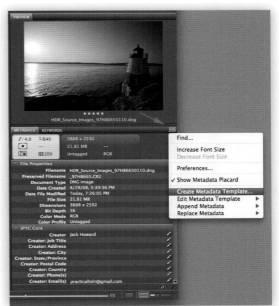

Notice that the Metadata box had **HDRI Demo** selected? Before you can import images with custom metadata, you've got to make a template in Bridge. Choose **Create Metadata Template...** in the flyout box to assign all sorts of cool and useful information to your source images.

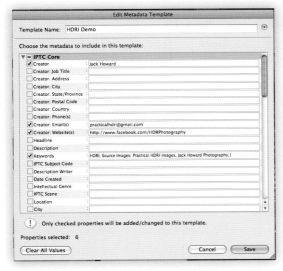

Once you've chosen your import location and assigned keywords and metadata, go ahead and click **Get Photos** and all the photos will be copied to your destination. In this case, it is a master folder named Ch_4-8_2nd_Edition_Demo_Folder.

There are many different fields that can be filled out in the **Edit Metadata Template** to identify the owner and creator of the image along with the image content itself. Include as much information here as you want, knowing that this same information will be applied to each and every imported image. It can always be updated later. Since this folder of images is a mixed bag, I am going to include high-level keywords, including *HDRI, Source Image, Practical HDRI*. I'll add much more detailed keywords to some images later. It is always a good idea to include copyright status and a contact email as well.

## Image Organization, Stacks and Ratings, and Even More Keywording

Next I'm going to show you how to use the tools available in Bridge to make this collection of images much more manageable with subfolders, ratings, colors, stacks, and even more keywords.

I try to include a geographic and subject-specific term in the folder name along with the date and my standard shorthand for my different cameras. For example, my folder named **SanFranKauaiPentaxK7082009** contains source images shot with the Pentax K7 on a trip to San Francisco and Kauai in August 2009. Looking at the other two folders' names in this screen shot should tip you to what's inside.

Bridge has a number of great ways to sort, sift, filter, and rank images in a folder, and we can use these to our advantage with our HDRI workflow to keep track of all our bracketed images. Let's look first at how labels and ratings can help us keep our bracketed shots orderly. Forget for now how Adobe intended them to be used and what meanings are assigned to the colors and stars. Just look at these as differentiators for your bracket sequences.

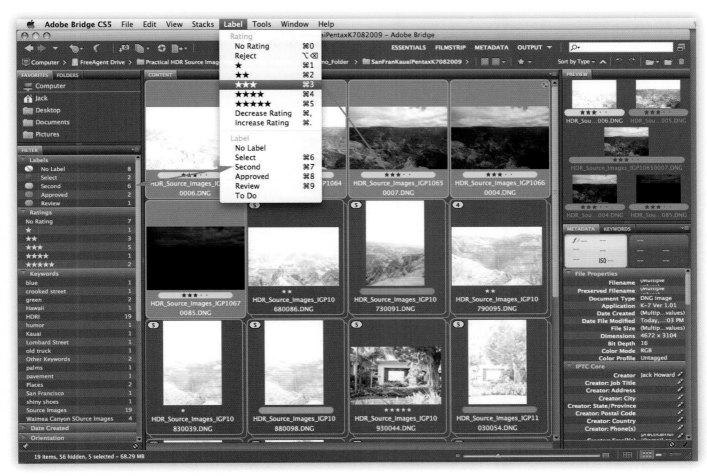

Look at the five highlighted images at the top of the image browser. I have rated these **3 Stars** and labeled them **Yellow**. Look at the other images and stacks in this folder. Notice that some have colors, some have stars, and some have both. The combination of 0 to 5 stars and none or four colors adds up to 30 possible star and color combos that can easily be assigned by simply selecting all the source images from a given bracket burst and using a couple of keystroke shortcuts, as shown in the screen shot.  If you want to follow the visual language cues in Bridge to rank your bracket sequences, **5*Red** is tops, with **No*None** at the bottom. Personally, I just try to make sure similar compositions are rated and labeled differently to help me sort them out. And this helps with grouping into Stacks, as I'll show you really soon.

▲ ②

Now I am unlikely to accidentally grab and attempt to merge source images that aren't from the same bracket sequence. Notice that there are several source sequences for each scene and how each sequence is rated in a way to separate it from its similar, but not identical, shot sequences.

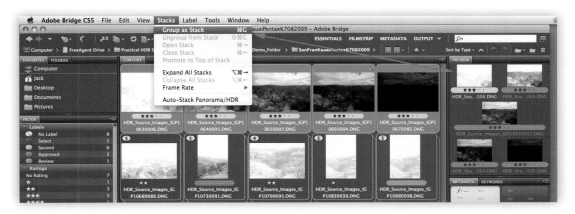

 **3**

Next, we're going to group these five bracketed source images together into a stack. Select all five images and choose **Stacks > Group as Stack (CMD+G)**. As you can see, I have already grouped many of the other bracketed source sequences into stacks in this folder.

 **4**

**Stacks > Auto-Stack Panorama/HDR** is a cool feature of Bridge, and it is usually pretty accurate in sorting and stacking source images together. You may want to give this a shot to potentially save some time. You can always ungroup stacks or combine stacks if it doesn't quite get it right.

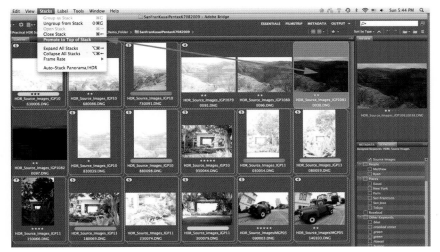

**5**

Notice these handy keyboard shortcuts: **CMD+right arrow** and **CMD+left arrow** to open and close the active stack and the Shift-added version of these shortcuts to expand/contract all stacks. You can always reassign an image to be the top of stack image, which is very handy when the default top image in a stack is very under- or overexposed. You can easily tell which stacks I've already reassigned a top image to and which are still waiting to be updated.

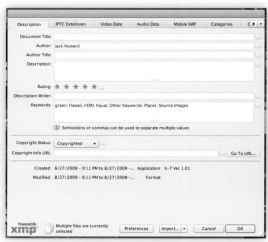

▲ ⑥

You can update file information and keywords for any and/or all images in a stack either directly in Bridge by clicking in the Metadata or Keyword field or under **File** > **File Info** (CMD+I). I prefer the **File** > **File Info** method because the forms are bigger and more well padded from one another.

Stacks are great, and handy, and have a lot of really good things going for them, but there are a few things to pay attention to in order to avoid trip-ups. When stacks are collapsed, it is very easy to accidentally select just the top image in a stack. And you can select just the top images in a number of different stacks, which then messes up all your stacks if you move just the top shots. You've got to click on the very slight edge of the back-of-stack icon to select the whole stack when stacks are compact. And stacks are folder specific. If you select a couple of image stacks from Folder A and copy the images to Folder B, they come over as discrete, unstacked images. Ratings and labels stay, but the stack organization goes away. *But if you copy a folder, the stack information comes along too*. Some of my naming, labeling, stacking, and keywording suggestions may seem very much like overkill at first, but it is better to over-ID your files than under-ID them, especially for

the next phases on the HDRI workflow with 32-bit files and tone-mapped images. It really helps when you need to lean on your computer's search function to track down an errant EXR that got saved to a default locale.

## Saving Back to the Stack

Now here's where it can get confusing. Each program has a different default naming scheme and potentially different save locations for high-bit and tone-mapped images. You can usually append or replace default naming and save locations, but if you forget, you'll be cluttering up forgotten corners of your drives and you'll lose time searching for images. Pay attention to the **Save As** and **Save Images Location** prompt boxes. Always remember to route to your desired subfolder and append or replace the default names with descriptors that will jog your memory. For complex mergers that require

alignment or deghosting, it's a good idea to include the HDR-generation program shorthand and style of merge. For example, if I use Photomatix Pro with deghosting set to **Background Movement High** for a shot of Waimea Canyon from the folder shown here, I might name the 32-bit HDR file **WaimeaCanyon1PXdeghostBackgroundHigh.exr**. Yes, it's a mouthful, but it tells me exactly what the HDR image is and how it was generated. The reason this step is so important is that the most universal 32-bit format,

OpenEXR, doesn't currently support IPTC data, and each program handles this differently. Adobe Photoshop CS5 passes along all the keywords from the source images, but Photomatix Pro will keep only the source image keywords in the tone-mapped output file if the merged image is tone-mapped without having been saved as an OpenEXR. That's why I strongly suggest mirroring top-level keywords, dates, and geos in the 32-bit file name and saving back to the stacked source files folder.

I've now created a 32-bit HDR image and also a tone-mapped JPEG from this stack of source images. Notice the file names that mirror the keywords and identify a lot of what's in the image. I'm now going to add these into my source image stack for easy organization.

We now have seven images in this particular stack: our original 5 source images, the OpenEXR HDR file, and a tone mapped JPEG file.

You cannot edit the metadata or keywords of an OpenEXR file in Adobe Bridge CS5. If you try, you get a warning that this file type isn't supported.

You can, however, edit all these fields provided you do so directly through Adobe Photoshop CS5 via **File>File Info**. Note how the 4 Star rating and keywords show up in the fields even though this information is not viewable in Adobe Bridge. And the 32-bit file should inherit all the keywords from the different source images.

Photomatix Pro allows you to add keywords to your tone-mapped file under **Photomatix Pro > Preferences**.

## PROGRAM SHORTHAND YOU MAY NOTICE IN SCREENSHOTS

- Photomatix Pro: PX
- FDRTools Advanced: FDRTools, FDR
- Dynamic Photo HDR: DP, DPHDR
- Adobe Photoshop CS5: PS, PSCS5, CS5
- Adobe Photoshop CS5 Extended: PSE, PSCS5E, CS5E
- Adobe Camera RAW: ACR
- Adobe Bridge CS5: Bridge, BR
- HDR PhotoStudio: HDRPS
- Adobe Photoshop Lightroom: LR

The most important thing is to make a file management and naming system that works for you. The way I do it works for me. Feel free to integrate your HDR images and folders into your existing naming strategy, but be sure to use some internally consistent logic. If you don't have a strong file management system in place, trust me—start thinking of a logical organizational system for your HDR work now, before you start clogging your hard drives randomly.

## BACKING UP DATA ONSITE AND/OR OFFSITE

There are many different methods for backing up data. Options range from simple, onsite offerings such as Apple's Time Machine and other archiving/recovery solutions to RAID drives, offsite hard drives and optical memory, and service offerings such as cloud storage. HDRI photography data can quickly balloon, so it is a matter of your comfort level for potential data loss and cost that will determine how you approach preventing (or limiting) it. Keep in mind that no matter the extent of local redundancies you put in place, in the event of fire or flood the entire information cluster will be destroyed. Cloud storage (aka virtual storage accessed via the Internet) allows you to essentially rent storage space as needed from a cloud service provider. While cloud storage offers flexible pricing models, it can become costly; consider that your data is less vulnerable to physical loss but make sure the cloud provider you choose is reputable and has a guarantee against data loss. ∎

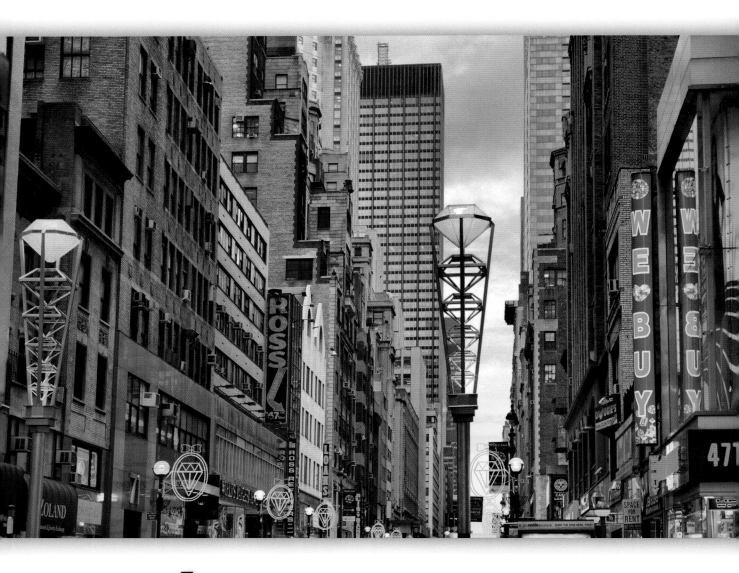

**5**

**HDR Generation from your Bracketed Photos**

Combining the bracketed low dynamic range source images into a single high-bit, high dynamic range image is the first processing step toward producing an image that preserves the luminosity over a greater range than is possible in a single image. Each of the HDR programs we explore in this book have different interfaces and different merging options, but the end result is the same: A high dynamic range image with a tonality and luminance range much greater than a single traditional low-bit, low dynamic range image. We'll explore the basic techniques, including manual and automatic alignment, along the way.

## Before We Start: A Visual Thumbnail Viewer Is a Good Thing!

One of the most complicated parts of the high dynamic range workflow is simply keeping track of which photos are part of which bracketing sequence to be merged together. A visual thumbnail viewer is a good thing to help sort the photos! Your native operating system may or may not support thumbnail display of your RAW files. Adobe Bridge supports a great number of RAW formats, but with brand-new cameras, it may revert to a generic icon with RAW files until the next incremental upgrade. If none of your third-party or native OS viewers will display your RAW thumbnails, it's a sure thing that one of the programs that shipped with your camera will.

Depending on both the viewer application and the HDR generation program, drag-and-drop or right-click functionality may be a possibility. For example, it's possible to drag and drop LDR bracketed source images straight from Adobe Bridge CS5 into Photomatix Pro Photoshop CS5, FDRTools, and HDR PhotoStudio; however, Dynamic Photo HDR does not support much drag-and-drop functionality. In this case, the visual thumbnail viewer is simply a guide to aid in mapping to and selecting the correct source files for HDR generation. It's quite frustrating to wait a few minutes for a big HDR generation process only to discover that you've accidentally included the wrong photos from a file list!

Many HDR programs, such as Photomatix Pro, support drag-and-drop or right-click functions straight from Adobe Bridge CS5 and other viewers, such as Lightroom.

## Patience Is a Virtue!

Even with a big, powerful computer, the processing time for the various stages of high dynamic range imaging can be very long, especially with full resolution RAW images from high-megapixel cameras. There's always a slight chance a program is hung-up if it takes more than a few minutes, but more often than not, your processor is simply working as fast as it can to get it right. Each additional option and

Whether you're a beginner or a risk-taker, experimenting and learning with lower-resolution JPEGs can dramatically cut down on processing time. And if your merging works with the low-res JPEGs, it should work with the higher-resolution RAWs.

step, such as automatic alignment and deghosting, can add to the processing time.

While you are in the learning and experimentation stage, you may want to consider working with lower-resolution JPEGs, especially with high-risk sequences that may not properly align or deghost; you will save some time on the front end. And if the smaller files align and deghost, odds are the RAWs will as well. Oftentimes, with challenging HDR scenes, you may want to include or exclude a couple of shots from the sequence to see if it helps alignment and deghosting—and again, you'll find out a whole lot quicker with small JPEGs than big RAWs.

Don't fall into the trap of thinking your system is hanging permanently if any HDR process takes more than a couple of seconds. There's a lot of crazy math going on, and it can take a lot of time to get it right!

For example, on a 2.4 GHz iMac with 4 GB of memory it took over 10 minutes to merge seven images in Nikon D3 NEF format in Adobe Photoshop CS5 as opposed to 36 seconds for the downsampled 1200 x 798-pixel JPEGs of the same scene. These were handheld shots and needed a good bit of alignment assistance.

Ten minutes is a long time to wait to see if the computer can correct for your gambles!

Once you've determined which source files you will merge together to make the best high-bit image, you can repeat the steps with your high-resolution RAW files—and then pop out for a cup of coffee while the processing chugs along!

## A Little Bit of Goldilocks Syndrome Going On

Remember, it's almost always better to have too many source images rather than not enough. It isn't truly possible to build a bracket sequence in the digital darkroom—that must be done in the field. But sometimes an HDR image won't look right if you have too many or too few source photos involved. More images means more chance for moving elements between frames and more chance of alignment problems. However, more images also means more sampling to determine 32-bit color and luminosity values at each pixel point—leading to a better high dynamic range representation of the scene.

Don't be afraid to toss out one (or more) of the source images in a large bracket sequence

if it appears to be the problem image. Tossing out the brightest or darkest images will have an impact on the overall dynamic range, which can lead to over-aggressive tone mapping to attempt to compensate for the smaller dynamic range.

But skipping a near-median image may also have an overall impact on the image quality because the darker and brighter pixel-point numbers may sway the averaging—potentially resulting in increased high-key chromatic aberrations and excessive low-key chromatic noise in the high dynamic range image.

Moral of the story: Experiment and see if you can get it just right. And then experiment some more.

**SORTING OUT BEST SOURCE IMAGE FORMATS**    A few years ago, RAW was considered the undisputed champion of formats for source images to merge to a single high-bit HDR file in pretty much every HDR generation we explore in *Practical HDRI*. But in the past few years, increased file sizes and additional complexities during RAW conversion has changed the landscape. Quite honestly, RAW file evolution has outpaced the development of the RAW decoders employed in most of the small-shop HDR programs. Shooting RAW in-camera is still highly recommended for the best-quality source files. But converting these RAW files to "straight-as-the-camera-saw-it" minimally processed 16-bit TIFFs via Adobe Camera Raw, Lightroom, DxO, Aperture, or camera-specific software prior to HDR merge is now a recommended step in the workflow for some of the programs in this book in order to deal with noise suppression, chromatic aberrations, lens corrections, and so on. I offer my suggestions on whether to choose RAW or 16-bit TIFFs from RAW source files for each software title in this chapter. ∎

## Converting RAWs to Minimally Processed TIFFs

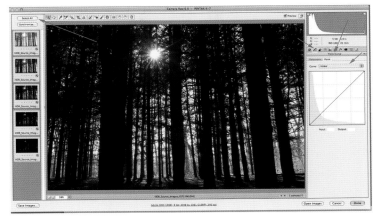

▲ Select your RAW shots in Adobe Bridge CS5 and double-click to launch into Adobe Camera Raw and you will see this screen. Click **Select All**, click the **Curves** button (second from left), click on the **Point** tab, and select **Linear** from the drop-down menu. Leave almost everything else in the ACR settings alone. Then click **Save**.

▲ Append your file names with **TIFF_CONVERSION_** or something logical and pick a save location. Choose TIFF from the drop-down menu of file types and select **NONE** for compression. One thing you will not see is a TIFF bit depth option! You must select this along with resampling or original file size in the last step! In the lower right is an indicator as to how many images were pulled into Adobe Camera Raw and how many the current actions will be applied to. We're 5 for 5, so we're all good.

## Merging of Images to HDR in Adobe Photoshop CS5, Photomatix Pro 3, FDRTools Advanced 2.3, Dynamic Photo HDR 4, and HDR PhotoStudio 2

If you haven't done so already, now is a good time to download trial versions of each of these programs.

- Dynamic Photo HDR 4: http://mediachance.com
- FDRTools Advanced 2.3: http://fdrtools.com
- Photomatix Pro 3.2: http://hdrsoft.com
- Adobe Photoshop CS5/CS5 Extended: http://adobe.com
- HDR PhotoStudio 2: http://www.unifiedcolor.com

**FREE TRIAL TIPS**    Since it's a free trial, you may as well go for the gusto with Photoshop, and give CS5 Extended a whirl. This ultra-version of CS5 costs several hundred dollars more, but has some really impressive features for photographers, including one of the most amazing and easy de-ghosting processes I've discovered.

These five programs follow different workflow paths to arrive at a 32-bit high dynamic range image. All but HDR PhotoStudio 2 offer some form of ghost management options, and each can be effective sometimes (we'll explore this in Chapter 6). And all offer automatic and/or manual alignment options. Adobe Photoshop CS5 , FDRTools Advanced,  Photomatix Pro, and HDR PhotoStudio support both Radiance (.hdr) and OpenEXR (.exr) 32-bit formats. And HDR PhotoStudio's 32-bit proprietary BEF format is readable by Photoshop CS5 via a filetype plugin. ∎

These five programs follow different workflow paths to arrive at a 32-bit high dynamic range image. All but HDR PhotoStudio offer some form of ghost management options, and each can be effective sometimes (we'll explore this in chapter 6). And all offer automatic and/or manual alignment options. Adobe Photoshop CS5, FDRTools Advanced, Photomatix Pro, and HDR PhotoStudio support both Radiance (.hdr) and OpenEXR (.exr) 32-bit formats.

Dynamic Photo HDR supports only the Radiance format. All five programs support read/write of  8- and 16-bit TIFFs, JPEGs, and many different RAW formats. And now I've arrived back at the only real reason I can think of to use Radiance instead of OpenEXR format: cross-program compatibility with Dynamic Photo HDR (DPHDR). If you wish to generate your HDR image in another program but take advantage of DPHDR's robust set of tone mappers and fun extras (or generate your HDR image in DPHDR but tone map elsewhere, for that matter), you've got to save your true 32-bit HDR image in Radiance format. HDR PhotoStudio's BEF format looks promising as both an in-camera and on-computer file format, but we'll have to see if it takes off and gains acceptance. (Check back in a few years for the 3rd edition updates!)

### Merging to HDR in Adobe Photoshop CS5

Unlike some of the other HDR-specific programs we'll explore in this book, Adobe Photoshop CS5 is an amazingly robust image-editing program, and HDR processing is but one of thousands of options for image editing. Whether HDR generation is initiated  in Adobe Bridge CS5, Adobe Lightroom 3, or Adobe Photoshop CS5, all the heavy lifting is done in Adobe Photoshop CS5. If it's hosted through Bridge

or Lightroom (LR), alignment is automatically applied if the HDR merge programming in CS5 deems it necessary. If hosted directly in Photoshop, there's a check box option to align the images.

Bridge has a few major advantages for using at the start of the CS5 HDR process:

- You can continue to work in Bridge CS5 once you've sent a series of shots to Photoshop for HDR merging.

- Bridge is capable of reading and rendering thumbnails of all the 32-bit filetypes supported by Photoshop CS5.

- Bridge CS5 (and Adobe Lightroom 3) support right-click-on-image on-the-fly menus to edit/export into many third-party HDR programs, including Photomatix Pro, HDR PhotoStudio, and FDRTools Advanced.

There are a couple of things to be aware of when using Bridge CS5 as your HDR merge host into Photoshop CS5:

- RAW/DNG source images will be sized to the current scale-down or scale-up setting

in Adobe Camera Raw, even though you will never see the ACR dialog box during the merge to HDR Pro process. (This also holds true when RAW/DNG files are selected via Photoshop CS5's **File > Scripts > Merge to HDR Pro** command path.

- There is no option to deselect image alignment via Bridge. If you are certain the images are pixel-perfectly aligned but the auto-alignment process is causing problems, follow the **File > Scripts > Merge to HDR Pro** path in Adobe Photoshop CS5 and uncheck **Align Images**.

---

### RAW, TIFF, OR JPEG FOR PHOTOSHOP CS5?

For merging to HDR in Adobe Photoshop CS5, my recommendation right now is to use RAW for best results. The Adobe Camera Raw engine, combined with the new lens correction feature, is a very powerful tool! Pay attention to the currently active size selected in Adobe Camera Raw because your files may be resized depending on this setting. ■

---

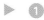

Select your bracketed source files in Adobe Bridge CS5, and select **Tools > Photoshop > Merge to HDR Pro**. And then wait patiently as Bridge hands it off to Photoshop CS5 for the remainder of the HDR generation process. Keep in mind that the resize settings in Adobe Camera Raw will be applied to any RAW/DNG files selected!

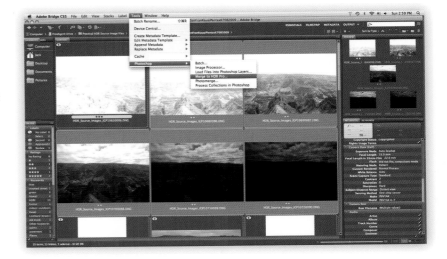

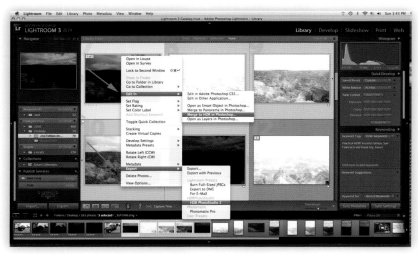

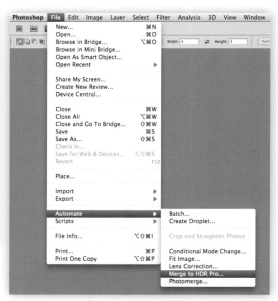

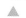

If you are more comfortable working in Adobe Lightroom 3, you can initiate CS5's HDR merge from Lightroom by selecting the source images and selecting **Edit In** > **Merge to HDR in Photoshop**. Additionally, you can oftentimes export your source images from Lightroom or Bridge to many third-party HDR generation programs.

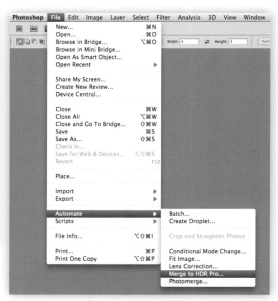

If you prefer, you can work directly from Photoshop. **File** > **Automate** > **Merge to HDR Pro** will bring up the **Merge to HDR** dialog box. Keep in mind that the resize settings in Adobe Camera Raw will be applied to any RAW/DNG files selected.

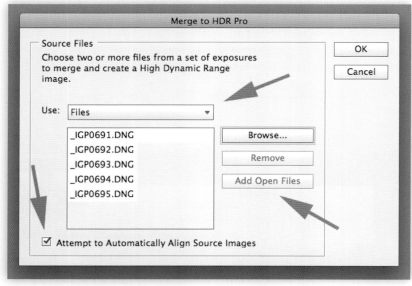

The **Merge to HDR Pro** dialog box allows you to browse to source images, including RAW/DNG filetypes, or select images that are currently open in Photoshop. Check the **Attempt to Automatically Align Source Images** option if there is a good chance the images are not pixel-perfectly aligned.

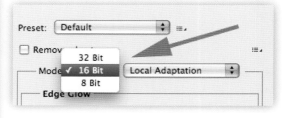

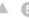

Whether you started in Bridge, Lightroom, or Photoshop, all roads lead to the **Merge to HDR Pro** preview window. This window's default setting is to open with the bit depth set to 16 bits and the **Local Adaptation** adjustments active, but I am going to go ahead and change this to 32 bits right now. (You *can* skip working on and saving your 32-bit file and jump right to tone mapping at this point, but when you see all the cool things Adobe Photoshop CS5 can do in 32-bit space, you'll probably want to reconsider.)

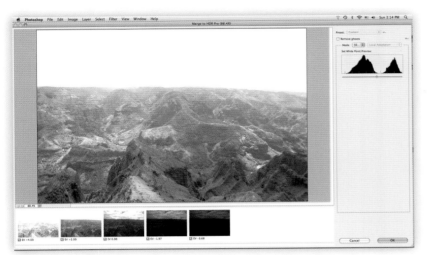

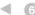 **6**

There's a lot going on in this very clean, crisp interface. Below the HDR preview are the low dynamic range bracketed source images, with the EV offset of each. The preview window has an option to scale the preview up or down (CMD Plus or Minus also works).

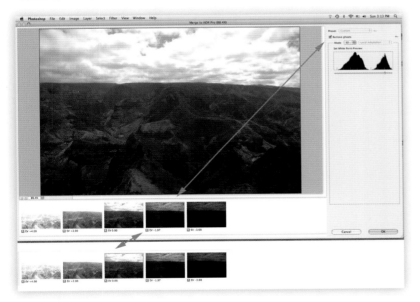

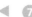 **7**

There is now a **Remove Ghosts** option in Adobe Photoshop CS5. This is a very welcome addition to the HDR merge process. Notice that the green highlighted source image is the anchor image for the deghosting process. When the **Remove Ghosts** button is checked, click on a different source image to make it the ghost-removal anchor image.

☐ EV +4.00          ☑ EV +2.00          ☑ EV 0.00          ☑ EV −1.97          ☐ EV −3.68

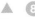 **8**

You can uncheck any of the LDR source images, and the histogram will refresh to reflect their exclusion. This is just for demonstration. I am going to reactivate all originally imported source images now. With your own shots, you may choose to include or exclude any of the source images in this step.

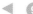 **9**

Adjust the slider under the histogram to **Set White Point Preview** for both this window and when the image is opened into Photoshop. It can always be adjusted temporarily or reassigned in Photoshop if you need to examine and edit a different EV slice section.

 **10**

If you want to skip the options to save the 32-bit high dynamic range image and skip working up your 32-bit file in Photoshop before tone mapping, you can drop the bit depth down to 8 or 16 bits per channel and jump right into Photoshop's great new tone mapper. But after you see some of the cool stuff you can do in 32-bit space in Photoshop CS5, you'll probably reconsider. So click OK instead to open the 32-bit high dynamic range file in Adobe Photoshop CS5.

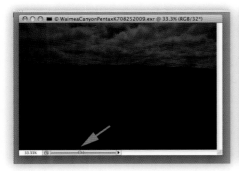

▲ ⑪

Remember the white point preview we set in the **Merge to HDR** window? That lines up with the middle image here. All three of these shots are the same image, but with different white point previews set on the slider on the bottom of the image window. This setting is not "sticky", and adjustments are per view. If you close and reopen the 32-bit file, it will be opened to the white point that was originally selected during HDR merge. A nice touch: Double-clicking the slider reverts it to the original setting.

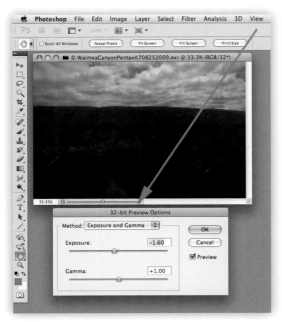

▲ ⑫

If you do want or need to permanently reset the white point of a 32-bit file in Adobe Photoshop CS5, this can be accomplished with the **Exposure and Gamma** settings under **View > 32 Bit Preview Options**. This is particularly handy when HDR files created in one program open to an out-of-screen-gamut EV slice in a different program and the HDR file is projecting on screen close or past the 0s or 255s.

▲ ⑬

Depending on your program settings, the 32-bit Exposure slider may not show in the window frame, even when you are working on a 32-bit image. But don't worry, just click the arrow on the bottom edge of the frame and select **32-Bit Exposure** from the drop-down menu if you need to adjust the exposure level.

▲  ⑭

Selecting File > Save As allows you to save your 32-bit high dynamic range image in a number of different formats. OpenEXR offers lossless compression and good color fidelity. But if you want to tone map your 32-bit file with Dynamic Photo HDR, also save a version as a Radiance (.hdr) file. The other formats you see here are rather unwieldy and will unnecessarily clog up your hard drive for long-term storage. But if you want to work with alpha channels and adjustment layers in 32-bit space, you'll have to save as Photoshop (.psd) or Large Document Format (.psb). Be forewarned that these layered files usually won't play nicely with other HDR programs and will need to be flattened and saved in a more universal format such as OpenEXR for cross-program usages.

That's the basic high dynamic range generation workflow for Adobe Photoshop CS5. We'll revisit working in 32-bit space in Adobe Photoshop CS5 in the next chapter. We'll also check out a really cool way to deghost in CS5 Extended using multiple source images for each exposure value in the source image series.

## Merging to HDR in Photomatix Pro 3.2

Photomatix Pro 3.2 is an extremely popular dedicated high dynamic range imaging program from HDRSoft. There are a handful of general imaging utilities, such as crop and rotate, but the primary purpose of Photomatix Pro is HDR image generation and tone mapping. Any advanced global or local post-production work is handled in your normal full-service image-editing program—the Photoshop family, Corel's Paint Shop Pro Photo X2, and such. Photomatix Pro offers two image alignment options, two deghosting methods for higher-risk merging attempts, and a feature-rich batch task utility.

---

**I KNOW MY SHOTS WERE ALIGNED WHEN SHOT, BUT THEY'RE UNALIGNED AFTER HDR MERGE!**

If you have this problem, try one or two of the following:

- Turn off any user-selectable alignment options.
- Consider throwing out the hottest and/or darkest image in the bracketing sequence.
- Try to manually align the shots in either FDRTools or Dynamic Photo HDR. ■

---

**RAW, TIFF, OR JPEG IN PHOTOMATIX PRO?**

For merging to HDR in Photomatix Pro, my recommendation right now is to use 16-bit TIFF files converted from RAW files via ACR, LR, or your camera's proprietary converter with minimum processing for best results. ■

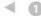 

You can launch Photomatix Pro by dragging your bracketed source files onto the Photomatix Pro icon on your PC desktop or Mac Dock. Or if the program is already launched, you can click the **Generate HDR Image** button on the **Workflow Shortcuts** panel. This will bring up **the Generate HDR - Selecting Source Images** window (top right). Clicking **Browse** will allow you to navigate to your source images. Macintosh users may be able to get visual confirmation of which files are selected in RAW, JPEG, and TIFF formats straight from the OS, but Windows users may not have visual thumbnails of RAW files, depending on their version of Windows (which is why I suggest keeping Bridge running in the background for visual confirmation). Select the images you wish to merge in Photomatix and click **Open**, then **OK**.

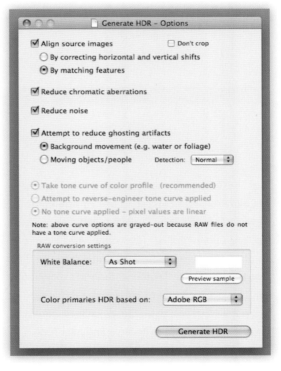

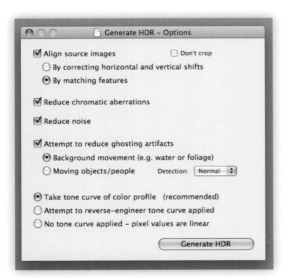

The next window to pop up will vary slightly depending on whether you are using JPEGs/TIFFS (left) or RAW files (right). For RAW images, you may adjust the white balance to a number of common presets or throw in your own custom Kelvin number if you are not happy with the in-camera setting. You can also select sRGB, Adobe RGB, or Pro Photo RGB as your color space. I generally stick with Adobe RGB to keep with my general imaging workflow and color profiling standards. Feel free to give **Reduce Chromatic Aberrations** and **Reduce Noise** a shot with some of your most-used lenses and styles of HDR photography to see if these settings are useful in your workflow. I generally keep **Reduce Chromatic Aberrations** checked but uncheck **Reduce Noise** because if you've bracketed widely enough for the full dynamic range of the scene, shadow noise isn't so much an issue. But if you've accidentally underbracketed a source sequence, this setting can be useful.

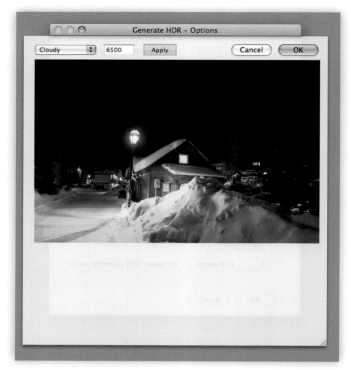

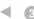

If you're not happy with the **As Shot** white balance, you can apply several common presets or even your own Kelvin temperature. Click **Preview Sample** and navigate to the median image in your HDR bracket sequence to see if a different color temperature fixes casting.

For JPEG images, you may select **Take Tone Curve of Color Profile** (Recommended),  or **Attempt to Reverse-Engineer Tone Curve Applied**. For TIFFs, **No Tone Curve Applied - Pixel Values Are Linear** is also an option. Under most circumstances, you'll want to stick with **Take Tone Curve of Color Profile**, but if you are employing in-camera dynamic range tweaking on your source images, you may want to try **Attempt to Reverse-Engineer Tone Curve Applied**. Do not confuse **No Tone Curve Applied - Pixel Values Are Linear** with any curve adjustments made in Adobe Camera Raw using the **Linear Curves** tab—this simply means that ACR isn't preloading common image-adjustment presets to the curve. However, these images have already had a gamma curve applied and thus aren't linear (makes perfect sense, right?).

Whether your images are RAW, JPEG, or TIFF, you may check the **Align Source Images** box and choose one of the two alignment algorithms. If one doesn't work perfectly, try the other. Note that the **By Matching Features** option may re-render your source images if there is rotational shift between source images. Checking **Don't Crop** will leave a row of blank pixels along the edges rather than cropping out the unaligned dead space. Check **Attempt to Reduce Ghosting Artifacts** and choose either the **Moving Objects/People** radio button or **Background Movements** (e.g., ripples). The default setting is **Normal,** but if it is ineffective, give **High** a shot (we'll revisit ghost management in Chapter 6).

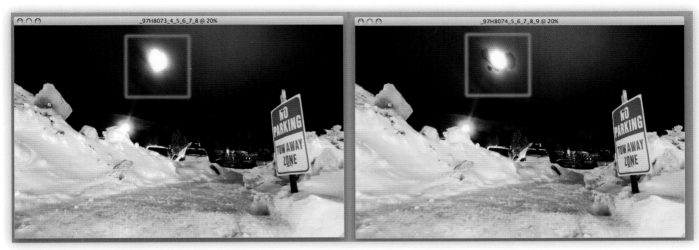

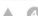 **4**

However, for long exposures with moving clouds and water where you want to include the movement as a scene element, don't use the deghosters—let pixel-point averaging during HDR generation attempt to work it out. The left screen shot shows HDR generation without deghosting, while the right one has deghosting set to **Background Movements**. Remember, objects that move about during split-second frames are generally more problematic than movement in a frame during long exposures.

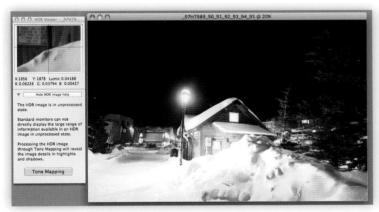

 **5**

Once Photomatix chugs through all the data, your merged 32-bit image will display on-screen, along with the HDR viewer, which applies quick tone mapping to a small section of the image. **View > Adjust HDR Image View** and/or **CMD+** will slice the EV shift of the HDR image to expose brighter or darker on your screen.

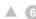 **6**

Selecting **View > Image Properties** and **View > HDR Histogram** will shed some light on the technical details of your high dynamic range image, including the estimated dynamic range, which is 39,008:1 in this case. In **Image Properties,** notice that the pixel depth is given as 96 bits—that's 32 bits per channel.

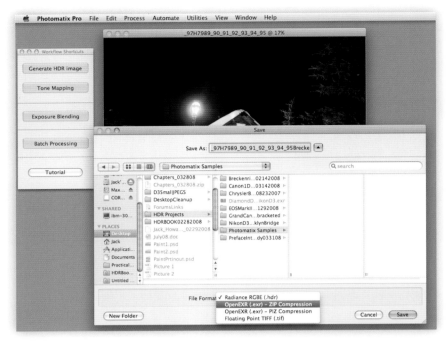

 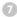

Selecting **File > Save HDR As** will allow you to save your HDR image. It's always a good idea to save your 32-bit files because different tone map settings can be applied to the same file so you don't have to slog through HDR generation over and over again. Photomatix has a great built-in naming scheme that includes the first full alphanumerical file name and then differing digits in shortened form when the shots are straight from the camera and not renamed. You can keep this as is or replace it with your own file-naming scheme. I choose to add a few descriptors to the existing name, in this case BreckenridgeCanonMark3.

And that is the basic HDR generation workflow in Photomatix Pro 3.0. We'll revisit batch processing, ghost management, and some other cool tricks with Photomatix a little bit later.

## Merging to HDR in FDRTools Advanced 2.3

FDRTools Advanced 2.3 is a cool HDR-specific program. It wears its own graphical user interface skin over command-line functions on both Macs and PCs, and because of this, it doesn't support much drag-and-drop functionality on either platform, although you can drag a collection of source images onto the Dock (Mac) or

Desktop icon (PC) to launch into HDR merge. Don't let the mechanical GUI interface scare you off. Once you get the hang of FDRTools Advanced, you'll like what it's got to offer: hot-swapping between HDR generation and tone mapping to tweak both the LDR source images and tone-map setting in real time, the ability to launch your HDR or tone-mapped output image directly in Photoshop for further editing and refinement, and other cool features that make the strange interface unique and powerful. All in all, there's a brilliant Teutonic sense of logical design to FDRTools; for example, the alignment utility is called simply Tripod.

FDRTools launches into the Project pane, which can be a little confusing at first. Don't worry. It's really not all that scary once you get the hang of it. But getting started, we're going to skip over the projects and just get up to speed on merging a series of images to high dynamic range with the Average operator. We'll check out the Separation, Creative, and xDOF mergers in the next chapter.

**RAW, TIFF, JPEG OR FDR TOOLS?**  For best results for merging to HDR in FDRTools Advanced, my recommendation right now is to start with 16-bit TIFF files converted from RAW files via ACR, LR, or your camera's proprietary converter with minimum processing for best results. ■

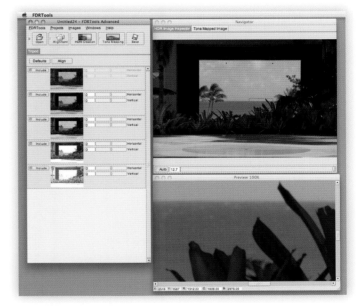

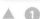 **1**

I'm going to skip the Projects buttons and jump right into basic HDR generation with FDRTools Advanced. Click **Images > Open** to browse to your source files. You've got to ensure that you select the proper file type in the **File of Type** drop-down. Notice how I have **Generic DCRAW** selected to open my Nikon NEF files. On a PC, only files of the selected image type will then be visible; on a Macintosh, other file types will be grayed out.

**2**

Once the source images load, the Navigator will launch and the main window will show the Alignment utility. It automatically determines if alignment is necessary. If your HDR image isn't aligned properly straight away, click **Align** again. Clicking on **Default** resets all to zero. If it is still misaligned, you may manually adjust any of the images along the horizontal or vertical axes. Unclick all but two of your source images, and align these two. Then add the next source image and align this to the other two. Repeat until all images are manually aligned.

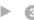

**3**

After alignment, click **the HDRI Creation** button to assess the 32-bit image. If you want to exclude any of the source images, uncheck **Include**. You may also check the **WB Ref** box to assign a specific image as the white balance reference image, but this is optional. Notice the drop-down menu with the five choices: these different options affect the color and brightness value for each pixel-point based upon different weighting schemes from the source images that may be used to smooth noise and how each image affects the resultant HDR. Since this is FDRTools, you can always adjust the points on each relative histogram manually as well. Experiment!

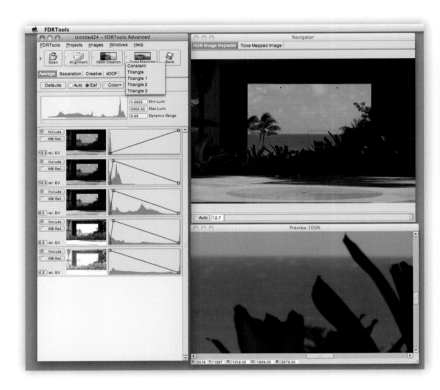

**4**

Even though FDRTools Advanced has a very mechanical and utilitarian interface, it has lots of helpful mouse-over tips. Rolling over **Average** during HDRI creation explains that the Average mode calculates the HDR as a weighted sum of the source images and is a good choice for source images that are very static. If you are confused about a function in FDRTools, linger your pointer a moment and more info may come to light. If nothing happens, you may have to turn these hidden notes on under **FDRTools > Preferences > Gui Settings > Show Tooltips**.

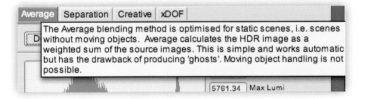

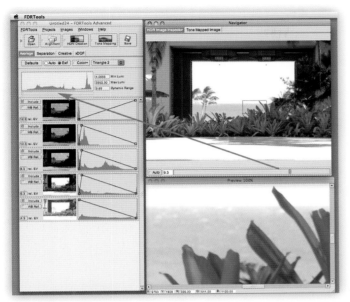

◄ ⑤

We're looking at HDRI Creation here. Clicking anywhere in the Navigator will launch a 100% pixel preview window. And notice the EV slice number and slider in the Navigator window. The displayed range is underscored in the HDR histogram in the main window. Slide the exposure preview up or down and the histogram slice changes on the fly. (You can also swap the Navigator tab to **Tone Mapped Image** to see the real-time effects on the output image, which is useful for images with a very high dynamic range—where the on-screen slice of the HDR isn't easy to work with and visualize.)

◄ ⑥

If you are happy with the looks of your HDR, you're all set to save the 32-bit file. Click **Save**, browse to your saving location, and select a file type. The default file types for saving both 32-bit and tone-mapped LDR images may be changed under **FDRTools > Preferences > Devices > Output Device**. *Remember, you want a lot of descriptors in the 32-bit file name because these often lose metadata and keywords.*

There is one more window to manage before the file is actually saved. Depending on the file type, the save options may differ slightly, but you can always check **Write Metadata to HDR Image** and **Open HDR Image With** and browse to any other HDR-capable program for 32-bit image editing or tone mapping. I've now created and saved a 32-bit file in FDRTools using the basic workflow. We'll cover deghosting using the Separation function (and the two other mergers) in chapter 6.

Now, let's close the main FDRTools window. You'll get a prompt asking if you want to save the untitled project. Click **Save** and you can give it a name and revisit it later. Click **Discard** if you're just looking to quit out of FDRTools. But really, give it a shot and save the project—and it will be waiting for you the next time you want to play with it.

## Merging to HDR in Dynamic Photo HDR 4.6

Dynamic Photo HDR (DPHDR) 4.6 by Media-chance is a Windows-only program. But it runs on Macintosh computers as well. In an interesting programming trick, the Mac version of DPHDR ships inside a self-contained version of the CrossOver Windows emulator. There's no need to install extra software or be running Bootcamp or Parallels.

It's weird, but it works—with some quirks. External drives may be named according to Windows conventions as alphabetized drives, or they may not appear to be mounted at all. So if you are on a Mac, you will want to have your source images for Dynamic Photo HDR 4.6 on your main drive for best results. The screen shot

examples in this book are from the Windows version of the program, running inside a full version of CrossOver on my Mac.

This HDR-specific program packs a ton of features, functions, and tone mappers into a slick interface with great in-program quick tips and expanded online support and a really fun "little planet" feature in post-HDR editing that we'll get to much later in the book.

**RAW, TIFF, OR JPEG FOR DYNAMIC PHOTO HDR?** For merging to HDR in Dynamic Photo HDR, my recommendation right now is to use 16-bit TIFF files converted from RAW files via ACR or LR or your camera's proprietary converter with minimum processing for best results. ∎

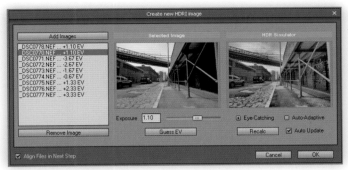

 **1**

Click **Create HDR File** to launch the **Create New HDR Image** window. There's a lot going on in here! Click **Add Images** to navigate and import your source files. Most of the time, the EV offsets will automatically be recorded; if for some reason, however, DPHDR cannot scrape the EXIF info, you can ask DPHDR to estimate the offsets by clicking the **Guess EV** button. The left preview window shows a thumbnail of the active image, while the right one simulates one of two tone map settings, **Eye-Catching** (a local operator), or **Auto-Adaptive** (a global operator). And way in the bottom-left corner is a tiny check box labeled **Align Files in Next Step**. Check this to let DPHDR take a crack at aligning your images—and if it doesn't nail it, you've got a powerful alignment utility to play with. Note well: If you want to use the deghosting mask or the advanced HDR generation tools, *you have to check this box*, even if you do not think your images need to be aligned. It's a quirk of the programming. For high-megapixel cameras (12+MP), 16-bit TIFFs are preferable over RAW files for HDR generation, but note the three RAW processing options available. See if any of these yield better results than 16-bit TIFFs for your shots: there are too many cameras, too many source bracket sizes, and too many other variables to definitively say which may work best for you.

 **2**

Click **OK**, and if you've checked **Align Files in Next Step** you'll wind up here. And look, more adjustments and buttons! The preview window shows a 100% pixel view of the center of the frame, and you can manually scroll about the image by click-dragging on the preview window or by clicking the **Center, LT, RT, LB, RB** buttons that will jump to center, left top, right bottom, and so on. See the file name pairs listed in the right of the frame? *You've got to inspect each and every listed pair to ensure alignment.* You can use the three dials to correct for horizontal, vertical, and rotational shifts. In this example, the first image pair displayed is slightly misaligned and needs to be manually fixed.

---

**PIN WARPING? WHAT'S THAT?**   If you've been using a tripod, you probably won't need pin warping. But for handheld, bracketed shots, it is possible that the images aren't simply misaligned along perfectly defined axes parallel to the focal plane. It is possible that there is some combination of pitch, yaw, and roll between shots (which can also be compounded and amplified by the optical characteristics of a lens), which means that it is impossible to align the images perfectly by simply shifting pixels up and down, left and right, or rotationally around the image center. Pin warping pushes and pulls the pixels and may bulge or pinch or bend columns and rows of pixels as necessary to align an area of the image. And yes, it's a last-ditch gamble, but give it a shot, particularly if you've got source images that align at center but don't align elsewhere and the nonalignment cannot be attributed to subject movement between frames. ■

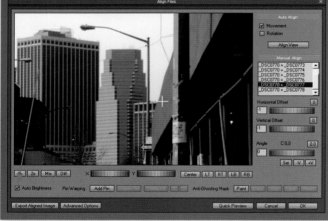

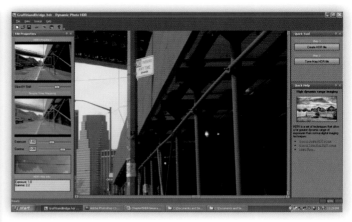

 **4**

In the big window, you'll see a 100% view of the HDR image, which you can inspect by click-dragging to move or by repositioning the preview box in the HDRI Preview box (top left). Moving the **Slice EV Shift** slider will change the viewable range of the HDR in this small window. The lower image shows a quick Exposure/Gamma tone mapping operation. And you can tweak the HDR preview curve in the histogram window to "dodge and burn" parts of the HDR for a quick examination. (These effects are for previewing purposes only and don't affect your actual 32-bit file.) If you are satisfied with your HDR image, selecting **File > Save HDRI** allows you to save your 32-bit file in Radiance (.hdr) format.

  **3**

If you're having a hard time sizing up the relative exposures, try hitting the **DIFF** button (top), which will make a different image with an embossed effect where unaligned. Or check the **Auto-Brightness** box to gain up the exposures (bottom). And that's the basic route through HDR generation. Click **OK** to create your HDR image.

That is the quick and easy route through HDR generation with Dynamic Photo HDR. We'll check out their interesting ghost masking and advanced HDR generation settings shortly. If you want to skip HDRI saving and jump right into tone mapping, simply click the **Tone Map HDRI File** button. We'll explore the tone mapping options in an upcoming chapter.

---

**RAW, TIFF, OR JPEG FOR HDR PHOTOSTUDIO?**
For best results for merging to HDR in HDR PhotoStudio, my recommendation right now is to start with camera RAW files and consider 16-bit TIFF files converted from RAW files via ACR, LR, or your camera's proprietary converter with minimum processing. ∎

## Merging to HDR in HDR PhotoStudio 2

HDR PhotoStudio by Unified Color is a serious new player in the HDRI scene for still photographers, and as such, I've decided to include it. HDR PhotoStudio is a different sort of program with an emphasis on what we've taken to calling "soft tone mapping". And as you'll see in later chapters, HDR PhotoStudio excels at working in 32-bit space. In fact, I've juggled and shuffled in a new chapter for this edition to talk about working in 32-bit space in both Adobe Photoshop CS5 and HDR PhotoStudio prior to—or instead of—global or local bit-drop tone mapper paths. Basic merging is a pretty simple process, with an option for automatic alignment, white balance tweaking, and not much else.

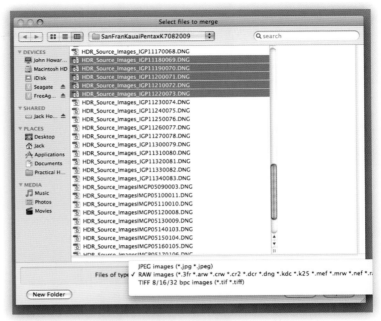

Selecting **File > Merge to HDR** launches the file selection window. As you can see, JPEG and RAW as well as 8-, 16-, and 32-bit TIFFs are acceptable file types. Select your source images and click **Open**.

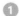

Add or remove source images, if necessary, and check **Align Source images** if there's a chance your shots aren't perfectly aligned. You may choose **Default (D65 standard)**, **As Shot**, or **Manual** for white balance. If you select **Manual**, you will see the window in the next screen shot to tweak white balance. But don't worry if you aren't happy with the **As Shot** white balance once the image opens—you can always adjust it later. Either way, click **Merge** to create your HDR image.

▶ ③

If you selected **White Balance Manual**, you'll see this dialog box. Click on the eyedropper and then pick a neutral gray tone in the frame to adjust white balance. Alternately, you can pick a white balance via either **Color Temperature** or **Tint** or both. It's very straightforward. Just make sure you've got **Preview** checked. When you're content, click **OK**. In this case, I picked a spot on the slate walkway in shadowed foreground for the cool neutral. Click **OK** and your HDR opens into HDR PhotoStudio.

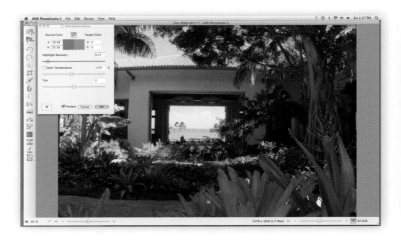

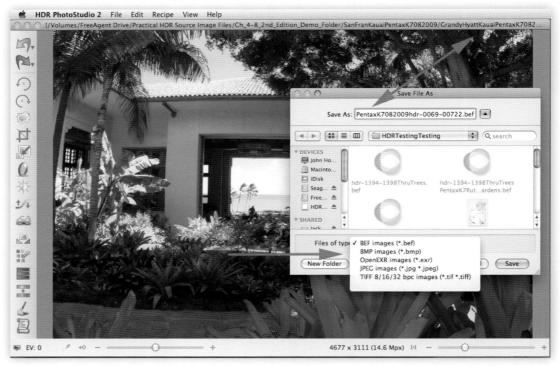

▲ ④

As always, the first thing we do after creating an HDR is save it. For maximum cross-program compatibility, save your HDR as an OpenEXR file. But keep in mind that you can also work in HDR PhotoStudio's native BEF format and color space, and there's a Photoshop file type plug-in available to allow Photoshop CS5 to decode BEF files and color space for working in 32-bit space between these two programs (as we'll explore in Chapter 7). As you can see, I've added lots of descriptors to the 32-bit file.

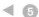

Fidelity to the original image in the BEF format is measured along a visual error (VE) scale. The greater the VE number, the more compressed and lossy the file. The smaller the VE number, the larger and less lossy the file.

And that is the quick and easy HDR merge method using HDR PhotoStudio. If you've got ghost issues, you've got to merge elsewhere.

**VISIT ME ON VIMEO FOR PROGRAM UPDATES!**

I'll be posting screencast updates on my Vimeo channel any time there's a significant change to the programs featured in Practical HDRI. Check it out at **http://www.vimeo.com/channels/hdrphotography** Stop by and say hello! ∎

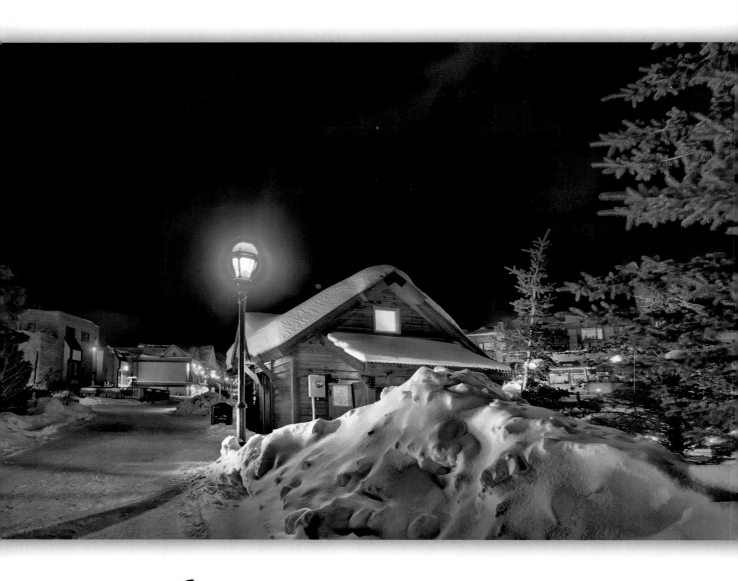

**6**

## Advanced HDR Merging Techniques & Tricks

Usually, the basic HDR merge techniques we just explored will do a fine job of creating your 32-bit high dynamic range file. But try as you may to control the universe, there will be times when there is a moving object in your source images, which will result in "ghost" images. In this chapter, we'll look at some potential solutions to ghost problems with each program. Do keep in mind that there's always a chance that deghosting won't work—that's a chance you'll just have to take and hope for the best when shooting high-risk scenes for HDR. But it's not just about deghosting. To round out the chapter, we'll look at some other cool features and functions waiting to be unleashed to help you create killer HDR images or streamline your workflow in these programs.

## Photomatix Pro 3.2 Deghosting and Other Tricks

HDR merging with Photomatix Pro is very straightforward, and very automated, as I explained earlier. Deghosting either works—or doesn't work—based on the source images. The only real user tweaks are to swap detection from **Normal** to **High**, or the type of deghosting from **Background Movement** to **Moving Objects/People**. If you still have ghosts, analyze the HDR image

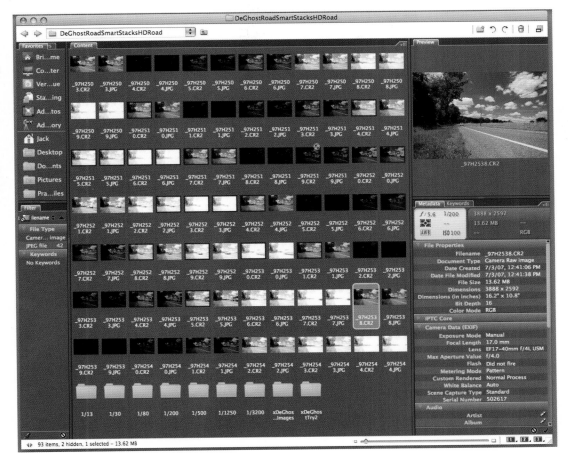

I shot this same stretch of road in a seven-shot bracket sequence 18 times. Notice that I have subfolders for each shutter speed where I have put likely candidates for deghosting. I'm going to select five shots to attempt to merge to HDR after several unsuccessful experiments with a seven-shot merge.

**IMPROVE YOUR ODDS WHEN GAMBLING WITH GHOST-RIDDLED SCENES**   You are always taking a gamble when you shoot a scene with moving objects. But you can improve your odds. Use a tripod, and shoot a lot of bracketed sequences of the same scene. Select source images from different bracket bursts so there is minimal overlap of moving elements at each exposure level. And throw different combinations of source images into an HDR merge. If one image is obviously causing ghosting, toss it out! Remember, it's always better to have too many source images than not enough. For the example, I shot 126 frames (18 sets of seven-shot bracket sequences), and it took a good deal of experimentation to get clean, deghosted HDR images. And I ended up using only five exposures in the example. If you shoot a ton of source bracket sequences, there's also a good chance you'll wind up with very clean source images at different exposure levels—meaning you might not need to deghost at all! This holds true for every program we explore in *Practical HDRI*. ∎

to discover where the ghosts are coming from, and swap out that EV's source image if you've shot multiple source-image bracket sequences as illustrated later in this chapter, or exclude the problem images from the merge. This may affect the overall image quality and/or total dynamic range of the HDR, but if you are hell-bent on ghost removal with Photomatix Pro, this is how you *might* accomplish it.

## Photomatix Pro's Batch Processor

Almost every operation in Photomatix Pro 3 can be automated with the Batch Processor, found under Automate > Batch Processing. It's really quite self-explanatory. Just select which operations you want applied to which images and click Run (the Run button is replaced with the Stop at Next Combination button while batch processing is occurring.)

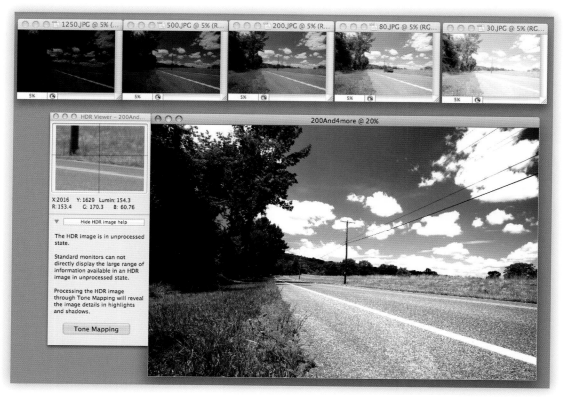

Looking at the source images, there's one big, red, obvious ghost and a bunch of tiny vanishing-point ghosts. I am most concerned with the red car in the second image from the right, and Photomatix finally nails it and eliminates all ghosts when I use High Detection of Moving Objects.

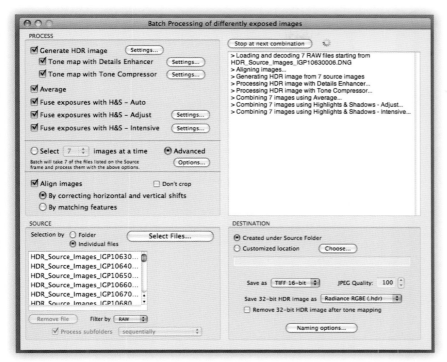

Batch Processing is a great feature, particularly for HDR merging after a long day of HDR shooting. It can be set up to merge all the images in each subfolder (useful for when there are varied numbers of bracketed shots in different capture sequences) or in uniform increments (three or five source images per merge, for example) in a single folder. Alignment or deghosting options are applied equally to each merge. Tone mapping and exposure blending can also be automated; however, there is no image preview during batching. This does limit its usefulness a bit because tone mapping is a very visual process for many photographers. But for the growing subgenre of HDR timelapse, batch processing can be very useful. The interface behind each of the Settings buttons mirrors the interfaces for each operation, minus a preview pane. I'll cover each of these operations in chapter 8.

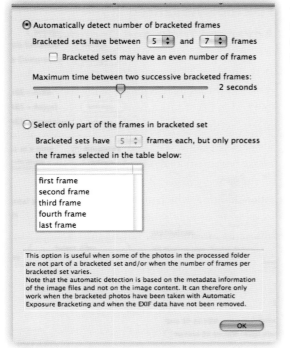

Hiding behind the Options button under Advanced is this cool smart batcher that uses EXIF data to make non-standardized HDR mergers, with some cool options.

## The Single File Conversion Automator

If you've been paying attention all along, you've come to grasp that high dynamic range imaging is a multiple-source-image style of photography. However, it is possible to tweak a single image —whether it is a RAW file, a 16-bit TIFF, or even a low-bit, in-camera processed JPEG—into a "pseudo-HDR". This process will apply tone mapping to your file, and stylistically, the image will resemble an HDR image, although you cannot actually increase the dynamic range of the single shot, even by upsampling to 32-bit space.

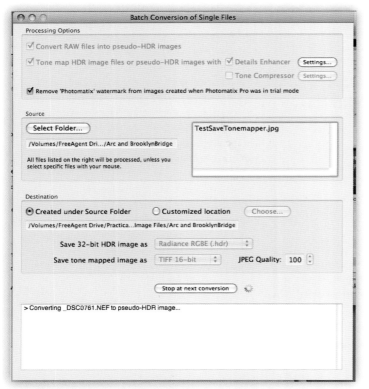

Notice the third option button in the **Batch Conversion of Single Files** command box: **Remove 'Photomatix' watermark**. Running this command will remove the watermark from all of the tone-mapped output images processed with the trial version of Photomatix Pro, but only after you purchase and register the software. This means you do not have to go back and manually redo the tone mapping of every image you experimented on during your free trial of Photomatix Pro. However, it will only successfully remove the watermark from output images that haven't been resized or otherwise post-processed in Photomatix Pro or any other third-party editing software. So, it behooves you to make a dedicated folder of your straight-from-the-tone-mapper watermarked images during your trial period with Photomatix Pro, and they can then be "un-watermarked" should you decide to purchase. Then make duplicates of each image in this folder and post-process these duplicates instead.

Furthermore, tone mapping is usually aggressively overapplied to give the "HDR feel" to the image to compensate for the limited dynamic range of the single-shot source image. What you get is a stylized pseudo-HDR without actually realizing the gains (less shadow noise, decreased highlight fringes, overall greater detail at all brightness levels) of the true HDR processing of multiple source images. In any event, you can batch a whole bunch of single images into pseudo-HDRs via this interface, if you want, under **Automate > Single File Conversion**.

## FDRTools Advanced 2.3 — Advanced Tricks and Deghosting

In the basic HDR merge section in chapter 5, I took you through HDR merge using the *Average* method in FDRTools Advanced 2.2. For static images without moving objects, this is the best method to produce the highest-quality source image because it analyzes each pixel-point from all the source images. But now, we'll use **Separation** merging, which pulls each pixel-point value from a single source image. What's the difference? Deghosting! What's the trade-off? Potentially more shadow noise and highlight artefacting, particularly if you scrap or deweight a couple of near-median source images in your quest for a ghost-free image.

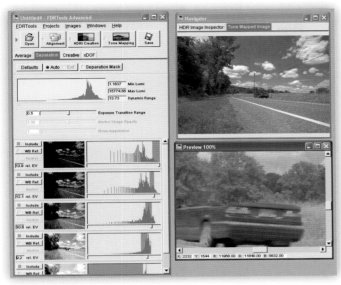

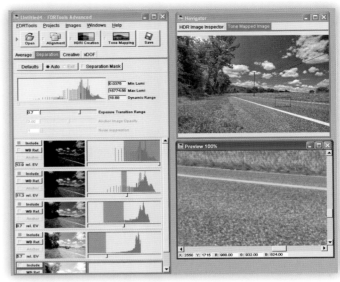

I open the same five source images in FDRTools and, after alignment, FDRTools Advanced 2.3 automatically selects the **Separation** merger based on its ghost element recognition. But notice I've still got partially ghosted automobiles. Let's see what some manual control can do.

With this series of shots, I decide to turn off the hottest image and deweight the image with the car in the middle ground by moving the histogram sliders for each image. It gets rid of ghosts but gives the darkest image in the series a more significant role.

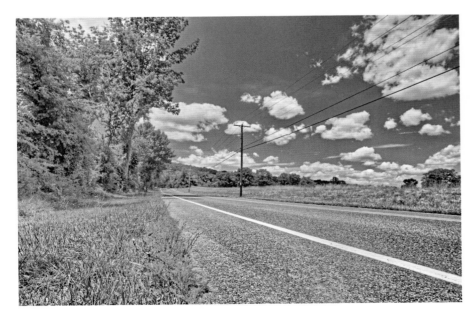

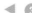

When switching to tone mapping, there are some noise issues due to the heavy influence of the darkest image during HDR merging. I have successfully deghosted, but I've introduced noise. That's the case with this series of images, but don't think that deghosting with FDRTools will always lead to noisy output images. It depends on the source data and which frames are causing the ghosts.

## FDRTools's Creative HDR Merge Function

Most HDR merge functions analyze the histograms of each image and look for overlap to determine the 32-bit histogram and overall dynamic range of the source images. FDRTool's Creative Merge function downplays this idea and opens up new possibilities for creative high-dynamic-range-style images—shooting the same scene with a tripod at different times of the day, multiple exposures of the same scene with different directional lighting (think one strobe emulating a multi-light setup), or even merging nonidentical scenes for your own creative visions.

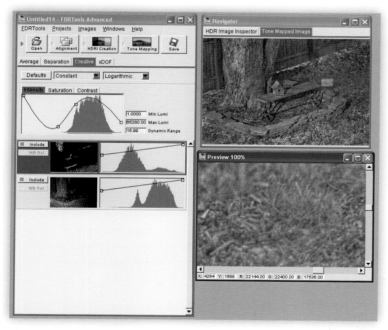

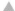
Remember the benches from the introduction? In real-world luminance, there's no overlap of these source images, and these two images from those experiments have different point light sources, resulting in overlapping, directional shadows in this **Creative** merge. Experiment!

## FDRTools xDOF Merge Function

Technically speaking, xDOF is not an HDR merging process in the slightest. Instead, it analyzes relative image sharpness of a set of source images captured at the same exposure level—but at different focal distances. And these images are then combined to produce an output image with much greater depth of field than is possible in a single image at an optimal middle aperture. And of course, it is then possible to employ the xDOF merger at each exposure level and tone map each gently, then use these tone mapped output images as a set of source images for a second HDR merge and tone mapping for extreme depth of field with amazing detail. I still haven't had much time to play with this, but I am excited about the possibilities!

## Batch Importing of Source Images with FDRTools

Close and relaunch FDRTools if you've got it running and check this out. FDRTools 2.3 has a very cool batch import function that can import either by number of shots for each project or by time difference—from 1 second to 999 seconds. The creation time offset option is a great way to bulk-import lots of different source image sequences quickly.

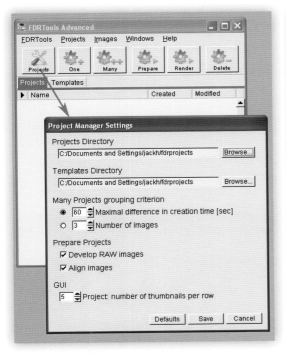

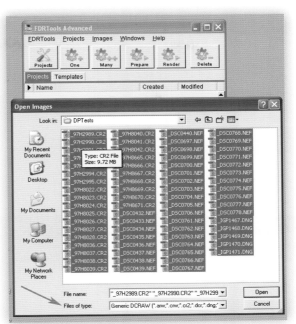

◀ ②
In the main window, click the **Many** button to import your batched source images. Notice in this example that I have Canon CR2, Nikon NEF, and Pentax DNG format RAW files, and the FDRTools **Generic DCRAW** file-type option pulls them all up. I highlight all the RAW files and click **OK**.

▲ ①
Click the **Projects** button in the main window to launch the **Project Manager Settings** dialog box. Select either the **Maximal difference in creation time [sec]** or **Number of images** radio button. You can select either parameter. Note that all the bracket sequences must contain a uniform number of frames for the second option or you'll wind up with bizarre mergers of nonidentical source images. I set my time offset to 60 seconds because I have some long night exposures in my source files. Click **Save** to close this window.

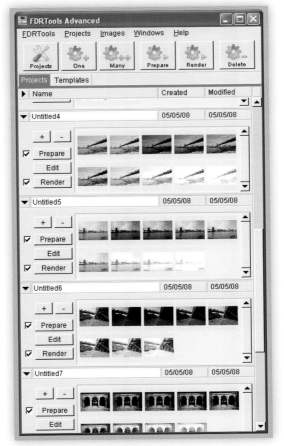

◀ ③
After some processing time, I now have several projects loaded into FDRTools. I can descriptively rename each if I want to break from the generic Untitled(x) naming scheme.

# Dynamic Photo HDR 4 — Deghosting and Advanced Merge Techniques

Dynamic Photo HDR 4 has a unique ghost mask function to help you deal with moving objects. It is easy to make a misstep or two until you get the hang of it, so pay attention and avoid common pitfalls I describe in this example!

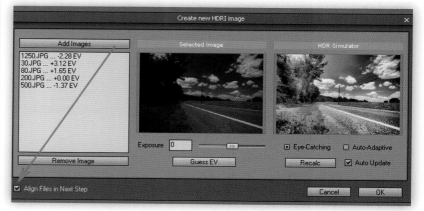

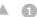 **1**

In Dynamic Photo HDR, if you don't have the **Align Files in Next Step** option checked during source image import, the program not only skips alignment, it skips the deghosting and advanced options as well. So, even if you are certain your source images are aligned, *you must check this box for deghosting and advanced options during HDR generation with Dynamic Photo HDR.*

 **4**

There's a lot happening in here. Notice that you can highlight an entire project—and then use the top buttons to **Prepare** (import the full-resolution images to the alignment stage in the background), **Render** (run tone mapping and save the output image), or delete multiple projects. Within each project, you can highlight an image and use the (–) button to delete a source image or click (+) to add one. The most exciting button is **Edit**, which brings you into the alignment, HDRI creation, and tone mapping interface. In chapter 5, you learned about alignment and HDRI creation. Tone mapping will be covered in chapter 7.

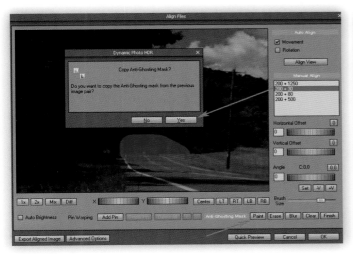

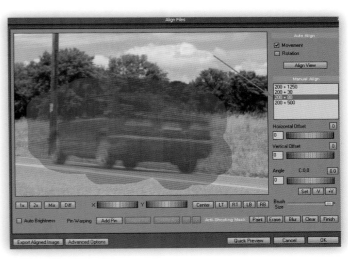

▲ ②

Align your source images, if necessary. Click the **Paint** button and brush over all the ghosts visible in the top image pair. You can scale the brush or switch to **Erase**, if necessary. If there are ghosts outside of the preview pane, right-click and drag the image to navigate around the image. Once you have masked all the ghosts on this image pair, click on the next image pair. It will ask, *"Do you want to copy the Anti-Ghosting mask from the previous layer?"* Click **Yes** if there may be ghosts in the same area on the next set of image pairs. Click **No** if there aren't ghosts in the same area on the next image pair. (Clicking **No** doesn't affect the previously painted mask. The mask is just not preloaded into the next image pair.) Repeat this process for each and every image pair. Be sure to explore the entire image! Big Red in the foreground wasn't visible in the preview window when I first switched to this image pair. Once you think you've gotten rid of all the ghosts, click **OK** to generate your (hopefully) deghosted HDR image.

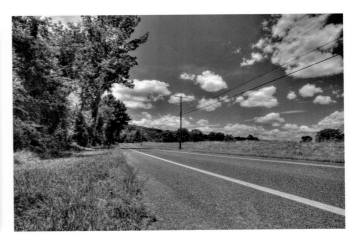

▲

Once your HDR builds, inspect the image, especially the areas where the ghost masks were painted, to ensure that the deghosting was successful.

▲ ④

After tone mapping, I have a deghosted scene! But sharp eyes may notice a tiny little car near the vanishing point. This isn't a true ghost, as it appears as a solid object. It didn't get swept away due to the math behind the HDR generation process, which is usually a weighted sum function (which throws out or de-emphasizes the nearly 255, 255, 255 and nearly 0, 0, 0 values before averaging) and not a simple averaging. In any case, it will be easy enough to erase this little vehicle in post-production if I want.

## Smoother, Sharper, or Custom Curves

From the same window that launches when the **Align Files in Next Step** option is checked, you can also launch the advanced HDR options window by clicking the button of the same name.

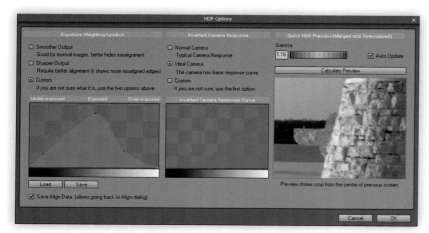

 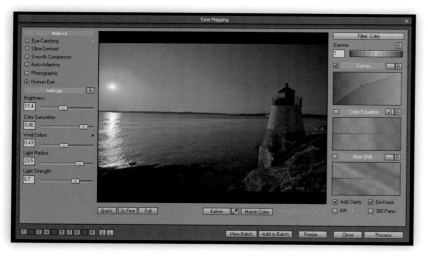

In this window under the **Exposure Weighting** function, you can select **Smoother Output**, which is more forgiving of slight misalignments, or **Sharper Output**, which is crisper, but less forgiving of misalignments. Or you can select **Custom** and tweak the Exposure Weighting curve yourself. For a challenging sunset and shadows scene, I made a slightly more underexposure-intensive curve to emphasize the shadows and manage the extreme luminosity of the blazing sun reflected on the water. But the sky's the limit. It doesn't have to be a bell curve. You can push or pull the existing points or click anywhere on the curve to add an additional point (right-click to remove a point).

In this same window, under **Inverted Camera Response**, you can also select **Normal Camera** for a normal response curve, **Ideal Camera** for linear data, or **Custom** if you'd like to attempt to replicate or guesstimate your camera's response curve. Click **OK** to apply these settings or **Cancel** to exit this window without applying the settings.

I had a tough time working with these source images using basic HDR merge techniques, but tweaking the **Exposure Weighting** function during HDR generation helped me make this challenging image look good when tone mapped with Dynamic Photo HDR's **Human Eye** global operator.

# Batch Merging with HDR PhotoStudio 2

Batch processing with HDR PhotoStudio 2 is a pretty straightforward affair without too many user options along the way. Most important to note is that all mergers must have the same number of source images.

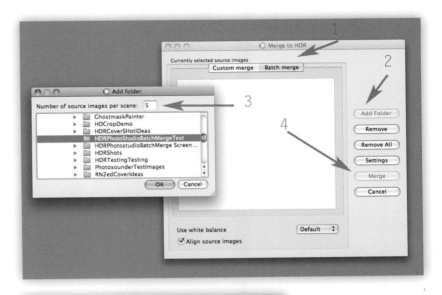

 **1**

Selecting File > Merge to HDR opens the Merge to HDR dialog box. (1) Click Batch Merge, (2) click Add Folder, (3) select a folder and number of shots per merge, and click OK.

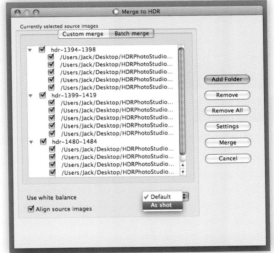

 **2**

Check Align Source Images and select a White Balance and you're good to go. (4) Click Merge.

 **3**

After some processing time, you'll get this happy little message that the batch process is complete. And that's all there is to it!

## Deghosting with Adobe Photoshop CS5

Adobe has finally added a deghosting feature to the HDR merge process in Photoshop CS5, and it's about time, if you ask me! Similar to FDRTools Advanced, the "anchor" image is selected automatically, but the process also allows for manual override.

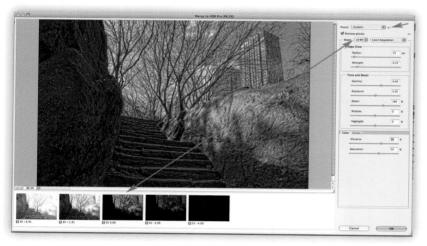

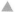

Check the **Remove Ghosts** box to activate deghosting, and Photoshop will pick an anchor image. You can always choose a different image if there are still ghosting issues. Notice that I am previewing this in **16-bit** mode, with detail-intensive **gamma** and **detail** settings to ensure that I have a view of ghosts at all exposure levels. I will flip to **32-bit** mode once I am satisfied with the deghost settings to open the image into Photoshop for saving as a true HDR image. But see the small tick marks next to the presets? I can save my 16-bit tone map settings here and later apply them to my HDR image during HDR toning. Just click on the "mini menu" (indicated by the red arrow at upper-right) and save the settings with a descriptive name. The other "mini-menu" below is for response curves and will not be accessible during later HDR toning.

## Adobe Photoshop CS5 Extended – Deghosting with Smart Object Stacks at Each Exposure Value Level before HDR Merging

The Extended version of Adobe Photoshop CS5 packs a number of additional features and functions into the program, including Smart Object stacking modes. Among the benefits of Smart Object stacking in CS5E is five-click easy "tourist erasing". This is another multiple-source image technique, although all of the exposures are captured at the same exposure, combined into a Smart Object stack, and blended using the Median command. And yes, it is possible to capture a number of bracketed sequences of the same scene, apply the "tourist eraser" workflow to each exposure value stack to make deghosted source images at each exposure level, then use these as your source images for HDR merging when it is not practical or possible to eliminate all moving elements from a scene. Think about it. I would have needed a permit to shut down this bridge to ensure that there'd be no foot or vehicular traffic on this busy afternoon. But all I needed was a tripod, a big CF card, and a cable release to capture a number of bracketed source images. Most of these screen shots are of Adobe Photoshop CS3 Extended as there is no meaningful change to this work path between CS3E and CS5E.

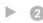
**1**

I shot 14 sets of seven-shot Auto Exposure Bracketed sequences of this busy car- and footbridge to ensure that there would be enough object movement to get clean (nonmoving element) pixels at every point in the image, at every exposure level. Notice how Adobe Bridge has been configured in seven columns, and each column corresponds to a different exposure level. I selected seven images from the 1/50-second column to open into Photoshop CS5 Extended.

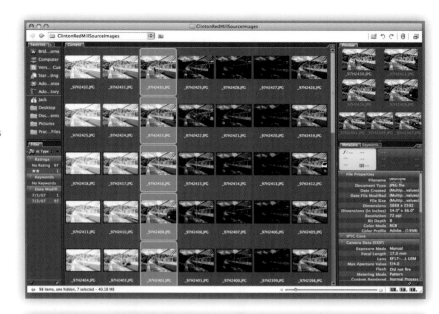

**2**

Alternately, you can use the shutter speed filters in Bridge to quickly and easily pull up all the images captured at the same shutter speed.

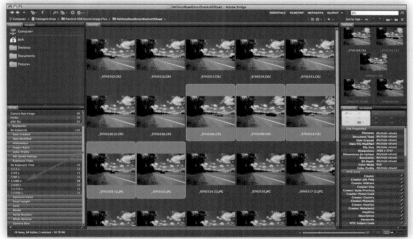

**IS IT REALLY WORTH THE UPGRADE TO ADOBE PHOTOSHOP CS5 EXTENDED FOR THIS DEGHOSTING TECHNIQUE?**   Adobe Photoshop CS5 Extended costs several hundred dollars more than the already expensive version of CS5. Many still photographers may be able to live without Smart Object stacks (and the other CS5E features) because it is also possible to manually re-create this deghosting workflow with selective erasing of layered images of the same scene in the non-Extended version of Photoshop (even Elements, for that matter). But for higher-end commercial and stock photographers who want to remove a significant number of people or cars from a scene, the automation and time-saving offered in CS5E may pay for itself in the sale of just a few images made using this technique. Additionally, CS5E is great for animating still frames to video for HDR timelapse photography. ■

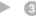

Next, choose File > Scripts > Load Files into Stack and the Load Layers dialog box will appear. Click Add Open Files and check both Attempt to Automatically Align Source Images and Create Smart Object after Loading Layers. Then click OK.

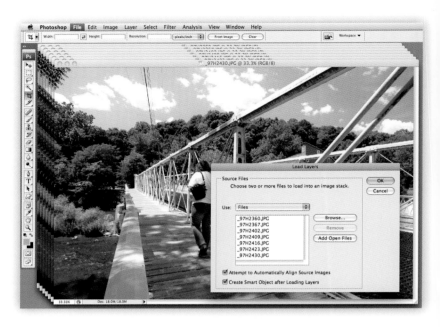

Notice the small icon on the layer thumbnail preview. It indicates that this is a Smart Object stack. Select Layer > Smart Objects > Stack Mode > Median to let CS5E work its "tourist erasing" magic.

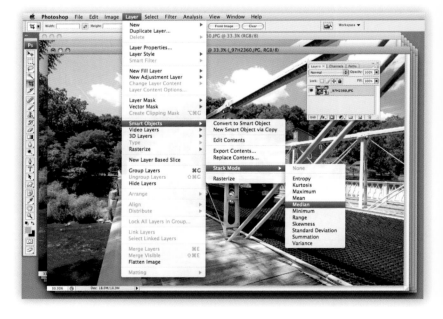

 **5**

Once the action is completed, the Layers palette should change slightly. Clicking the arrow will expand the box to show the stack mode. Flatten the image from either the Layers palette options or the Layers menu.

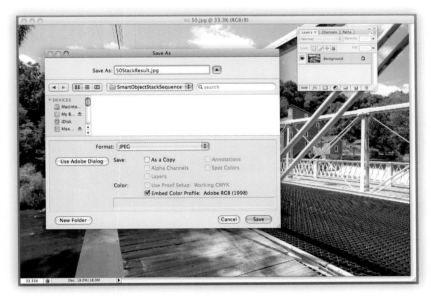

 **6**

I make a new nested folder titled "SmartObjectStackSequence" and save the flattened, deghosted images. For the file name, I use the shutter speed without the numerator (1/50 becomes 50, for example) plus StackResult. So this shot will be called 50StackResult.jpg. It will be joined by 13StackResult.jpg, 200StackResult.jpg, and so on, until I have repeated this process at each exposure level.

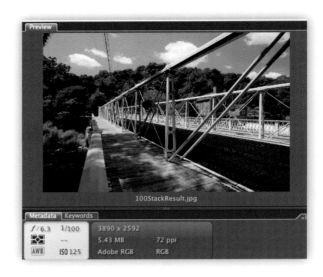

 **7**

Did you notice that the pixel dimensions of these two image-stack results vary ever so slightly due to the alignment function? This single extra row of pixels is enough to throw off HDR merging. Review each image's pixel dimensions.

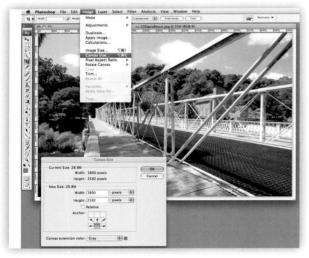

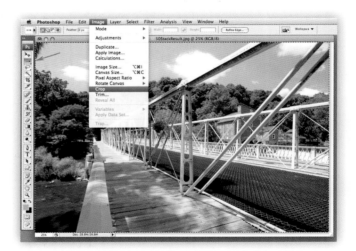

 **8**

Adding a row or column of pixels is easy: Selecting **Image > Canvas Size** will allow you add a single row or column to any source image.

 **9**

Removing a single row or column of pixels without rerendering the image takes a bit more work. Set the **Marquee tool** to either **Single Row** or **Single Column**—depending on where there's a line of excess pixels. Line up the selection at the very edge of the image, and then choose **Select > Inverse**. Finally **Image > Crop** will then shave the single line of pixels off the image. Resave the image and repeat these steps as necessary until all Stack Result images have the identical pixel dimensions. And now you've got a set of completely deghosted source images to merge to HDR!

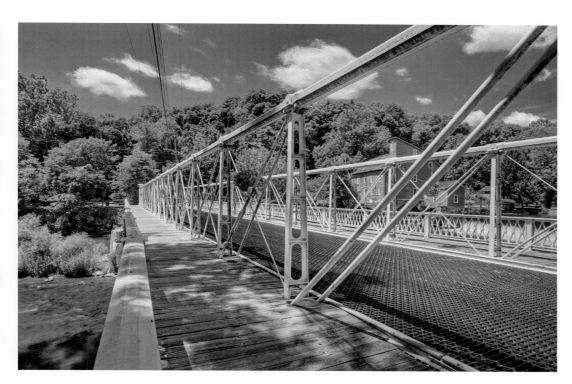

Usually, this software-based solution is easier than securing permits to close a busy roadway or public plaza!

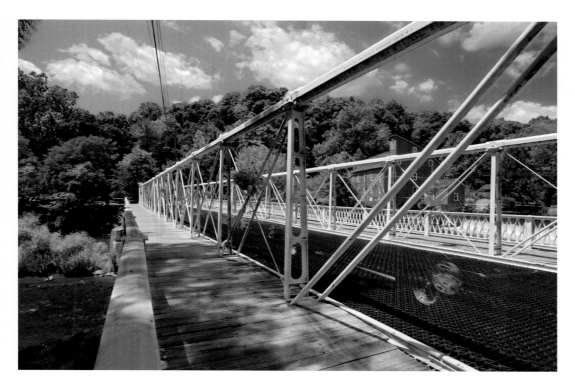

For comparison, here's how this looks with a single source image at each exposure level. Yuck!

# 7
## Working on Your HDRs in 32-Bit Space

dobe Photoshop CS5 and HDR PhotoStudio 2 offer a robust set of operations, actions, recipes, and adjustments for editing and toning your HDR image natively in the 32-bit high dynamic range color space prior to—or in place of—the "classic" bit-dropping tone mapping work paths that we'll cover in chapter 8. HDR PhotoStudio is a new player in this space. Its unique color tuning, excellently controlled saturation along six different wavelength segments, and halo controls even along high-contrast edges are fantastic tools for fine-tuning an image. Photoshop is unique among the programs we explore here in that complex local selections and adjustments are possible. And Adobe brings the full power of its great layers and brushes workflows to the nonextended version of CS5, which is great news for HDRI photographers.

▲ Menu items that are not active in 32-bit space are grayed out, and tools that are not active show a "no" symbol instead of the normal cursors.

## Photoshop's 32-bit Toolkit

Of all the programs mentioned in this book, only Adobe Photoshop CS5 allows for localized image editing of true high dynamic range images in 32-bit space via selections and masked adjustment layers. Not every tool and command in Photoshop CS5 works in 32-bit space, but there is a lot that can be done with the ones that do!

Before you read any more, spend a few minutes or so navigating the menus and tools in Adobe Photoshop CS5. Menu items that cannot be employed in 32-bit space are grayed out, and tools that don't work in 32 bits show the "no" symbol (a circle with a slash) to indicate that they aren't available for HDR image editing. Let's not worry about what isn't available. Instead, let's make the most of the great toolset we do have in 32-bit space!

## Making Selections with the Lassos, Wands, and Pen Tools

Let's explore a few methods for making local selections of increasing complexity with different tools and tricks available to the HDRI photographer in Adobe Photoshop CS5. Mind you, I am talking about the complexity of the edges of the selection, which doesn't necessarily have a one-to-one relationship to "more challenging" for the photographer.

## The Lasso Tools

The good old free-form lasso and polygon lasso tools both work in 32-bit space, but the magnetic lasso is unavailable. Hold down the mouse button and trace your selection edges, clicking with the polygon tool to make a point and another straight line segment.

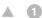 **1**

Hold down **Shift** to add to an existing selection and hold down **Option** (for Mac) or **Alt** (for PC) to subtract from a selection. As you can see here, I am making a selection that loosely wraps the tungsten interior of this little city newsstand. Notice that I have the **Feather** radius set at 0 px. There are much more powerful edge adjustment options available behind the **Refine Edge** button which you should click once you have traced your whole selection.

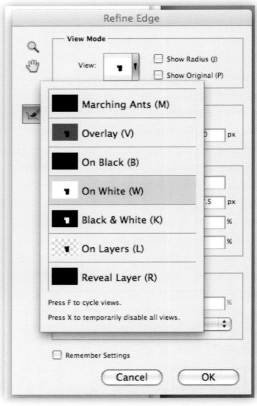

 **2**

After clicking **Refine Edge**, pick a selection view mode that is going to work best for your particular needs. Keep in mind, it might not always be the same one that's "best"; it will depend on the nuances of your particular image. I chose **Overlay** for this image.

◀ **3**

If you want to adjust your selection edge, you can use the **Refine Radius** brush, and you may change brush size from the floating menu. (You can also erase refinements with the **Erase Refinement** brush to undo unwanted adjustments.) You can try **Edge Detection**, but it sometimes has trouble with very high-contrast HDR edges. You're better off refining your edge manually with the brushes. Selections should always be feathered to blend in the edges. Very complex selections may also benefit from a light push on the **Smooth** slider. Let the image preview masks guide you for how wide feathering and smoothing should be applied.

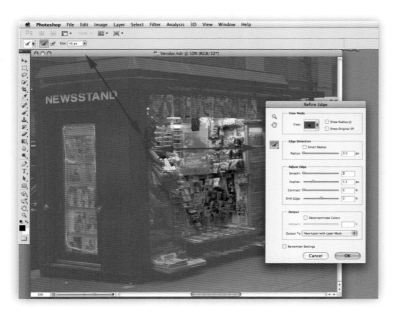

There are a number of different **Output** options for your refined localized editing edge. The simplest option is **Selection** for a basic feathered selection, because you can then make some of your local adjustments and simply save your HDRI as an OpenEXR and tone map without having to do anything with extra channels and layers, which I'll touch on next.

Notice how the marching ants here have a much softer edge now? My localized adjustments will now blend with the non-touched pixels along this border much more smoothly. There are only a very, very few times when it is not advisable to refine a selection edge for noncomposite images.

Quick tip: When you've got a selection tool active, a right-click will bring up this mouse-point on-image Context Sensitive menu to launch the **Refine Edge** dialog box, along with many other useful commands. Many additional tools feature on-image right-click menus for workflow expedience. Explore your Photoshop workflows to see where right-clicking and other speed-ups are available!

## The Quick Selection Tool

The magic wand doesn't work in 32-bit space, but the Quick Selection tool does. This tool "automagically" makes contextual selections based on color range and edge contrasts. It may take into account edges and colors that are outside of the screen gamut for your HDR images, so be sure to select a white point via the window's 32-bit exposure slider or under **View > 32-bit Preview > Exposure and Gamma** to bring much of your anticipated selection edges into screen gamut.

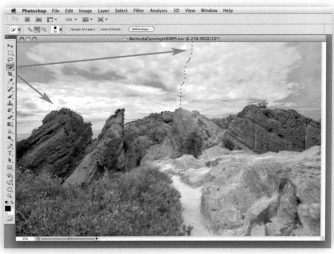

▲ ❶

The **Quick Selection** tool is being used here to select the sky and clouds in this image. You can see where I have already drag-brushed the tool to start my selection. Just keep dragging over the areas you wish to add to the selection. Drag+Option deselects areas previously selected. I'm going to select the whole sky and click the **Refine Edge** button.

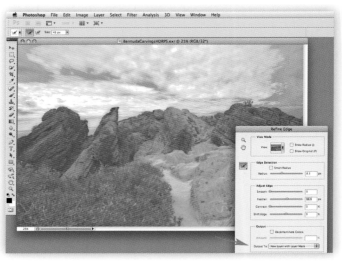

▲ ❷

The clear area shows where my selection is, and I have feathered the edge to soften the effect along the dividing line between the rocks and sky. Notice that I have selected **New Layer with Layer Mask** from the **Output options**. Next I click **OK**.

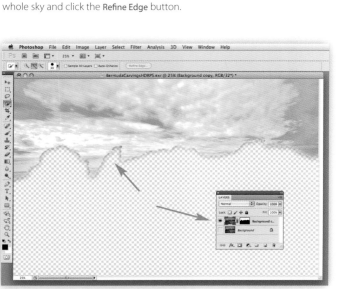

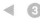

◀ ❸

As you can see, I now have a new layer with just my selected pixels and a feathered edge.

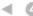

Now I've turned on visibility for the background layer and set the sky selection layer mode to **Multiply** with **Opacity** set to 58%. This simple process darkens the sky and pulls all of the cloud detail into screen gamut for this image. Adjustment layers and layers from selections are powerful tools for the HDRI photographer.

## Complex Masks Using Color Range and Bit-depth Drop-down

This cool workaround takes advantage of a little-known secret to bypass the HDR Toning dialog box when dropping bit depth.

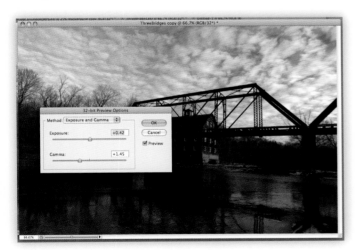

I want to select the sky in this scene, but between the branches and the bridge sections, this is an extremely complicated mask to make manually. Instead I am going to adjust the screen display to bring the sky into screen gamut via **View > 32 Preview Options > Exposure and Gamma**.

Next I'm going to crank up saturation via **Image > Adjustments >Hue/Saturation** to really make those blues "pop". Then I am going to select the entire image (**Image > Select All**) and then copy (**Edit > Copy**).

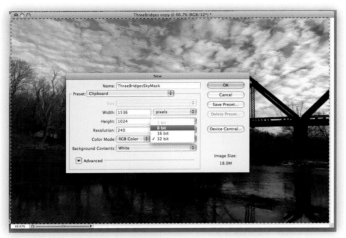

 **3**

After you copy a selection in Photoshop, **File > New** (CMD+N) preloads the dimensions to create a new file to the copied selection. If you select 8-bit (or 16-bit), you will be able to paste (CMD+V) your HDR image into the new document as it appeared in your 32-bit file without visiting the HDR Toning screen.

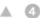 **4**

**Select > Color Range** allows you to use the **Eyedropper** tool or color preset drop-downs to make selections. **Fuzziness** controls edge smoothness and **Range** determines how much of the area surrounding the sampled color will be included in the selection. Once you've got a good mask preview, click **OK**.

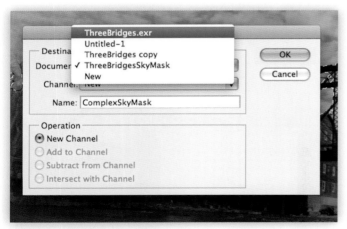

 **5**

Now I'm going to save the sky mask into a 32-bit HDR image via **Select > Save Selection**. I choose the 32-bit file as the **Destination**, save it to a new channel, and name it **ComplexSkyMask**. When I return to the original HDR file, I can now load this complex selection in.

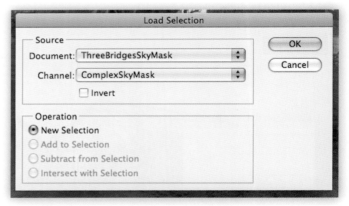

▲ **6**

Before I load this mask, I need to step back in the history palette to before I cranked up the saturation, and then I will load the selection by choosing **Select > Load…** Notice that I can load the selection or the inverse along with a few other options.

I've now got the complex selection loaded into HDR and I can apply all sorts of effects, such as the cooling photo filter shown here or any other 32-bit adjustment, or I can click **Refine Edge…** or make this an adjustment layer under the layers menu.

## Making Selections from Paths

Paths are vector-based tools that are at the core of Adobe Illustrator. These bezier curves can be created and adjusted with the **Pen** tool and a couple of other Illustrator-like tools hiding behind the **Pen** tool along with the **Path** and **Direct Selection** tool arrows.

Under the **Pen** tool are other options for adding or modifying anchor points to better match the outline of your object.

The **Pen** tool can be used to make smooth paths that follow the outlines of a section of your image. Click and drag to pull and curve your lines. It takes a bit of practice, but once you get the hang of it, it can be a very graceful and accurate way to make smooth selections.

Convert your path to a selection with **Make Selection**, either via right-clicking the image or choosing from the menu in the **Paths palette**. From there you can click **Refine Edge…** and treat it just like any selection.

## Image Editing Tips in Adobe Photoshop in 32-bit Space

There are several adjustments that can be applied to your 32-bit HDR images in Adobe Photoshop, either globally or locally. The only difference is if localized selections have been utilized to include certain areas of the image. And of course, Layers and Adjustment Layers expand the range of possible image adjustments in great ways. We're going to look quickly at some of the most useful tools for HDR photography.

## Image > Adjust > Exposure

Image > Adjust > Exposure is very similar to the 32-bit preview option Exposure and Gamma. The big difference is that Image > Adjust > Exposure can be applied to selections and Adjustment Layer masked selections to help pull different areas of an HDR image into display and print gamut.

Here is an HDR image. I've made a quick selection of the sky and now I will make an Adjustment Layer called SkyMask via Layer > New Adjustment Layer > Exposure. Mode is Normal and Opacity is 100%. It can always be changed on the Layers palette.

---

**YOU MUST FLATTEN YOUR IMAGES BEFORE TONE MAPPING!**   I show you lots of great tips and tricks for employing **Layers** and **Adjustment Layers** to your HDRs in this chapter. And of course, you can save your layered files in several 32-bit Photoshop file formats, including PSD, PSB, and TIFF, for interim saving. But you will be greeted by a warning screen that states, *"Reducing the document depth can affect the appearance of layered HDR images. Merge layers before changing depth?"*

If you click the **Don't Merge** button, you will get ugly results that don't necessarily represent what you saw in 32-bit space. If and when you see this warning, you should click **Cancel**, save your layered file, and then flatten (**Layers > Flatten**) and drop bits to tone map again. The same goes for the **HDR Toning** command with a slightly differently worded warning screen. This works only with flat files, regardless of original bit depth. **Yes** flattens the image and launches the HDR Toning window, while **No** cancels the command. I always advise saving your layered image prior to HDR Toning because it allows you to easily go back and make 32-bit image tweaks without having to start over from an earlier point in the work path.  ■

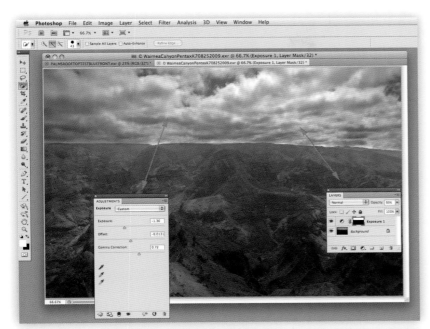

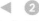

I adjust **Exposure**, **Offset**, and **Gamma** just enough to pull in all of the sky detail. There are also positive and negative EV offset presets under **Custom**. Notice also that I have dropped the **Adjustment Layer** opacity just a touch to blend it in with the background pixels. The **Exposure**, **Offset**, and **Gamma** controls, when used with a light touch, can oftentimes give great contrast without looking too artificial, as is the case with the clouds.

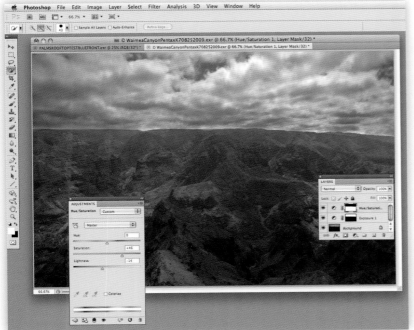

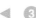

The rest of this image doesn't need any **Exposure** adjustments. Instead it just needs a little saturation boost, so I invert the original selection and make a new **Hue/Saturation** adjustment layer and boost up the colors in the canyons a touch to make this image pop! The great thing about Adobe Photoshop's localized adjustment layers is that different effects can be applied to different parts of your images!

## Saturation Effects via Levels > Midtones Adjustments

Sometimes it helps to think a bit differently about 32-bit space. For example, one of the best ways to boost or diminish color saturation during tone mapping is via the **Levels** midtone control point. I'm going to start with the same HDR image and simply change the **Levels** midpoint to show two very different effects.

 **1**

Here is the original HDR file merged from five source images.

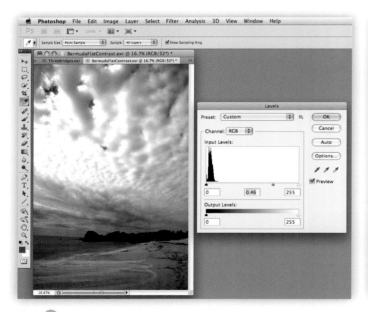

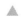 **2**

I am going to boost saturation here by pushing the midpoint on **Levels** toward white.

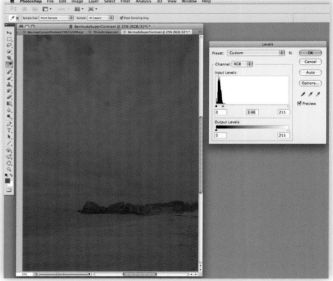

▲ **3**

And here I am going to diminish saturation by pushing the midpoint on **Levels** toward black.

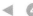 **4**

At left is the image with the midpoint pushed toward white, and at right, the midpoint was pushed toward black. Notice in particular the **vibrance** and **saturation** settings. Neither of these versions is "more correct" than the other. It is just a matter of your personal HDRI visions.

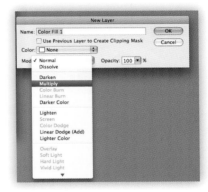

## Built-in Photo Filters and Customizable Photo Filters

Photo filter adjustment layers are a quick way to warm up or cool down your HDR images. And yes, these photo filter adjustment effects can also be applied to local selections.

 **2**

But **Layer > New Fill Layer > Solid Color** offers a lot more quick control. In the **Mode** dropdown, select **Multiply** and click **OK.**

 **3**

The **Color Picker** will open, and you can select your fill color as well as intensity. Here I am adding a warm orange to emulate 1960s-style emulsion. You can amplify or diminish the filter effect via **Layer Opacity.**

 **1**

There are a number of classic styled photo filters available under **Layer > Adjustment Layer > Photo Filters** or **Image > Adjustments > Photo Filters.** Each is pretty self-explanatory once you launch the window.

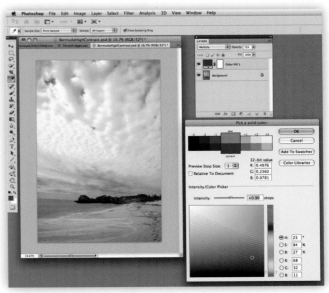

## Adjusting White Balance with Levels

White balance can be adjusted, globally (in an entire image) or locally (in a selection), via the white point **Eyedropper** on the **Levels** palette. Unlike in lower bit space, you are not clicking a white clip point, so no data is lost. It may be pushed off screen gamut, but the data is still available.

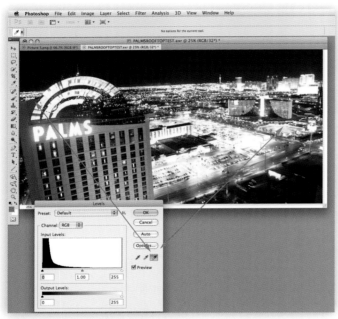

▲ ①

Most of the foreground of this shot is inside a selection, though it's tough to see because of the busy nature of the image. I want to cool down the yellow cast in the foreground, and I am going to use the white point **Eyedropper** to do it. I click around in the image and try to find a good neutral to assign for white reference.

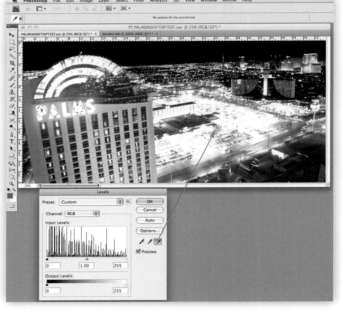

▲ ②

I click in this area, and I just cannot find a good neutral reference. I'm going to have to get creative.

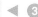

There's a lot going on here. I made a duplicate of the image and blew it up to 200% to pick a white point reference with more precision. But look at what else I did. I double-clicked the white point tool to select a target highlight color. I pick a neutral gray with a little more intensity than the current color level, and I'll use this as my target. Now when I click in the image, it will take into account the image brightness along with the target neutral to determine pixel value reassignment. I have now cooled the color casting in the foreground of this image. Feel free to experiment with nonneutral "white points" and various intensity levels to alter the white point and Kelvin casting in your HDR images. And of course, you can attempt to neutralize—or amplify—casting from different Kelvin sources for various creative effects.

## Light-Painting Brushes

Another of the cool tools that has migrated for the first time to the non-Extended version of Photoshop CS5 is Brushes, which can be used for both positive and negative "light painting". Negative light painting—or "burning in", in the language of the wet darkroom—is easier to get a handle on, so I'll cover that first.

▲ 4

The last thing I'm going to do before saving this in 32-bit format is use the **Exposure** control to pull the adjusted selection back into screen gamut.

▲ 1

First, I double-click on the foreground color icon in the toolbar to open the **Color Picker**. Then using the **Eyedropper** tool, I select a new foreground color off this Vegas Strip mall to even out the blue-cast lighting on this building. Intensity isn't a significant factor for this operation, provided it is not significantly brighter or darker than the current exposure slice. I click **OK**, which makes my light-painting brush use the active color in the **Color Picker**.

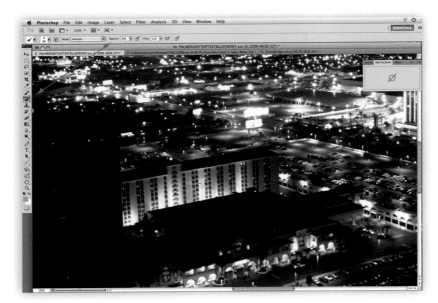

◄ ②

I click on the **Brush** tool and select a soft-edged 88 pixel brush for this print-sized image. I set **Mode** to **Multiply**, **Opacity** to 80%, and **Flow** to 35%. You'll always want **Multiply** as your mode, and you'll have to experiment with **Opacity** and **Flow** percentages depending on your particular scene.

◄ ③

Using the light brush, I have now burned in the hotspots from the uplights on this building. I've done a good job at matching the colors and giving the illusion of blue-tinted light sources. You can mix up this light painting trick two different ways: Use a perfect neutral (equal RGB channel gray, in other words) for your light brush to skip having to select a slightly casted light brush, or go the opposite way and paint in shadow light from articially created, differently "colored" "light sources" in your shots.

## Dodging/Adding Light

This is a bit more challenging to get the hang of to make it look natural. It takes practice and patience to really pull off the effect. I'm going to try to brighten two sets of archways in this next exercise.

If, after doing steps 1-3, I wanted to get creative, I could also burn in the light on this building with a nonmatching color to give the illusion that there are different color lights illuminating the building. Get creative, have fun, and experiment!

 **1**

Using the **Eyedropper**, I select a light source from under this well-lit archway that is +1.51 stops more in intensity. I'm going to use this color as my light-paint brush color for the two sets of archways next to this one. You can eyedrop a color or pick your own color and crank the intensity up a bit.

 **2**

I zoom in to get a better work space, select a brush size, set **Mode** to **Luminosity**, and set very low **Flow** and **Opacity** values.

 **3**

It takes a very light touch, and the results can appear artificial, as in the center three archways, or pretty natural, as with the far archways. As I said, it takes a lot of practice, experimentation, and patience!

**SELECTIVE LOCAL ADAPTATION TONE MAPPING: A USER CHALLENGE**    All the information you need to apply Local Adaptation to a selection of a 32-bit file is contained in *Practical HDRI*.

Here are a couple of hints:

- Save the selection into both your original and target document.

- Consider tone mapping an entire image before cutting out the selection; otherwise you'll get nasty gray tone map edges, which while not impossible to blend into background pixels, do create more speed bumps.

- Layered documents cannot be tone mapped.

- **Exposure and Gamma** is usually the best "boring operator" for WYSIWYG (what you see is what you get) conversions to lower bit space after you've achieved the effect.

- Think you've got it figured out? Stop by http://www.facebook.com/hdrphotography and share your results! ■

## The Rubber Stamp for Spotting and Cleanup

The trusty rubber stamp works in 32-bit space, just as it does in low-bit spaces. But there's no healing brush for working up your HDRs. Be sure to inspect your image at different exposure levels to see if dust spots are hiding outside the current exposure slice!

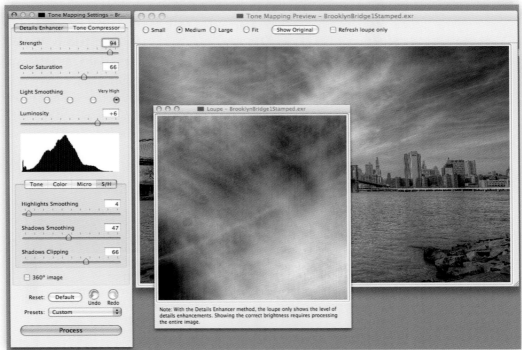

But be careful! Tone mapping—particularly when micro-contrast is cranked way up—can amplify stamp edges, requiring additional post-tone-mapping cleanup. I'll take care of those dust spots I missed in post-processing as well.

## Tuning and Toning HDRs in HDR PhotoStudio

HDR PhotoStudio 2 runs natively in 32-bit space, using their Beyond RGB Color Model for incredible levels of control over color and luminance information within your HDR images. The engine running HDR PhotoStudio 2 is powerful, and the results can be amazing in terms of photo-realism and color.

The interface is clean and crisp, with tons of opportunities for saving presets, creating "recipes," and more. There is no one all-powerful tone map interface window to be found in HDR PhotoStudio—instead, there are several tools that can be used to edit, adjust, and tweak your 32-bit HDR image for saving either to 32-bit or to lower-bit spaces. All of the advanced image processing taking place in 32-bit space can take some time, especially with very large files, so it is a good idea to get used to HDR PhotoStudio 2 by working on some scaled-down HDR files first.

HDR PhotoStudio 2 can certainly be used as a start-to-finish HDRI solution, from merging through bit-drop. But just as with the 32-bit processes described in this chapter for Adobe Photoshop CS5, any or all of these tweaks may be applied to your HDRI file, which can then be saved into 32-bit space for tone mapping with one of the other programs in this book.

Think of it this way: HDR PhotoStudio is a 32-bit image editor. And it is also a very capable tone mapper that excels at photo-realism. And if you want to use it for wild-style surrealism, it can do that as well. There are a number of different tools to adjust the look and feel of your 32-bit file, and there's no rock-solid rule that you must do this before that, but generally speaking, it's a good idea to start at the top of the toolbar (excluding, of course, Undo and Redo) and work your way down through the tools you want to employ.

We're going to look at a few different images while we explore what HDR PhotoStudio 2 has to offer for high dynamic range image editing.

### Getting a Feel for the HDR PhotoStudio Work Paths

It may take some users a few minutes to get comfortable with HDR PhotoStudio, but once you get a feel for the way the program works, it makes a lot of sense. Let's take a look at the program interface, presets, recipes, and such to warm up.

**1**

First, notice this tiny little monitor icon in the lower-left corner of the application window. From here, we can select different monitor calibrations, as well as our rendering intent. If you've already got a calibration system in place, it's easy to get HDR PhotoStudio synced up. Otherwise, you can just let it ride with the default settings.

Very often, when you see an **Eyedropper**, you'll also see a slider that controls the same command. On the edge of the application frame, this **Eyedropper** and slider control **Display Brightness**, or the EV slice of the image within the screen gamut, in other words.

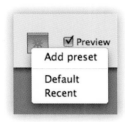

Almost every command and function inside HDR PhotoStudio shows the gear icon for saving or loading presets, along with a **Preview** check box. As you get comfortable with the way HDR PhotoStudio works, you may want to uncheck the **Preview** box because the program will refresh the on-screen display with every nudge of a slider in a command box. You may want to bundle tweaks and then check this box, especially with larger files, in order to minimize preview render time.

As you can see, I've done a major amount of work on this shot since the last screen shot, and all the while the program has been documenting the processes in the **Undo** menu. A simple CMD+Z will undo the last command (CMD+Y will redo), but clicking **Undo** (or subsequently, **Redo**) allows you to quickly jump back to anywhere in the image's edit history from the time it was created or opened.

## Working with Recipes

**Recipes** in HDR PhotoStudio are simple scripts of commands and settings to be applied to your images; they're similar to the actions in Photoshop. Best of all, there's no proactive step you must take to create a recipe. All your command settings are constantly being recorded in the background both for powering the undos and for creating recipes. You can create a recipe at any point during your work on an image simply by selecting **Create recipe** from the **Recipes** menu. HDR PhotoStudio also ships with a couple of recipe presets for different tone map feels you can apply to your images.

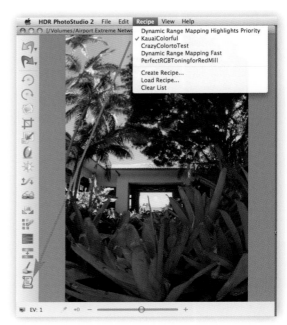

 **2**

Once you've save a **Recipe**, you can apply it to other images. Here I make sure KauaiColor is the active **Recipe** as indicated by the check mark, and then I click the **Recipe** icon. Notice that there is a mix of preloaded **Recipes** and custom **Recipes** that I've added to the **Recipe** menu.

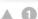 **1**

Here I've pulled up the **Create recipe** dialog box, and as you can see, it has listed every command and setting applied since I've opened this image. You can check or uncheck any command settings and then save it and give it a name that makes sense for you. I'll named this recipe "KauaiColorful".

 **3**

The **Recipe** gets me most of the way there, but there's a still a little tweaking to be done. I have to juice up the color in the sky to give the exact feel I want in this image. Notice the richness of the colors in this image without excessive haloing!

Generally speaking, the more simple a **Recipe**, the more easily it may be applied to different shots. HDR images are very complex beasts, and the more steps and adjustments there are in a **Recipe**, the more likely the results will be off the mark between different images.

Conversely, if you have many HDR images that are variations on a theme, such as a horizontal and vertical of the same scene like we explored here, the more likely it is that a multistep **Recipe** will steer you very close to your target adjustments with just a few extra clicks needed after applying the **Recipe**.

## Rotating, Cropping, Resizing, and Whatnot

These tools do pretty much exactly what you'd expect. The **Rotate** buttons turn in 90° increments. **Free Rotate** lets you draw a line on the image to determine the horizontal or vertical axis. **Resize** and **Crop** offer a couple of options and, of course, the gear is for saving and loading presets.

### HDR PHOTOSTUDIO'S BEF FILE FORMAT

Note that when you are working in HDR PhotoStudio's native BEF file format, your image adjustments are persistent even through iterative saves. Be sure that the checked/unchecked items in both the File History list and Current History list match up to avoid suprises!. ∎

If you want to fix an uneven horizon, you may do so with the **Free Rotate** tool. Just click a start and end point as indicated by the yellow line, and away you go! **Crop** has the option for free cropping or constrained via either **Aspect Ratio** or pixels.

### Toning and Tuning your Image with the HDR PhotoStudio Toolkit

HDR PhotoStudio's toning and tuning tools work globally—meaning there's no way to make local selections or apply adjustment layers. But at the same time, when working with the Unified Color Beyond RGB BEF format, it is possible to step all the way back in the 32-bit file's history. So in a way, this can be seen as sort of nondestructive image editing, as long as the image is saved back into the 32-bit BEF format. If you save it as a lower-bit TIFF or JPEG, you've permanently committed to the changes.

### Display Brightness Up/Down

Don't just "set it and forget it"! When you are image-editing in 32-bit color space, you can very often get better results if you actively adjust and readjust the displayed image EV slice and image brightness.

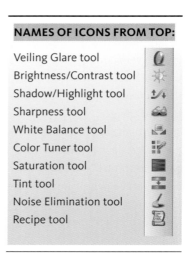

**NAMES OF ICONS FROM TOP:**

Veiling Glare tool
Brightness/Contrast tool
Shadow/Highlight tool
Sharpness tool
White Balance tool
Color Tuner tool
Saturation tool
Tint tool
Noise Elimination tool
Recipe tool

### Veiling Glare Tool

Very briefly, "veiling glare" is an optical physics term describing the loss of contrast due to scattering of light between lens elements. This is a big deal in HDRI because the multiple image process and extreme exposure range therein can amplify this effect. Add to this the virtually open-ended nature of the 32-bit space (meaning there's no hard-limited black and white points) and it can create some problems. The **Veiling Glare** tool can be used to overcome these issues. Here's how.

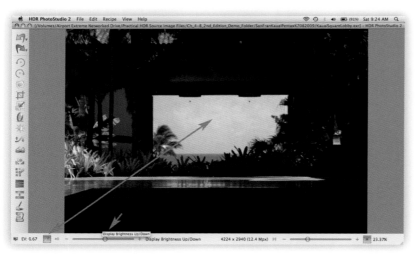

 Use the **Eyedropper**, or use the **EV** slider, but remember that you can always adjust the **Display Brightness** as you edit your images to inspect adjustment effects at the far reaches of your image's tonal range. You'll notice the EV slider moving very frequently in the subsequent screen shots. Do note that this isn't a "sticky" adjustment and does not actually alter the image content, just the on-screen display. If you are saving back to a 32-bit file format such as EXR, BEF, or TIFF (32-bit), the exact value of the display brightness is less critical than it is if you are saving to LDR spaces. We will cover this in more detail in chapter 8.

## Define a Black Point with the Veiling Glare Eyedropper

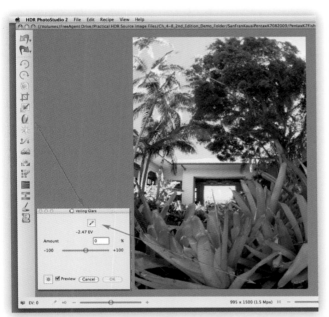

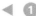 ◀

The **Veiling Glare** tool eyedropper is preset to -2.47 EV in relation to the display brightness. (This -2.47 EV figure equates to 18% gray reflectivity.) But you can use this dropper to define the darkest spot in your image—0, 0, 0 in low-bit space, in other words. I click on a spot under the shadowed foreground foliage in the Kauai scene to set a black point.

 ◀

Notice, first of all, that I have adjusted the **Display Brightness** to -3 EV to better tweak and treat the shadow details. Notice how the dropper now shows -7.19 EV? This is in relation to the original screen display 18% point. And I've pushed the **Veiling Glare** slider to -33 to crisp up the image contrast. Be careful with overdoing this setting. You probably don't ever want to go past -50 under normal circumstances. (You can also add a degree of haziness to an image by putting a positive value in the slider with this tool, which you may want to do for some soft landscapes, but again, keep in mind that a little bit goes a long way with this tool.)

## The Brightness/Contrast Tool

▶ ❶

The modestly named **Brightness/Contrast** tool in HDR PhotoStudio 2 is actually a control panel for tone map operators that can compress the tonal range of the image natively in 32-bit space. I will go into much more detail on the nature of tone map operators in the next chapter. The left **Eyedropper** is used to set a bright point on screen. The right **Eyedropper** is used to select a target 18% gray point in the image. This is very different from the **Display Brightness** setting, as these adjustments actually reassign the pixel values.

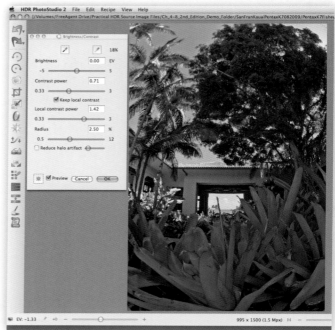

▲ ❷

Pay special attention to the inverse relationship of the **Contrast Power** and **Local Contrast Power** sliders in HDR PhotoStudio 2 and the effect these have on image quality and detail feel and what happens when these two are unsynchronized by unchecking the **Keep Local Contrast** box. You will see the echoes of these paired image adjustments in many local operators across the different programs. Take a look at how this image changes when we make some adjustments to these two tone map sliders, both in sync and independently.

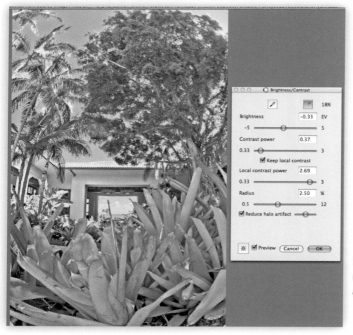

◀ ❸

Low **Contrast Power** (slider to left, value less than 1) and high **Local Contrast Power** (slider to the right, value greater than 1) emphasizes detail and compresses the tonal range quite well.

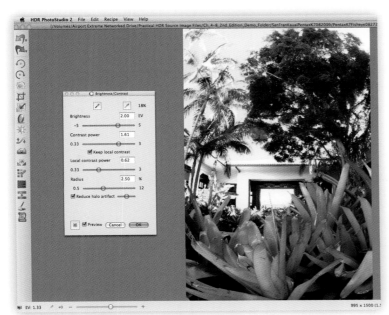

 **4**

High **Contrast Power** (slider to the right, value greater than 1) and low **Local Contrast** Power (slider to left, value less than 1) emphasizes smoothness but isn't quite as adept at compressing the full tonal range of the high dynamic range image.

 **5**

Low **Contrast Power** and low **Local Contrast Power** (both sliders to left, both value less than 1) softens edges, smooths color, and lowers contrast.

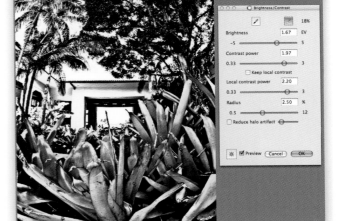

▲ **6**

High **Contrast Power** and high **Local Contrast Power** (both sliders to right, both value greater than 1) really crisps up edges and detail and boosts overall contrast.

Remember, these operations are all taking place in 32-bit space, so there's no clip as long as you stay in 32-bit space. And you can tweak images in HDR PhotoStudio for different effects and then tone map in any other program for a very different feel from the same source image. You will oftentimes have to readjust the **Brightness** slider after tweaking the **Contrast Power** and/or the **Local Contrast Power** settings.

**Radius** describes range of influence of the **Contrast Power/Local Contrast Power** settings.

▲ ❶

The radius number represents X percentage of the longer image dimension: For example, if **Radius** is set to 3 on an image that is 100 pixels wide and 66 pixels tall, the radius is 3 pixels. On an image that is 1000 pixels by 660 pixels, 3 equals 30 pixels, and so on. Lower radius numbers emphasize fine detail but can produce halos. Higher radius numbers smooth fine detail and edge contrast. You can determine the affected radius by looking at the pixel dimensions on these two examples with the **Radius** set to 1% and 6%

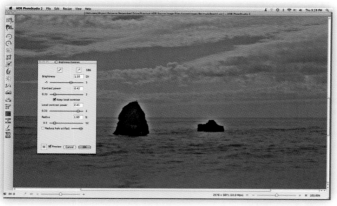 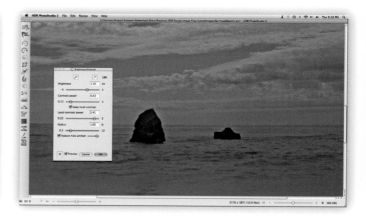

▲ ❷

The **Reduce Halo Artifact** operation is quite impressive at minimizing artificial-looking haloing along high-contrast edges. In the first image, it is unchecked, and in the second it is set to the highest quality setting. This is a great command! There are three settings for **Reduce Halo Artifact** ranging from **Fast** (left) to **Quality** (right).

## The Shadow/Highlight Command

The Shadow/Highlight command box is another way to compress or amplify the tonal range of your HDR image in conjunction with, or instead of, using the Brightness/Contrast commands. This command box can really tame highlights and pull out shadow detail! The Radius and Reduce Halo Artifact settings function the same as they do in the Brightness/Contrast command box.

Global and local operators are described in more detail at the beginning of Chapter 8.

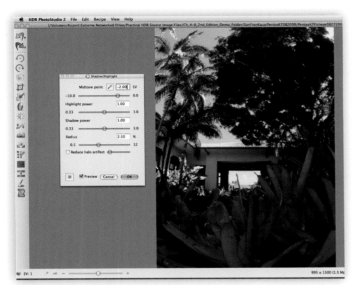

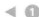 **1**

Here's the same image, reset to void out the Brightness/Contrast tweaks we explored earlier. It looks pretty good right now, but you can pull much more detail from this image. The Midtone Point eyedropper is preset to -2 EV to delineate between the shadow and highlight adjustments. You can click in the image with the Eyedropper to select a new midtone point or slide the EV slider to reassign the Midtone point. Values less than 1 (to the left) on both sliders push pixels closer to the midtone point—darkening up the highlights and lightening up the shadows, in other words. Values greater than 1 (to the right) push pixels farther away from the midtone point, darkening the darks and brightening the brights.

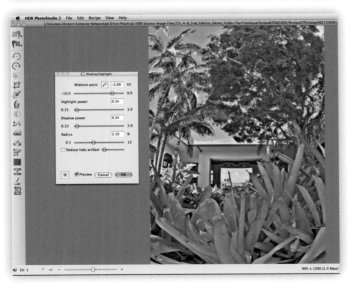

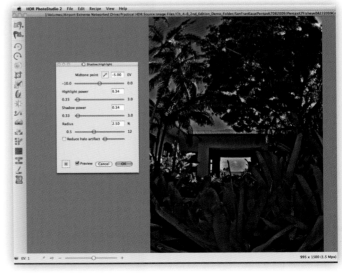

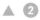 **2**

As you can see, here I've pushed both Shadow Power and Highlight Power to the left to compress the tonal range. Yes, it does feel a little strange to push both these sliders in the same direction at first, but you'll get used to it after just a few times.

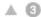 **3**

Here, I have adjusted the midpoint down to -5 EV, which may be a bit much for this image. Notice the increased halo effects in the sky? You can minimize this by readjusting the Midtone point, by adjusting the Radius, by clicking Reduce Halo Artifacts, or by using some combination of the three.

## The Sharpness Tool

The Sharpness tool in HDR PhotoStudio is excellent for pulling up fine detail and microcontrast in your HDR images as well as smoothing fine detail. Values less than 1 (to the left) smooth details, and values to the right (greater than 1) can really help pull out detail. Radius, here, refers to actual pixels, not percentages. The higher the number, the more far reaching the effect of the Power setting.

## The White Balance and Color Tuner Tools

These two tools are similar in function but don't give the same result. The White Balance tool allows for fine adjustments of the overall cast of the image, while the Color Tuner is a crazily powerful color reassigner.

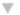 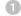

You can click anywhere in your HDR image to reassign white balance. I decided to warm up this shot by clicking on a blue-gray section of rock for a neutral reference under this decaying civil defense truck.

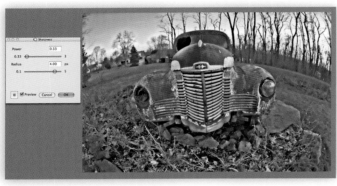

Power values less than 1 smooth out fine detail. A higher Radius setting increases the pixel values and creates a wider spread of the effect.

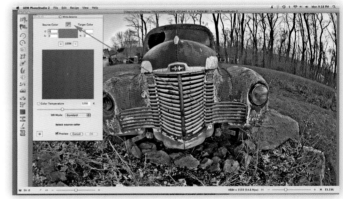

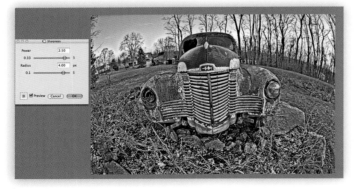

Power values greater than 1 accentuate fine detail. A higher Radius setting increases the pixel values and creates a wider spread of the effect. You can use the sliders or really crank up the effect by inputting greater numbers than the sliders allow.

▶ **②**

As you can see, the target rock is now perfectly neutral, which warms up the rest of the image. You can click and click again for a white point reference, or you can drag the square in the color map toward your new target neutral, which will live-update in the right color swatch preview. Or you can opt to input a Kelvin temperature by clicking on that box.

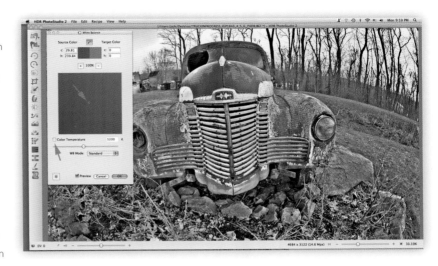

▼ **③**

Now let's look at the Color Tuner. The blue in the sky in this shot from Kauai just doesn't match up to the intense blue of the tropics—yet. I'm going to take the **Eyedropper** and click on the sky to tweak this.

◀ **④**

The X at the center defines the original color, while the square is hovering over the preferred target color. It's got much more "pop!" now. I click **OK** and the sky is much more blue.

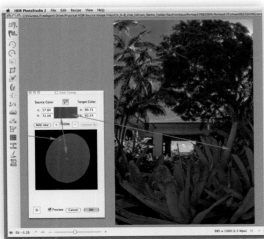

◀ **⑤**

Now, looking at the target point on the last image, you can see what I've done to freshen up the tropical greenery by swapping the source color for the new, brighter, target color. This is a powerful tool for HDR photographers. You can also shift **Hue** a full 360° for different effects if you want.

### The Saturation Tool

The **Saturation** tool is divided into six segments of the spectrum that can all be used to amplify or diminish the saturation along those wavelength segments. HDR PhotoStudio manages to crank up color in a manner that is both intense and natural at the same time. (It is possible to overdo it, but for the most part, this is a great operator.)

As you can see, I have chosen to boost the reds, yellows, greens, and cyans more than the blues and magentas in this lush view of Waimea Canyon.

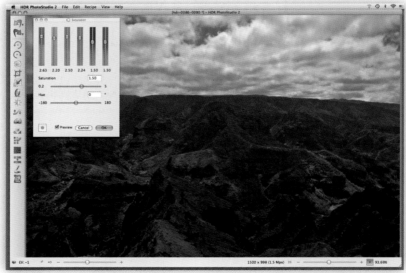

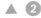 

And here is the coolest thing about the **Saturation** tool in HDR PhotoStudio. Once you have made channel-specific adjustments, you can boost or diminish saturation globally with the main slider, and your channel-specific settings adjust accordingly. So, for example, here I decide I need a bit more overall color, and this effect is applied to each channel, taking into account my previous adjustments.

## The Tint Tool

The Tint tool should be a big hit with landscape and cityscape photographers. It is really easy to use. Just pick a target color and saturation intensity, and away you go.

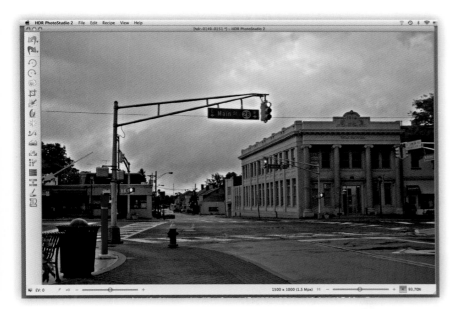

◀ **1**

Here's a cityscape that I want to convert into a monochrome, and I'll click the **Tint** tool to do it.

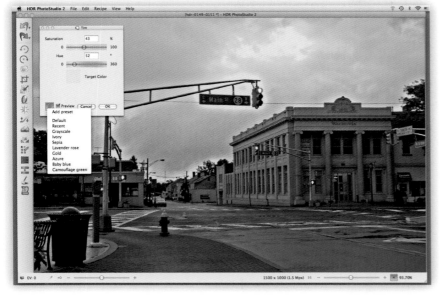

◀ **2**

You can select a **Saturation** level and a **Hue** to tint the image yourself. Or you can load in one of the many included presets. And of course, you can add your own presets. Depending on the overall luminance range of your image, the optimal saturation percentage will vary.

## The Noise Elimination Tool

The multishot HDRI process is itself a very effective noise-elimination technique. But if you have some noise you want to minimize, give the **Noise Elimination** tool a shot. It can tackle both luminance and chrominance noise.

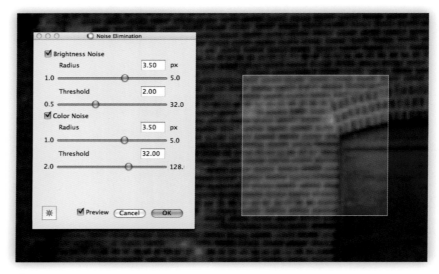

If you need to tackle noise in your 32-bit images, the **Noise Elimination** tool in HDR PhotoStudio is a good choice. Note that yellow square—it is the only active preview area for the noise settings. If your noise is speckled in dark areas, that's color noise. If you have edge and detail noise, that's brightness noise. Odds are if your HDRIs have some noise issues, it'll be color noise. But if you are pulling a single shot into 32-bit space, you could get both brightness and color noise.

## Saving Your HDR Image in HDR PhotoStudio

HDR PhotoStudio can save high dynamic range images in OpenEXR, 32-bit TIFF, and their proprietary BEF format. It is wise to skip the 32-bit TIFF format because 32-bit TIFFs are uncompressed files and will quickly gobble up more hard drive space than you can imagine.

A case can be made to save your images as either OpenEXR or BEF format, or perhaps even both. OpenEXR is readable by many programs,

including the Mac OS X operating system, while the BEF format is readable only by HDR PhotoStudio and Adobe Photoshop via a plug-in. But the BEF format preserves the history of the document, even through iterative saves, and can offer more compression without visual loss.

If you can spare the hard drive space, save your 32-bit images from HDR PhotoStudio as both BEF and OpenEXR for maximum versatility and cross-program tone mapping. **File > Save** launches the **Save** dialog box.

Precision in the BEF format is measured in **Visual Error** (**VE**). Values less than 1 are not distinguishable to the human eye. The finer the precision, the larger the resultant file will be.

I choose **Lossless compression** and usually just stick with **rle** compression (the default) for saving in OpenEXR format to bring my files from HDR PhotoStudio to the other tone mapping programs I use on a regular basis.

Next, we're going to look at bit-dropping tone mapping in all of the programs we are exploring in *Practical HDRI*.

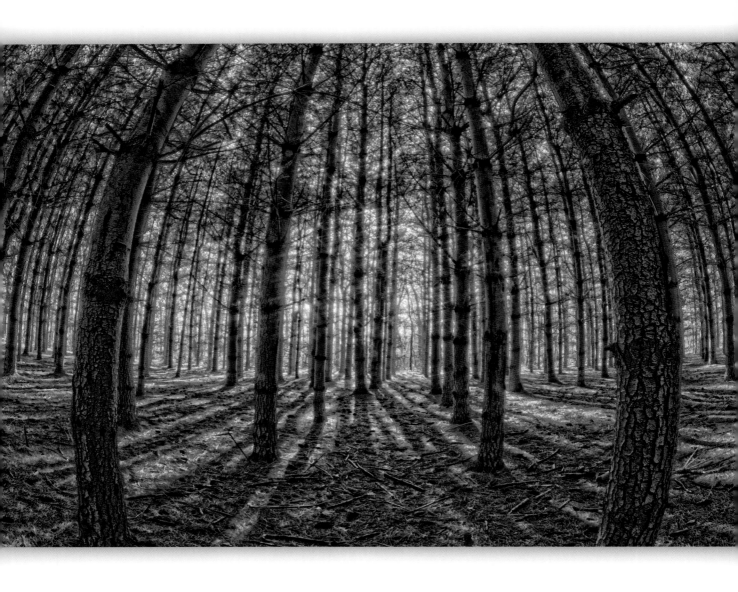

# 8
## Tone Mapping High Dynamic Range Images

Simply put, tone mapping is the third and final process in the high dynamic range imaging (HDRI) workflow. But in practice, it can be a bit complicated. As we compress the color and luminance data of the 32-bit HDR image into the smaller low dynamic range color spaces, we have many different options on how to represent the high dynamic range image on traditional monitors and printers. In this chapter, we explore the nature of bit-dropping tone mapping and the related workflows for Adobe Photoshop CS5, Photomatix Pro 3, FDRTools Advanced 2.3, Dynamic Photo HDR 4, and HDR PhotoStudio 2.

## Thinking of Your 32-Bit HDR Image as a RAW File

TONE MAPPING: A process of adjusting individual tone values in an HDR image to allow them to be reproduced in a device (such as a monitor or printer) that has a smaller tonal range than that of the original image. Tone mapping is especially useful for printing high dynamic range images, created by combining several images. Without tone mapping, the tonal range of an HDR image will exceed the ability to print it. Tone mapping reveals both highlight and shadow detail by compressing all of the tones in the middle. Specialized software and workflows are required.

Tone mapping your 32-bit HDR image file can be roughly equated to running your RAW files through a RAW processor. There's a ton of available data in the file—much more than can possibly fit into the 0, 0, 0 to 255, 255, 255 color space it is heading toward—and what you do with it is up to you. Just as there's no one absolute "proper" way to convert a single RAW image to 8 or 16 bits, there's no single

proper way to crunch your HDR image file into smaller bit spaces. Some photographers strive for seamless photorealism, while others push their HDR images to surrealistic, hyper-vivid extremes. The same tone map operator might pull amazing detail or offer smooth gradations of tones depending on the settings. One is not "better" than the next, per se—it is all about your personal vision. There is so much information available in an HDR image file made from a sequence of source images that captured the full dynamic range of the scene that it is truly up to you as to how to best translate this information into LDR space. Each software program does these processes with its own style of interface—and each program is capable of producing subtle or surreal LDR output images from your 32-bit HDR image files.

## Two Flavors of Tone Mappers: Think Globally or Act Locally

There are two main types of tone map operators: global operators and local operators. Global operators apply conversion settings more uniformly to the 32-bit HDR data, either linearly or along a basic curve, while local operators analyze the image, searching for contrast, and apply localized tweaks based on pixel values in discrete patches throughout the image. Generally, global operators produce results that are more subtle than those produced by local operators. Global operators are a good choice when the priority is for photorealistic results with smooth (if flat) color gradations across a wide dynamic range. HDR images processed with a global operator will usually need a decent bit of image editing after tone mapping to boost contrast snap and Unsharp Masking.

In many real ways, local operators are much more powerful than global operators. Local operators can push and pull the 32-bit data in amazing ways to crank up contrast and saturation, accentuate detail and textures, and create images that run the gamut from photorealistic to surrealistic or hyperrealistic, or all the way to artificial and absurd. (Of course, one photographer's "hyperrealistic" may be another's "artificial and absurd".) On the surface, local operators can compensate for not truly recording the full dynamic range of the scene during image capture bracketing. However, you will yield more natural (though not necessarily any less "dramatic") results with less tone map artefacting—such as excessive contrast halos—when you don't have to crank tone map settings to extremes to overcompensate for underbracketing.

You may notice that certain tone mappers in different programs behave similarly—that's because the underlying mathematical foundations are the same. There are a number of "academic" tone map operators that the commercial software developers can customize and integrate into their individual programs.

**If you're looking for the lucky numbers— keep looking!** I am not doing a side-by-side-by-side (ad infinitum) comparison of the same HDR image run through every available tone mapper in the five programs featured here. That would be very boring! Don't pay too much attention to the exact numbers and settings in each step-by-step example because each high dynamic range image is different than the next. There is no single, perfect setting that will always yield the perfect results—you will have to experiment and explore the functions of each program. You may start to discover baseline

settings that work well with your particular images, but your images will be improved when you take a hands-on approach and take the time to work up each image individually. Don't take this to mean that you shouldn't save and load tone map settings in the programs that support presets—rather, use these presets as shortcuts to get you to a likely starting point for your image-specific tone mapping tweaks.

Tone mapping is a very visual process. Studying the auto-refreshing histograms in the Tone Map Preview window in Photomatix Pro, for example, is a great way to get a feel for what happens with each push and pull on a slider. You will get better with it the more you experiment. It can be very challenging and frustrating at first, but stick with it! Soon you'll get the hang of it.

**Carpet Bubbles and the Princess and the Pea:** You *will* encounter a degree of carpet bubble syndrome with each and every program. Every setting and slider value will have an impact on the output image. A little twitch on this setting will crank up the effect of that setting and so on. Yes, it can be maddening at first. It may seem like you simply can't get it right and that the slightest adjustment on a slider will totally upset the overall image quality. But once you get acclimated to each program, you'll get a feel for how each setting affects the others. And instead of pushing this slider up to 8 and then cranking it back to 7, after pushing the other dial up to 9 and then back up to 10, after pushing the first slider to 7 and on and on, you'll get a feel for how to push and pull the HDR in more fluid ways and you'll be able to predict how each slider adjustment will affect the other settings. But try as you might, sometimes you just can't get it perfect. Don't worry. It's completely acceptable to polish and refine your LDR output image in a

traditional bit space image editing program for final optimization. In fact, even if tone mapping gets you 99% of the way, all of your LDR output images will benefit from a little bit of optimization—just like your traditional single-shot images!

## Faking It

Yes, every program we explore in this book can tone map a single image. Yes, you can use a local operator to pull tons of detail out of a single image. But you cannot truly make a high dynamic range image from a single shot—either RAW or JPEG. You can make a tone-mapped image from a single shot, but it will have a limited dynamic range—and you cannot retrieve blown highlights or blocked shadows. Also, you cannot minimize noise by overexposing the shadows. Some photographers will go so far as to completely fake a bracket sequence using a RAW converter. They are wasting their time. The results from a phony bracketed sequence and the results from the single shot will be virtually identical. If you are really into the tone-mapped look and want to apply it to your archived pre-HDR workflow images, give it a shot, but do understand that you won't realize a larger dynamic range, and in the process you will potentially amplify shadow noise and highlight fringing. Now that you understand the nuances of the true HDR workflow, don't cheese it! If you want to make great HDR images, don't cut corners anywhere along the line.

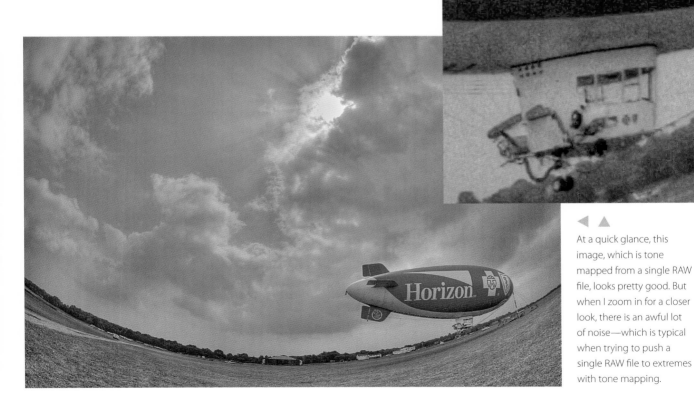

◄ ▲

At a quick glance, this image, which is tone mapped from a single RAW file, looks pretty good. But when I zoom in for a closer look, there is an awful lot of noise—which is typical when trying to push a single RAW file to extremes with tone mapping.

## Halos, Inversions, Hypersaturation, and Other Weirdness with Tone Mapping

Make this your tone mapping mantra: Just because you can do something doesn't mean you *should*.

Tone mappers are powered by bafflingly complicated algorithms that push and pull the numbers behind the pixels in amazing ways. You can make halos, invert tonal values, pull up obscene amounts of detail, and crank colors up to eye-piercingly vivid saturation levels. Give it a shot. Crank some settings up to maximum. Now crank up a few more. Then turn down the first settings to minimum. Are you beginning to understand the carpet bubble syndrome yet? Every setting will affect the other settings to some degree. But tone map settings resulting in excessives halos, tonal inversions, and

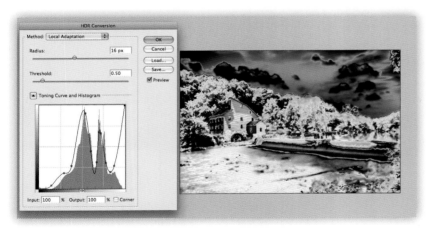

There are a many lessons to be gleaned from this awful tone mapping job. **Radius** and **Threshold** are cranked up far too much, which gives us halos. And by foolishly attempting to trace the histogram with the curve, I introduced inversions—the clouds and cascading water shouldn't be dark grays! Don't be afraid to push your personal vision, but do beware of the common mistakes many photographers make when they are first starting out. And while **Histograms** and **Curves** both illustrate the values in the image, these are two different representational models!

hypersaturation should be applied sparingly, if at all. As you experiment, you'll begin to notice high/low and low/high correlations between certain settings, particularly with local operators. Pay attention to how each setting affects the image and you will become more comfortable with tone mapping.

Or maybe you truly like the "to-the-extreme" look. If that's the case, go for it! Don't get so terrified of breaking the rules or upsetting someone else's sense of aesthetics that you pigeonhole yourself and fail to develop a personal style. But do be aware that over-the-top tone mapping of underbracketed images runs the risk of garnering nasty criticism on many an online photo sharing site.

---

**WHY DO MY HOTSPOTS HAVE DARK GRAY CENTERS?**  No matter how hard you try, there are times when the direct sun or other point light sources are still too hot (255, 255, 255) to be recorded without blowout even in your most underexposed source images. And these blown values can wind up as gray blotches in your tone-mapped image due to the way tone mappers look at the pixel values in your image (these spots have a set brightness, but no detail information, in other words). You can try tweaking your tone map settings to minimize the effect or fix it in a regular image editor after tone mapping.  ■

---

## Goodbye High Dynamic Range Image—Hello Tone-Mapped Image!

Do you recall the opening words of the introduction: "There is not a single high dynamic range image published in this book despite the title"? I meant it then, and I mean it now! Once you tone map your 32-bit high dynamic

range image into either 8- or 16-bit space, it is no longer a high dynamic range image. Feel free to tag your tone-mapped images with "HDR" or "SEO" on the Web, but do realize that your tone-mapped image is a high dynamic range image in the same way that a T-bone steak is a cow. Running a 32-bit image through tone mapping is a one-way operation. It is not commutative. You cannot reconvert your tone-mapped image back to 32-bit space and expect to regain the full gamut of luminosity and color values of the original high dynamic range image any more

than you can turn that T-bone steak back into a living, breathing, mooing cow. (Apologies to vegetarians, but saying "a living, photosynthesizing, crunchy carrot" just doesn't have the same ring to it!)

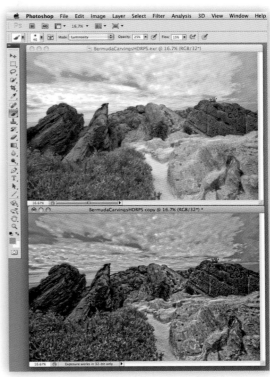

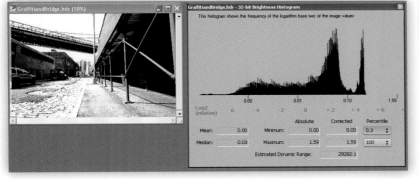

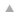
Here is a 32-bit high dynamic range image merged from seven shots at 1.5 EV spacing. Notice the numbers on the HDR histogram, and note the estimated dynamic range of 29,282:1.

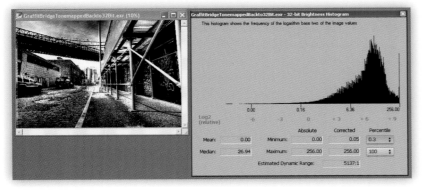

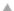
And here is a tone-mapped LDR output image from this HDR image file, which was then reconverted back up to 32-bit space in Adobe Photoshop. Notice the numerical range and estimated dynamic range of this "pseudo-HDR".

At top is a 32-bit HDR image merged from six bracketed source images. This image's dynamic range is much higher than the image below it, which is a duplicate of the top image that has been run through Photoshop's **Image > Adjustments > HDR Toning** command. This command can be used on images of any bit depth and returns the tone map image to the original bit depth. So, in this case, it applies true tone mapping to the HDR image and returns it to 32-bit space. But it is now an LDR image with 32 bits per channel with a significantly smaller dynamic range than the top image. And it will still need to be dropped down in bit depth for printing and web sharing, which may shift the image during bit depth conversion, depending on how this is achieved. **HDR Toning** can be useful in some situations, but it is also a little confusing. Generally, tone mapping in Adobe Photoshop CS5 should be initiated via **Image >Mode > 8-** or **16-bits/channel**.

But now check this out: You *can* apply tone mapping recursively to the LDR output image to accentuate color and pull up even more detail and contrast—but you are now working on a "pseudo-HDR" just as if it were a single-shot straight from your camera, and all of the color values of the tone-mapped image now live in the low dynamic range space of 0, 0, 0 to 255, 255, 255 values.

**8-BIT OR 16-BIT CONVERSION?**   If your primary concern is for speed, and your primary purpose of tone mapping is for Web-exclusive display, you'll be fine saving file space and processing time by converting to 8 bits per channel. But if you are most interested in the best-quality files for printing and display, tone map to 16-bit space, and then shed bits and pixels from your 16-bit file for Web sharing. Bit depth locations vary from program to program, but every title I explore offers Save options for both 8- and 16-bit filetypes. ■

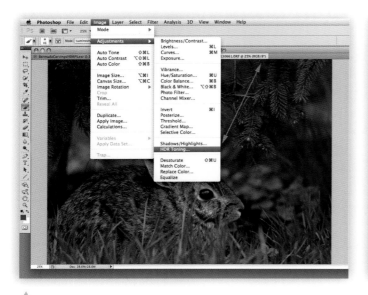

▲

HDR Toning can be applied to any image of any bit depth—in this example, a single shot in 8 bits of some little bunnies.

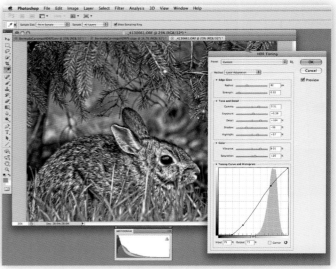

▲

HDR Toning launches the HDR Toning dialog box and pulls the image up to 32 bits per channel for processing. The script running behind this command returns the image to its original bit depth after you click OK. For pseudo-HDR work, this is okay, and it has its place, but for hard reassignment of bit depth, stick with the Image > Mode > x bits/channel path.

So, now you understand that we must tone map a true high dynamic range image to compress it to low dynamic range space. And then it is no longer an HDR after tone mapping.

However, we can also tone map low dynamic range images—and this does not make these pseudo-HDR images by any stretch of the imagination, since they were LDR images put into a process that outputs LDR images. Got that? HDR or LDR images can be crunched through a tone mapper, and the result is always an LDR image.

Enough with theory and caveats—let's actually get tone mapping!

## Tone Mapping High Dynamic Range Images with Adobe Photoshop CS5

There are three tone mappers in Adobe Photoshop CS5 that don't offer too much in the way of user-input options, but they can be very useful for different circumstances, in particular when "soft mapping", as discussed in chapter 7, has been applied to your HDR image and the intent is to shed bits without significantly altering the image data. And then there is the fantastic new Local Adaptation tone mapper that has seen its first significant upgrade since it arrived in Photoshop CS2! In addition to the "Curves with Corners" interface that has been brought forward from earlier versions, there are now several additional slider-based adjustments that allow for fantastic control over detail, compression, vibrance, saturation, and more. The Local Adaptation tone mapper is powerful–and now in CS5—simple as well. An obvious advantage of tone mapping with Adobe Photoshop CS5, for existing owners of the program, is that there is no additional software to purchase. Even better is that the layers and brush techniques we explored in the previous chapter have migrated to CS5, whereas in previous versions, these were exclusive to the Extended version.

### Build Yourself Some Keyboard Shortcuts

The preferred way to launch into tone mapping in Photoshop CS5 is by dropping bit depth—either through the **Merge to HDR Pro** window during the HDR-gen processes we looked at in Chapter 5 or, when a 32-bit file is the active image in the main Adobe Photoshop work space, using the command path Image > Mode > x Bits/Channel.

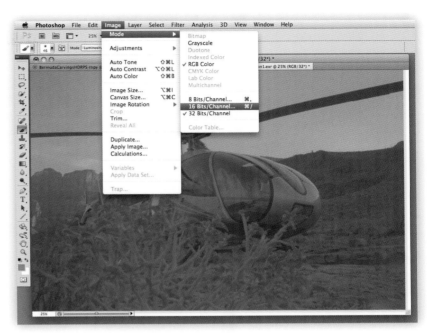

 Drop bit depth from **32 Bits/Channel** to **8 Bits/Channel** or **16 Bits/Channel** to launch the **HDR Toning** window. And notice the keyboard shortcuts for dropping bit depth to 8 or 16? These are custom shortcuts—not built-ins.

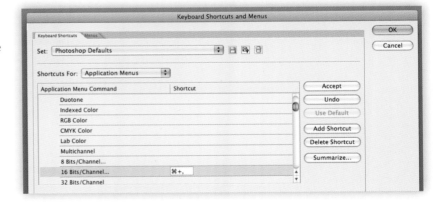

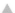 **Edit > Keyboard Shortcuts** gives you a list of every command and function in Photoshop. Simply drill down to **Image > Mode 16 Bits/Channel**. I've assigned CMD+, (CMD/CTRL and the comma key) since this shortcut is unassigned. Click **OK** and you've got a quicker way to launch tone mapping to 16 bits per channel.

I also want to make a keyboard shortcut for the mode change to 8 bits. But there are not a lot of keystroke commands in Photoshop that aren't already assigned. I hardly ever use CMD+/ to pull up Help, so I'm not concerned about overwriting this shortcut and I don't even bother reassigning Help. Now I've got two keyboard shortcuts to tone map my HDR image files in Photoshop—saving on mousework! (This particular shortcut is a conflict on Macs, but not PCs. You can make your own keyboard shortcut for dropping bit depth or any other function using this same menu, and it will always give you a warning if there is a conflict.) If you are repeatedly doing any operation in Photoshop, it is well worth the time to make a keyboard shortcut for it!

## Photoshop's "Boring" Global Operators

The three conversion methods Exposure and Gamma, Highlight Compression, and Equalize Histogram offer few or no user options. Despite that, there may very well be times when a simple, "boring" conversion to low dynamic range space is all you want. Always make sure Preview is checked!

## Exposure and Gamma

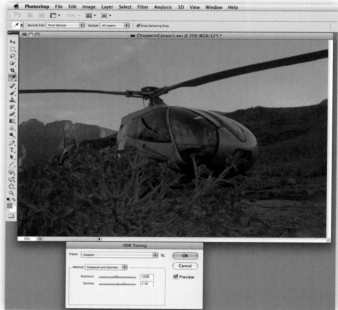

Dropping the bit depth either via Image > Mode > x Bits/Channel or directly from the Merge to HDR Pro window launches the HDR Toning window. The top setting in the drop-down is Exposure and Gamma. There are two sliders that act very similarly to (and just as boringly as) the Brightness/Contrast controls in normal bit space. Positive gamma values give a lower appearance of contrast and can pull more tonal information into the screen gamut, and negative gamma values give higher contrast and can introduce more clip at both ends. Positive exposure settings brighten the screen display, and negative values darken the screen display. And if you have Exposure and Gamma set as your 32-bit Preview Option under the View menu, you can adjust your settings before even launching the HDR Toning window for dropping bits. What you see on-screen is what you get—and that's it.

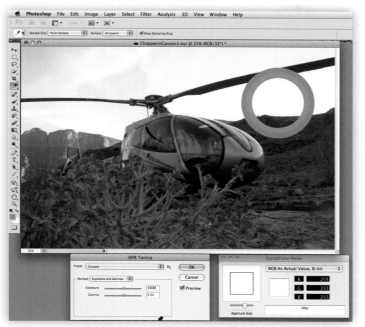

What you see on-screen is what you get! Values can be clipped at either end of the low dynamic range histogram. And the whole point is more, not less detail! **Exposure and Gamma** is good for previewing 32-bit data on your monitor and also as a "low-impact" method for shedding bits after "soft mapping" in Photoshop and/or HDR PhotoStudio.

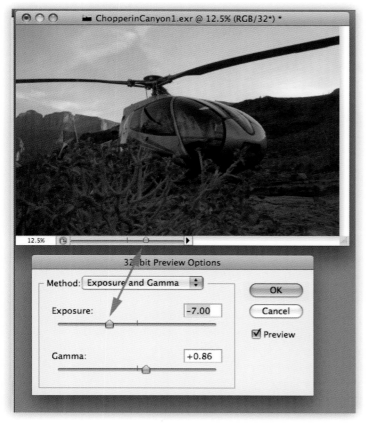

The **Exposure and Gamma** settings set under **View > 32-bit Preview** are "sticky". These will be the active settings when you drop bit depth, which is handy. And adjusting these settings under **View > 32-bit Preview > Exposure and Gamma** and saving the image in 32 bits will permanently reassign the white point that was set in Photoshop during HDR merge, or will help bring images merged in other programs into an on-screen display in gamut. The white point slider on the image itself is per view and not sticky.

## Highlight Compression

The HDR Conversion window states, "*There are no options for this conversion method*", but this is only partially true. Remember that under **View > 32-bit Preview Options** you can choose **Highlight Compression** instead **of Exposure and Gamma** as your HDR workspace. It is true that you can't tweak any sliders in the HDR Conversion window, but you can make any or all of the global and local adjustments we explored in chapter 7, in effect, to hand-tone the image. And all the while, the **Highlight Compression** algorithms are working automatically in the background and updating the tone map settings to preserve and protect the overall tonal range of the high dynamic range image. Whether or not you make local or global tweaks to the 32-bit file, you may need a fair amount of post-processing when using the **Highlight Compression** conversion method to make the image pop with contrast. When dead-on photorealism with an extended luminosity range is the primary and paramount goal, **Highlight Compression** is a wise route.

## Equalize Histogram

When using the simple tone mappers, it's a good idea to minimize the **Local Adaptation** drop-downs to keep the dialog box compact.

There are no options, and no live preview in the normal Photoshop workspace for the **Equalize Histogram** global operator. **Equalize Histogram** simply attempts to crunch all of the data from the HDR image file into the lower bit space with decent bell-curve-like distribution. It gives the output images good overall contrast pop, but when using this basic tone mapper you are likely to encounter shadows that are nearly blocked and blotchy and highlights that are nearly clipped with many of your high dynamic range images.

## Local Adaptation: Photoshop's Local Operator with a Cornered Curve Control and Lots of Sliders

**Local Adaptation** is the most powerful tone mapper in Adobe Photoshop CS5. As the name suggests, this is a local operator, and there is an amazing degree of control over image detail, contrast, and tonal range compression given by both the ACR-style sliders and the very powerful 32-bit curve controller. But it's not your normal Photoshop curve—there's a straight-line twist, in addition to the normal fluidic curves workflow. This is the most significant upgrade to HDR toning since CS2, and the new feature set is a much-appreciated addition to CS5.

▲ **1**

Select **Local Adaptation** from the drop-down menu, and if you minimized the window earlier, you'll have to click each pointer to expand all the controls.

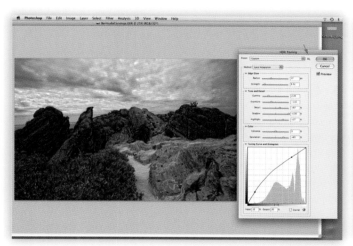

▲ **2**

If you've saved presets for tone mapping, click on the mini-menu to activate them. The **Radius** value in the **Edge Glow** commands will shift depending on the dimensions of the image, if **Default** is selected as the preset. **Edge Glow** is what Adobe is calling luminance masking and halo effects. If you crank either **Radius** or **Strength** up very high, you will probably notice shifts in the luminance masking near and along high-contrast edges. A smaller **Radius** is sharper, while a larger **Radius** is smoother. I generally leave these at or near the pre-loaded default settings. Those who are familiar with earlier versions of the **Local Adaptation** interface will appreciate the very light image tweaks via the **Curves** interface in this example. So much of the heavy lifting can now be accomplished via the slider-based controls. And if you like, there are a host of stylized presets pre-loaded into HDR Pro in CS5.

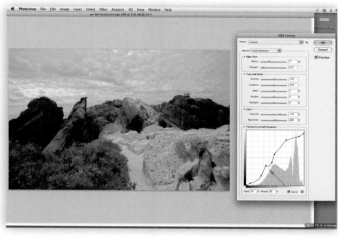

▲ **3**

If you want to do most of your work using the **Curves** interface, like older versions of Photoshop, you can! You can click to add as many control points on the curve as you want. Do you notice that there are a few straight-line segments in this curve? These are possible because of the **Corner** option. Click on a highlight point to activate it, and check the **Corner** box to get locked, straight-line segments that won't twist and change settings once you've locked in the values for a certain area of the image. The **Corner** function can be particularly effective for pinning down very localized tweaks when the sliders just can't pinpoint your specific area to be adjusted. (If you decide to go straight into bit-drop tone mapping in the **Merge to HDR Pro** dialogue box, **Curves** is accessed via a toggle-tab with **Color**.)

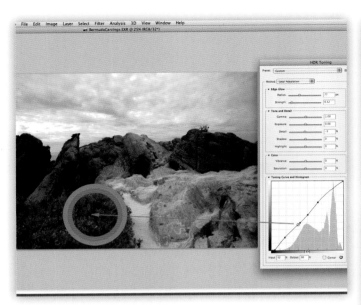

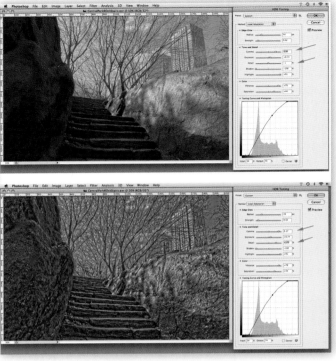

▲ **4**

Right-clicking the eyedropper allows you to change sample size from point, up to 101 x 101, and new for CS5 is the giant eyedropper orbiter to help you flesh out where you are in the image. The open circle on the curve indicates where on the graph the eyedropper is sampling. And a **CMD+click** locks the point on the curve. This is an excellent addition to the HDR toning process.

▲ **5**

Gamma and Detail in the **Tone and Detail** control area can be used together or separately to really accentuate microcontrast detail. As with the **Gamma** controls in **Exposure and Gamma**, positive gamma values bring more of the overall tonal range into the screen display gamut, and **Detail** really pulls fine detail out wherever it finds it. Negative values for **Detail** have a soft-focus effect, particularly along edges, and the effect can be muddy at times. All settings except **Gamma** and **Detail** are identical between these two images.

◀ **6**

Once you pull all the tonal range into the image via **Gamma** and get comfortable with the level of detail via **Detail**, tweak the overall image exposure via **Exposure**, **Shadow**, and **Highlights**. If anything goes out of screen gamut with **Exposure**, adjust the **Gamma** and **Detail** settings again. And don't be afraid to add some contrast snap or a midtone pop on the curve!

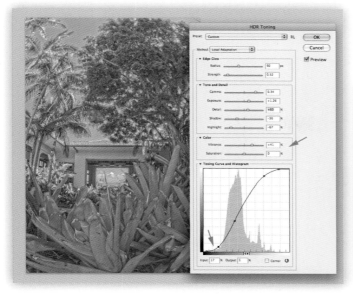

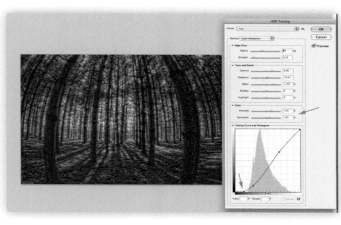

▲  ▶  **7**

**Vibrance** and **Saturation** both impact overall color, but in different ways. **Vibrance** affects only the primaries—red, green, and blue—while **Saturation** impacts the full spectrum. These two can be used together or seperately to crank up or tone down color during tone mapping. Notice the wide variations on these settings between these two screenshots, and it should be clear that this is something that must be experimented with. Many HDR images may need a black point set, as the pine tree example shows. And many HDR shots will benefit from a varation on the classic S-curve, as the tropical example illustrates. And of course, just as you can load in presets from the mini menu, you can save your favorite settings too. When you are happy, click **OK** and that's all there is to it!

Anyone who has tone mapped shots in earlier versions of Adobe Photoshop will be very excited by how much easier it is to make sharp, strong, crisp images in this new interface!

## Tone Mapping with FDRTools Advanced 2.3

FDRTools Advanced has a more fluid and commutative workflow than any of the other programs we explore when you are working straight from the bracketed source files and not a previously saved 32-bit file. When the bracketed source images are loaded into FDRTools, you can switch between HDR generation and tone mapping on the fly to adjust tone map settings or HDR merge settings at any time. When you are working with a 32-bit HDR image file that has been loaded into FDRTools, you do lose the back-and-forth functionality. In either case, there are two interesting tone mappers in FDRTools Advanced: *Receptor* and *Compressor*. There is also *Simplex*, but this is a basic exposure/gamma tone mapper controlled by a curves control that is best for quick ballparking, and not for nuanced tone mapping.

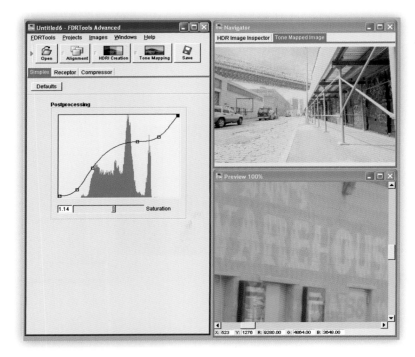

## Tone Mapping with Simplex

To launch tone mapping in FDRTools, click the **Tone Mapping** button on the main interface window. (If you are in **Projects**, click **Edit** to launch into the HDR workflow interface first.) The **Navigator** will automatically switch from the HDR Image Inspector view to the Tone-Mapped Image view, and **Simplex** will be the active tone mapping tab.

**Simplex** is a very basic tone mapper with just a curve control and a saturation slider. You have a little more control with **Simplex** than you do with Adobe Photoshop's **Exposure and Gamma**, but this is a very basic tone mapper.

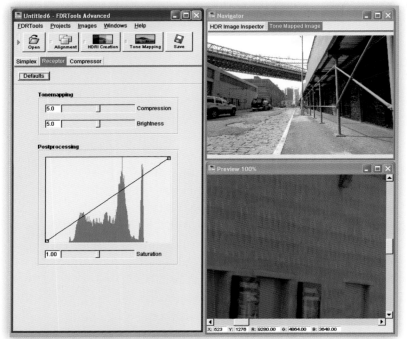

## Tone Mapping with Receptor in FDRTools Advanced

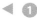

**Receptor** is the global operator in FDRTools Advanced 2.3. **Receptor** can make tone-mapped images that hold smooth detail without looking overly worked up. In fact, you will often want your LDR output file to appear very flat to bring the most information into your normal image editor for some final adjustments.

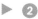 **②**

Use the **Compression** slider to control dynamic range compression—the higher the value, the more compression applied. **Brightness** should be obvious—this adjusts the image brightness. **Saturation** can be adjusted from complete grayscale (0.00) to hyper-vivid (2.00). And the curve can be adjusted to add both global and local contrast depending on the number of control points added. Use the curve control to fine-tune detail, but don't feel the need to completely tighten the curves to match the black and white points on the histogram. If you leave the image on the flat side, you have more information to work with in your traditional image editors for post-production work to add contrast pop.

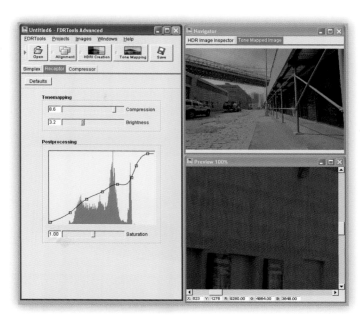

## Tone Mapping with Compressor in FDRTools Advanced

**Compressor** is FDRTools Advanced's local operator. This versatile tone mapper is very effective at crunching very wide dynamic range images into the LDR space—and it can do so with an emphasis on gritty details, smooth gradations, or a combination of the two.

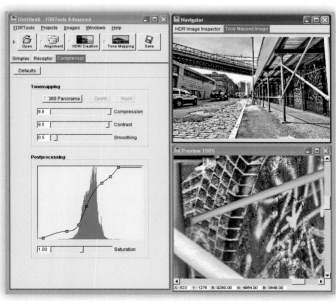

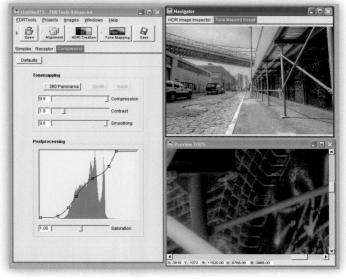

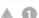 **①**

**Compressor** can pull amazing detail from HDR image files while simultaneously maximizing overall contrast and snap. Compare this with our earlier results with this same HDR image when we used **Simplex** and **Receptor**. Also found on the **Compressor** tab, **Contrast** and **Smoothing** are another of the high/low setting pairs you will discover.

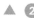 **②**

Notice what happens when I swap positions of the **Contrast** and **Smoothing** sliders.

Let's get away from this street scene and instead visit a mansion in Newport, Rhode Island, on a nice spring afternoon. Here is an example of how high dynamic range imaging with a pro-level camera makes an impossible vacation shot a reality. I was shooting with an ultrawide lens to capture this tea pagoda—and this meant I was shooting right into the sun! Doesn't it always seem to happen like that when you're on a touring vacation?

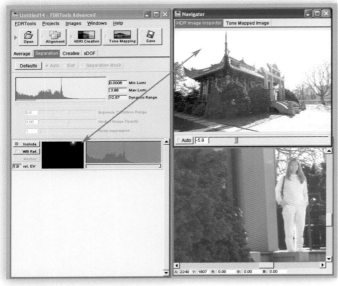

**1**

Here we are looking at the high dynamic range image. There's good detail on the subject and the pagoda, but the sky is completely bald. But check out the thumbnail. I've got a lot more information in this image than is seen on-screen.

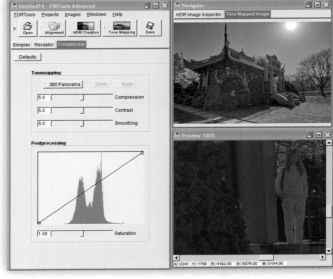

**2**

Click **Tone Mapping** and select the **Compressor** tab. The default setting of **Compressor** immediately makes the tone-mapped image look much better than any of the single source images.

**3**

I'm going to crank **Compression** almost to maximum. The wider the dynamic range of the scene, the higher this slider can be pushed, generally speaking. And I'm in a detail-priority mood, so I crank **Contrast** way up and **Smoothing** way down. And yes, the image does look a little more flat than before.

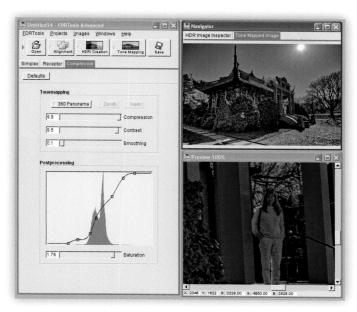

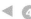

◄ **4**

Let's move down to the **Postprocessing** controls. Here I want to tighten the black and white point of the serpentine curve to line up with the histogram and boost some local contrast. And since I was shooting into the sun, I boost saturation to make the color palette much richer.

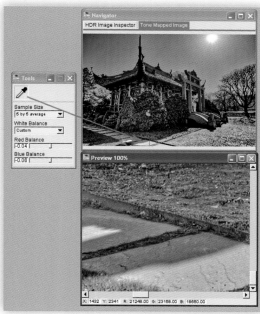

▲ **5**

Let's experiment with the **White Balance** tool found under **Windows > Tools**. Click the **Eyedropper** and select **Point Sample**, 3 by 3 Average or 5 by 5 Average as the **Sample Size**, and click anywhere in the **Navigator** or **Preview** window to set that as the white point reference. Here I've selected a 5-by-5 patch on the shadowed flagstone in the **Navigator** window—but it's just not right.

▲ **6**

So, next I try a patch of flagstone in the sunny part of the **Preview** window, but this still isn't quite right. I can also manually input red and blue values via the sliders or numeric inputs, if I want.

◄ ⑦

After experimenting, I decided that the camera and FDRTools did a fine job of determining the neutral values, so I revert the **White Balance** setting to **As Shot**.

▲ ⑧

Ghosting isn't always a bad thing. A gull in flight during the burst sequence is a visual haiku in the sky in this tone-mapped image. The dust spots in the sky, on the other hand, will be cleaned up in post-processing.

◄ ⑨

Once you are content with your tone map setting, click **Save**. Choose a save location, a descriptive file name, and a file type. I always save as 16-bit TIFFs for the highest-quality output image.

You will see one more screen before your image is actually saved. This confirms the save-to location of your tone-mapped LDR image, along with the file type and any file-type-specific options. You can check or uncheck **write metadata to LDR** to keep basic image size metadata. Checking the lowest box to launch the tone-mapped image right into your normal image editor for final adjustments is a very useful option.

### IS THIS ONE OVER THE LINE?

I've pushed up saturation and compression pretty far with this output image. In your opinion, is this tone mapping job close to the line or over the line? Is this image more or less realistic than a single shot from the series with undersaturated colors and a totally bald sky? As you learn how to use the HDRI workflow, ask yourself why you choose to use it, and how you feel about the effects. ■

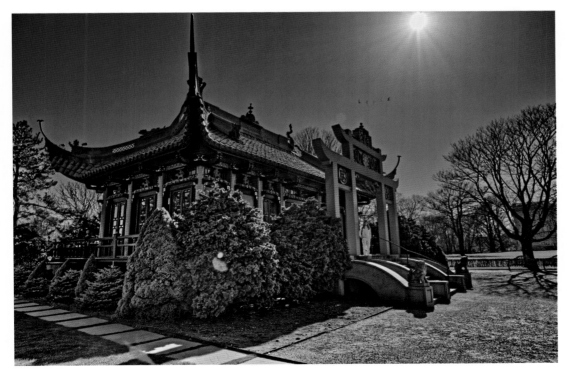

After experimenting, I decided that the camera and FDRTools did a fine job of determining the neutral values, so I revert the **White Balance** setting to **As Shot**.

## The FDRTools Advanced Photoshop Plug-In

Just before deadline for this edition, FDRTools released a new version of the FDRTools Photoshop plug-in with an even more detailed interface that will migrate to a future build of the stand alone FDRTools Advanced. This plug-in is a separate download from the standalone program, but the same license key works for both versions. Download it and add it to Photoshop's Filters folder and reboot Photoshop to activate. You've got to have an HDR image open in Photoshop to employ the plug-in version of FDRTools. In other words, it isn't a merger—just a mapper.

◄ ❶

Once the plug-in is installed and a 32-bit file is active in Photoshop, launch the FDRTools "filter" via **Filter > FDRTools > FDR Tools Compressor** and you'll see a window that's not too different from the standalone version. But there are some cool new differences, especially with **Compressor**. Notice that the curve **Postprocessing** control points can now be fluid "spline" curves, or point-to-point lines. (But unlike with Photoshop, it is only one or the other—not both). And the new interface response to pushing and pulling the black and white points is interesting, as the points remain stationary but pull the graph. Try it and you'll see.

◄ ❷

Notice the arrows near **Contrast** and **Smoothing**? These two settings can also be tweaked and twisted as splines or lines to completely fine-tune microcontrast effects to your HDR image, if the basic sliders leave you wanting or needing a bit more control. When you are satisfied with your settings, click **OK** to return your image to the main Photoshop working space.

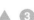 **3**

Your FDRTools settings will be applied, but your image will still be a 32-bit image, and sometimes the exposure level may be a bit high or low when it returns to Photoshop. Just go to **View > 32-bit Preview Options** and zero out **Exposure** and it will be back to where it was and where you want it.

 **4**

Now it is right where you want it with **Exposure and Gamma**. And from here, you can go to **Image > Mode > 16 bits/channel** and convert this image to 16 bits via the **Exposure and Gamma** method just as it appears on-screen.

## Tone Mapping with Photomatix Pro

Photomatix Pro 3.2.7 packs two slider-based tone mappers, one global and the other local. Both offer a great degree of control for fine-tuning your tone mapping. Photomatix Pro features a highly readable, real-time histogram refresh. Pay attention to how each adjustment affects the histogram and you will begin to understand tone mapping in a much more visual way.

In addition to these two true HDRI tone mappers, Photomatix Pro offers several *Exposure Fusion* methods. The *Exposure Fusion* methods are not true HDR processes, as there is never a 32-bit high dynamic range image involved

in the process. Instead, these *Exposure Fusions* methods analyze the low-bit pixels of the source images and blend the LDR pixels based on different formulas. There aren't nearly as many sliders or options, but sometimes, these simple low-bit methods may be all you may need for dynamic range optimization.

### Tone Compressor: Photomatix Pro's Global Operator

*Tone Compressor* in Photomatix Pro is a global operator. Don't be confused by the fact that FDRTools's **Compressor** is a local operator! *Tone Compressor* can help you hold detail over a wide dynamic range with the subtle and generally low contrast output typical of global operators.

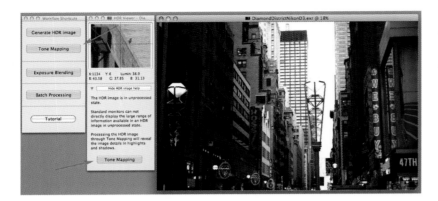

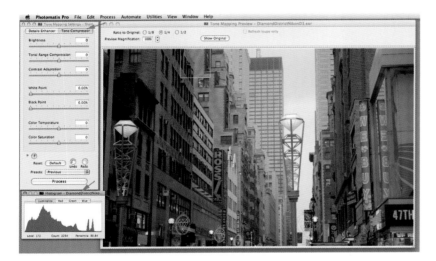

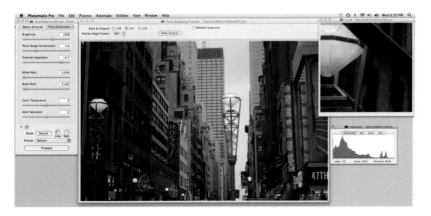

◀ **1**

To get started, open or generate a high dynamic range image in Photomatix Pro. Click the **Tone Mapping** button on the **HDR Viewer** or **Workflow Shortcuts** window, select **Process > Tone Mapping**, or simply press **CMD/Ctrl+T** to launch into the *Tone Mapping Preview* windows.

◀ **2**

Click the **Tone Compressor** button to use this global operator. Select a preview size if you want to scale the image. Clicking anywhere on the preview launches a pop-out full-resolution preview window. The Histogram window should automatically launch, but if it doesn't, you can find it under **Window > 8-bit Histogram.**

◀ **3**

Photomatix Pro is all about the sliders. **Brightness** affects both the image brightness and the tone map settings. **Tonal Range Compression** obviously controls how the HDR data is squeezed into the smaller bit space. The higher the value, the more compression applied. **Contrast Adaptation** impacts the overall HDR contrast. Push and pull **Contrast Adaptation** to extreme values to get a feel for this effect, which can be subtle or potent depending on the particulars of your HDR image.

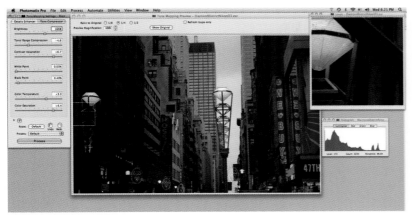

If you think you'll want to use these tone map settings again, you can save them in *Extensible Metadata Format* (XMP, with a filename extension of .xmp) from the **Presets** drop-down menu. But maybe you want to wait until you actually see the output image. In either event, click **Process** to apply the current settings.

**Color Temperature** can be adjusted along the blue/yellow axis. Negative values shift blue, while positive values shift yellow. **Color Saturation** can be amplified with positive values, or the image can be turned to completely desaturated gray tones with negative values. There's so much information in every high dynamic range image. How you interpret it is up to you! But I decided to go back to the setting I have shown in the previous figure before clicking **Process** to create my *Tone Compressor* tone-mapped image.

If you're very happy with the output image, you may now want to save the tone map settings in XMP format under **File > Save Settings**. And from the same drop-down menu, you can save your tone-mapped image for sharing or final editing in your full-service editing program.

 **7**

After I saved the image in Photomatix Pro, I pulled it into Adobe Camera Raw for some minor contrast tweaks for print optimization.

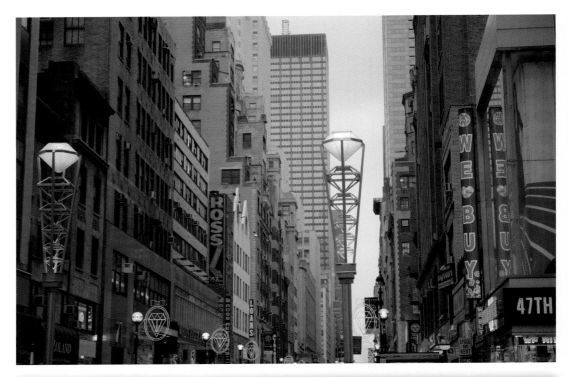

Note: With the Details Enhancer method, the loupe only shows the level of details enhancements. Showing the correct brightness requires processing the entire image.

▲ **8**

The loupe on the left shows a detail of this scene tone mapped with *Tone Compressor*, a global operator, while the loupe on the right shows the same section of the image with *Photomatix Pro Details Enhancer*, a local operator. Notice the differences between the two tone mappers.

## Tone Mapping with Details Enhancer in Photomatix Pro

The *Details Enhancer* tone mapper in Photomatix Pro is a very powerful and feature-packed local operator. It is great for pulling up detail and textures. It can really kick things up a notch—and the results can range from photorealistic, surrealistic, fantastical, and beyond. It is easy to go overboard with *Details Enhancer*—particularly when you are trying to overcompensate in tone mapping for underbracketing the capture data. There are many sliders and settings to keep track of. It can be a little confusing at first, so pay attention to the mouse-over descriptions to help illuminate the purpose of a setting. Launch or generate an HDR into Photomatix Pro to get started, and then switch into tone mapping as I explained in the preceding section.

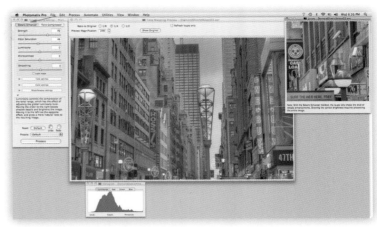

At the top of the Details Enhancer interface are five sliders. **Strength** adjusts the overall HDR compression. The higher the number, the more compression. **Color Saturation** adjusts the overall saturation levels (saturation can be tweaked differently for shadows and highlights in one of the lower tabs too). The higher you push the **Luminosity** value, the brighter the shadows become, along with increased local contrast. Higher **Microcontrast** values emphasize detail, particularly when combined with very low **Micro-smoothing** settings, which can be found hiding behind the **Miscellaneous settings** drop-down arrow.

---

### I DON'T UNDERSTAND THE MOUSE-OVER TIPS!

Yes, a lot of the descriptions of settings and sliders in Photomatix Pro and other HDR programs aren't always perfectly clear. High dynamic range imaging is a young technology, and it is first and foremost a visual and mathematical technology. It is not always easy to describe each function or setting with words—and that's why the descriptions can sometimes seem vague and circular.

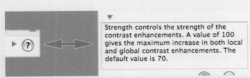

Strength controls the strength of the contrast enhancements. A value of 100 gives the maximum increase in both local and global contrast enhancements. The default value is 70.

Photomatix has consolidated all mouse-over tips into a collapsible window in the Tone Map Settings dialog box. If you want to see the tips, click on the arrow next to the question mark or atop the tips window to expand or hide the box. ■

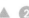

**Smoothing** can range from *Very Low* (far left) to *Very High* (far right) and controls the smoothing of contrast variations throughout the image. Checking or unchecking the **Light mode** box switches **Smoothing** from a slider to a series of preset buttons. There's no real difference between the sliders or buttons, except for the interface.

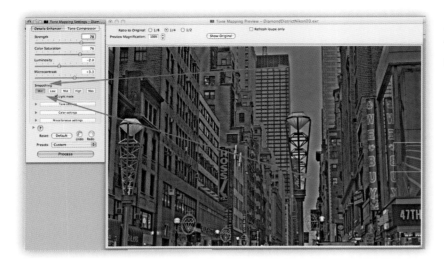

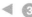

The *Very Low* setting should usually be avoided, as the results are often not pleasing.

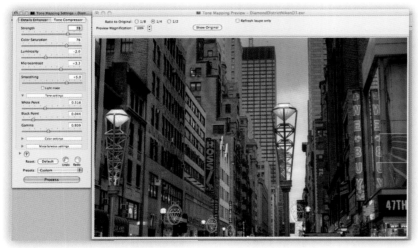

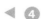

The three sliders at the bottom of the *Details Enhancer* interface—**Black Point**, **White Point**, and **Gamma**—are hiding behind the **Tone settings** drop-down arrow. Use these just as you would the Black, Mid, and White Point controllers in a regular histogram control to increase or decrease global contrast. Note that with Photomatix, a Gamma value greater than 1 darkens the image.

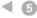

The **Color settings** drop-down arrow allows you to access controls to adjust the overall color temperature of the image along the yellow-blue axis. Positive values on the **Temperature** slider shift toward yellow. **Saturation Shadows** and **Saturation Highlights** adjust the saturation in the darker or brighter areas of the image, respectively. These settings are independent of the global saturation setting above the histogram, and even when the **Color Saturation** slider at the top of the *Details Enhancer* interface is set to minimum, boosting either of the **Saturation Shadows** or **Saturation Highlights** sliders will enhance local saturation.

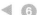

The **Miscellaneous settings** drop-down arrow hides a couple of cool sliders. **Micro-smoothing** affects and adjusts microcontrast. Push **Micro-smoothing** values to the right for less "gritty" detail enhancement. **Highlights Smoothness** and **Shadows Smoothness** smooth details and edge contrast in the highlight areas and shadow areas, respectively. Higher **Shadows Clipping** settings push more of the darker pixels toward the black point and can be used, in moderation, to help distribute pixels throughout the full low-bit histogram.

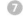

Photomatix comes preloaded with four presets. You can also save and load in your own from the **Presets** drop-down. Clockwise from top left: **Natural**, **Smooth Skies**, **Painterly**, and **Grunge**.

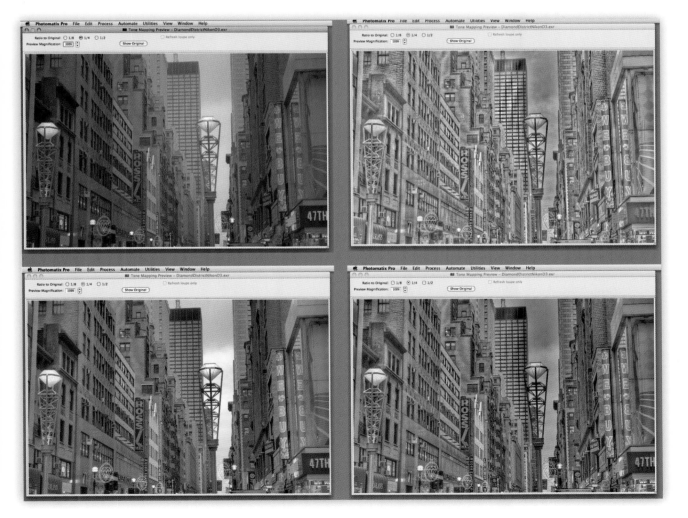

▲ ⑧

A few global adjustments in post-production and here's the *Details Enhancer* version of this image. Compare this with the *Tone Compressor* version. (See image 7 on page 160 for two variations on the same image. Which do you prefer? Why?)

## Exposure Fusion in Photomatix Pro

You may want to try these **Exposure Fusion** methods in Photomatix Pro. It's not a true HDR process, but it can sometimes do the trick of boosting dynamic range in a single output image from your multiple source images in a pleasing way.

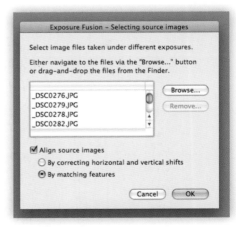

▲ ②

Alternately, clicking **Process > Exposure Blending** will launch the **Exposure Fusion – Selecting source images** window. Browse to your source files. (In this example, I am importing seven shots.) Choose an **Align source images** setting, if desired, and click **OK**.

 ①

Under *Preferences* in Photomatix, you can change the behavior when you drag and drop multiple files into Photomatix Pro to **Open the files only, Generate HDR,** or as we will do here, **Blend exposures** automatically if the **Bypass dialog** box is checked.

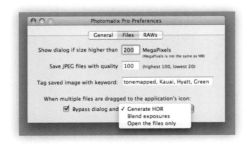

◀ ③

**Average** (top) is obvious: it averages each pixel-point value. **Highlights & Shadows – Auto** (middle) is obvious too. It is automatic. If you don't like it, you can't adjust it.

◀ ④

**Highlights & Shadows – Adjust** has some tone-map-like sliders. **Accentuation** controls the strength of local contrast adjustments. **Blending Point** controls the weighting of the over- and underexposed pixels toward the output image. **Shadows** adjusts the brightness of the shadow tones without affecting the mid or highlight tones. **Color Saturation** impacts overall image saturation. **White Clip** and **Black Clip** set black and white points for increased or decreased contrast, but these settings can cause values to be clipped, so use with caution. Negative **Midtones adjustments** add contrast "snap" and positive adjustments make the image flat.

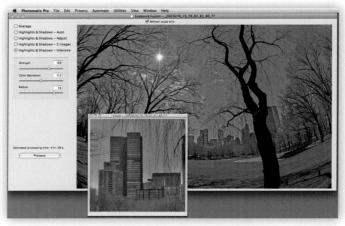

**Highlights & Shadows – 2 images** allows you to select any two (but only two) source images to be blended from thumbnail previews.

When using **Highlights & Shadows – Intensive**, consider checking the box on the preview window to set **Refresh loupe only**. It will definitely save you redraw time. This Exposure Fusion method is called "intensive" for a reason. Look at the estimated processing time! **Strength** controls the local contrast power, **Color Saturation** boosts or minimizes the overall color, and **Radius** adjusts the range of the contrast enhancement. Higher values tend to work best with both **Strength** and **Radius** for this processor.

When you are pleased with the preview, click **Process**. I went with **Highlights & Shadows – Intensive** for this seven-shot blend and went and refilled my coffee while the processor chugged away! (In fairness, the program does warn that the *Intensive* process is very time-consuming!) I added just a touch more contrast and sharpness in Adobe Camera Raw.

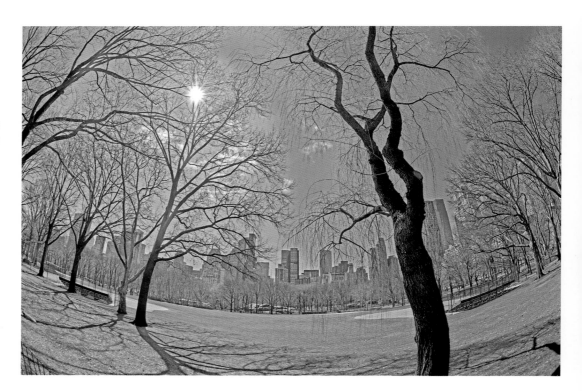

## Bit-Dropping and Tone Mapping with HDR PhotoStudio 2

As explained in Chapter 7, HDR PhotoStudio differs from the other programs we explore in Practical HDRI insofar as there is no bit-depth-dropping tone map operation that must be applied to the image to convert from 32-bit to lower bit spaces. In other words, you've got the entire HDR PhotoStudio 2 toolkit to apply to your HDR image. Then you can either save in 32-bit space and tone map in the other programs or convert your onscreen image to lower bit spaces. This sounds easy, and it really, honestly is, although there are a few pitfalls to avoid

along the way. The most important difference between working in HDR PhotoStudio to save back to 32-bit HDR space and bit-dropping is to ensure that once you have applied all your image adjustments, you've got a zero value for Display Brightness. It is possible to clip highlight and shadow values if you aren't mindful during bit depth conversion with HDR PhotoStudio because what you see on the screen is what you get—once you factor in the Display Brightness. Let's take a look at three images that appear virtually identical on-screen and what happens when we save as a 16-bit TIFF with different combinations of Display Brightness and image settings.

▲ ➊
Looking at this image in the HDR PhotoStudio window, it looks really good on-screen, but you'll notice our Display Brightness is at -3 EV (the slider at the lower-left of the screenshot), and in the **Brightness/Contrast** window, the **Brightness** slider is set to +3 EV. When saved as a 16-bit TIFF, it appears pretty overexposed, as you can see in the image at bottom.

▲ ➋
And here again, the image looks like a normal exposure, with good tonal range compression, within the HDR PhotoStudio window. But notice the Display Brightness here is set to +4 EV (the slider at the lower-left of the screenshot), and in the **Brightness/Contrast** window, the **Brightness** slider is set to -4. And as you can see, the lower-bit output file, when saved, is quite underexposed.

▲ ➌
And now it is just right! Display Brightness is set to zero, so I can push and pull and adjust the image. And when I save it to lower bit space, I don't have to worry about dramatic shifts in the exposure range between the on-screen display in HDR PhotoStudio and the output file in low-bit space image editors.

Saving your HDR image to lower bit spaces is easy: just select TIFF or JPEG from the Save As menu.

If you select TIFF, be sure to select 8 or 16 bit. A 32-bit TIFF file will be huge on your hard drive if you accidentally click on 32 bits. You can also embed an ICC profile at this point.

Choose **File > Save As** to save your image, whether it is to 32-bit or lower bit space. Your low-bit options are TIFF and JPEG.

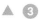

If you select JPEG, select a quality. I always go for the highest-quality JPEG because it can always be scaled down farther, but you can't really gain it back. Again, you can embed an ICC profile if you want at this stage.

HDR PhotoStudio 2 can be a great choice when photo-realism is the intention, but the tools in HDR PhotoStudio can also help push your images to extremes. For example, the ability to apply Local Contrast Power adjustments to your HDR image a couple of times before dropping bit depth can really, really pull up local contrast and detail.

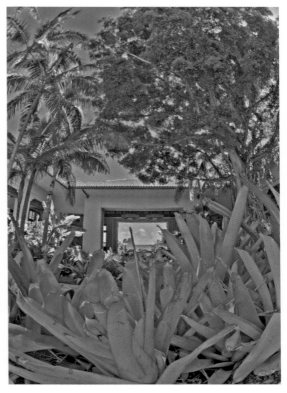

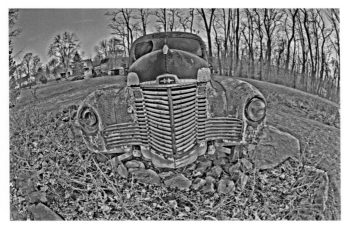

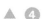 **4**

Recursive application of **Local Contrast Power** adjustments and **Shadows & Highlights** really allowed me to crank up the fine detail in this image. It also created some halos in the background that were tamed, but not eradicated, with the **Reduce Halo Artifacts** command.

 **5**

HDR PhotoStudio's toolkit also allows very photo-realistic results. If photo-realism is your goal, HDR PhotoStudio has a lot to offer.

## Dynamic Photo HDR: Tons of Tone Mappers and More!

Dynamic Photo HDR packs seven tone mappers. The first three are local operators, and the next four are global operators. If seven methods for tone mapping aren't enough to get you excited, Dynamic Photo HDR packs a ton of fun, functional, and funky buttons, sliders, and presets to help fine-tune your high dynamic range visions. Hold on tight, here's a whirlwind tour of some of the coolest features packed into every possible space of the tone map window. (And by the time you read this, Mediachance may have added a few more tweaks!)

## The Tone Mappers

Create or open an HDR image file in Dynamic Photo HDR to follow along in this walk-through of the Tone Map HDR Image interface.

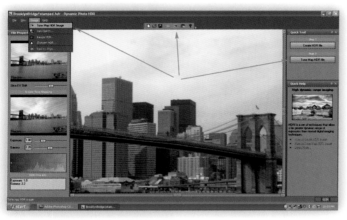

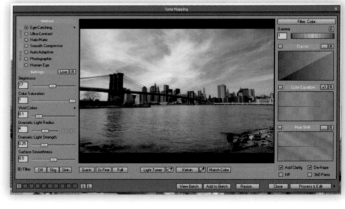

 **1**

Launch the **Tone Mapping** window using one of the following three ways: Click **Image > Tone Map HDR Image**, *or* click on the eyeball and triangle icon, *or* click the **Tone Map HDR File** button on the **Quick Tool** window.

 **2**

Notice that there are a large number of buttons, sliders, curves, and controllers all around the preview? We'll get to all of these eventually. Note that "R" buttons reset to company defaults, and small right-pointing triangles indicate a pop-up option. I will start in the top-left corner. There are six buttons for the seven different tone mapping methods. This window always launches with **Eye-Catching** method active.

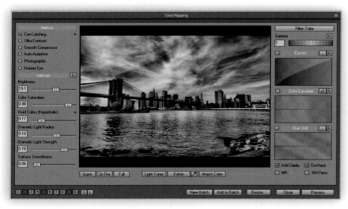

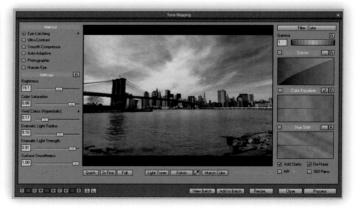

 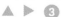 **3**

**Eye-Catching** is a local operator that can create smooth or ultra-detailed output images with great compression of the HDR data depending on the settings selected. **Dramatic Light Radius**, **Dramatic Light Strength**, and **Surface Smoothness** work together to make smooth or gritty local contrast enhancements.

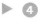 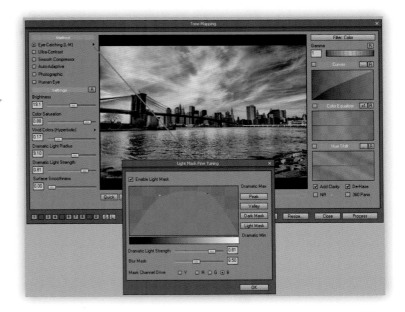

Notice the right arrow next to **Eye-Catching**. Clicking this and selecting **Light Mask Settings** causes the **Light Mask Fine Tuning** window to pop-up. You can adjust the curve via presets or direct input, increase or decrease **Dramatic Light Strength** and **Blur Mask**, and even select a color channel for the masking. "Y" stands for the Lightness/Luminosity channel—not yellow!

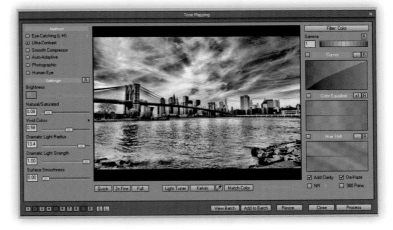

**Ultra-Contrast** is the second local operator in DPHDR. As the name suggests, it really cranks up contrast on all scales—from micro to macro. Think big with **Ultra-Contrast**: it is far from subtle!

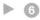 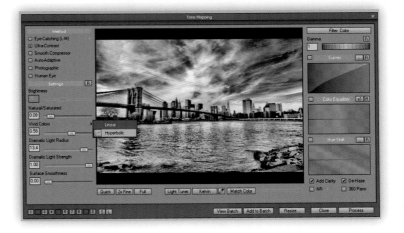

Notice the small right arrow on **Vivid Colors**? In both **Eye-Catching** and **Ultra-Contrast**, this setting can be Linear or Hyperbolic.

**Halo-Matix**, as you may have guessed, is a local operator that strives to emulate the grunge and ultra-saturated feel of the Details Enhancer TMO in Photomatix Pro.

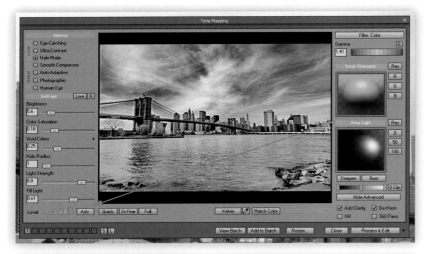

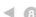

Be sure to click the **ADV.** (advanced) button when you're using **Halo-Matix** to launch the two orb controllers to really crank up the edge detail and contrast masking. These orbs and all the orb controllers throughout DPHDR are really intuitive and need to be experimented with to understand how they quickly and powerfully change image characteristics.

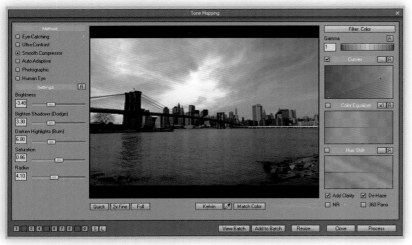

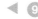

**Smooth Compressor** is a global operator that produces smooth, photorealistic images. Just don't go overboard with **Brighten Shadows (Dodge)** and **Darken Highlights (Burn)** or you may run into tonal inversions that look very hokey. Notice that I activated the **Curves** control for additional adjustments.

There are not many options with **Auto-Adaptive**. It is a global operator that produces smooth output images that do not have an overworked feel.

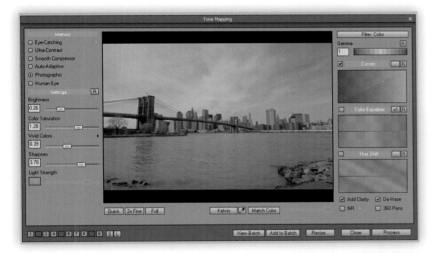

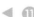

The **Photographic** global operator strives to emulate the feel of emulsion.

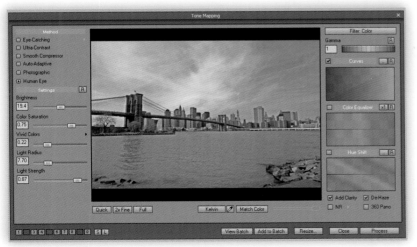

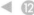

Like the global operators in some other programs, **Human Eye** attempts to map the HDR data as the rods and cones of human vision would.

## A Host of Features, Buttons, Orbs, Presets, and Whatnots

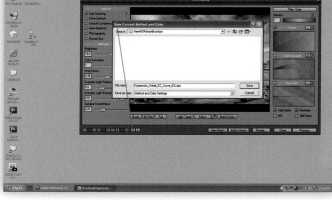

If there is a setting you think you want to use frequently, just click one of the blank squares to make it a numbered preset. But note that these shortcut buttons ignore the settings on the controls on the right side of the frame.

To save the **Curves**, **Color Equalizer**, and **Hue Shift** settings, click **S** to save it to a safe location on your hard drive. Click **L** to load in previously saved settings.

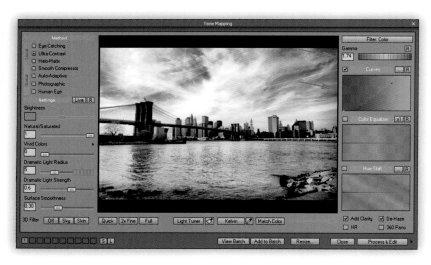

Use **Curves** and **Gamma** together and alone to increase or decrease contrast and overall image brightness. **Gamma** functions very much like a brightness control in DPHDR, with a more subtle effect on overall image quality characteristics than in Photoshop CS5.

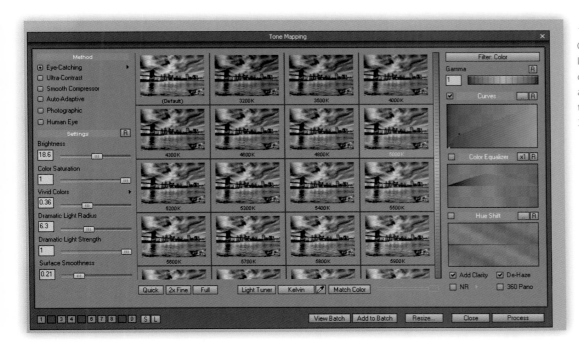

◄ **4**

Clicking the **Kelvin** button launches thumbnail previews of custom white balance adjustments in Kelvin temperatures from 3200K to 30,000K.

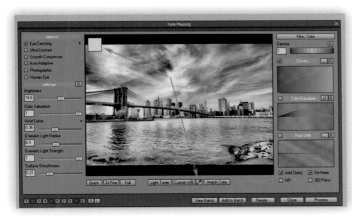

▲ **5**

If you cannot find a Kelvin temperature, the **Eyedropper** tool can be used to sample points on the image. The thumbnail preview at top right shows the target neutral from the **Eyedropper**'s sample.

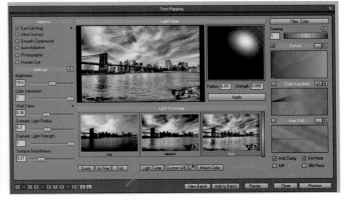

▲ **6**

With either the **Eye-Catching** method or the **Ultra-Contrast** method selected, try out the **Light Tuner**. It is an orb-based controller. Spinning it changes the image's pixel qualities in various ways. You have to try it out to understand it.

 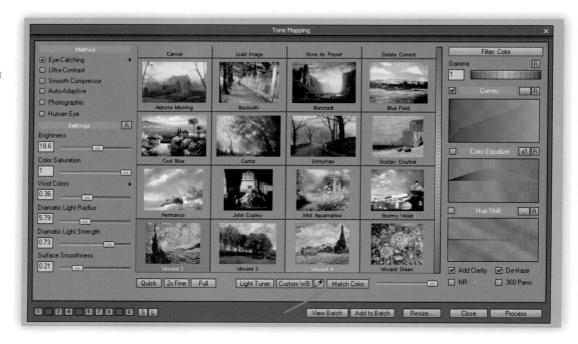

Match Color throws a number of artistically stylized presets at your HDR image file. Find your inner Van Gogh or Courbet!

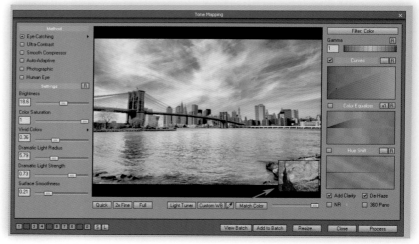

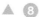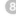

Here I threw **Vincent 2** (*Starry Night*) at this shot of the Manhattan Bridge. I kind of see it, do you? Either way, you do see that button on the upper-right labeled **Filter: Color**, don't you? Let's see what's behind this door!

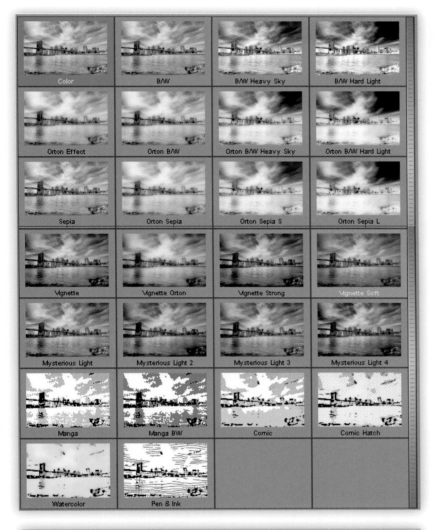

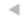

There are tons of presets in both color and monochromatic options along with illustration styles to choose from under the **Filter** button.

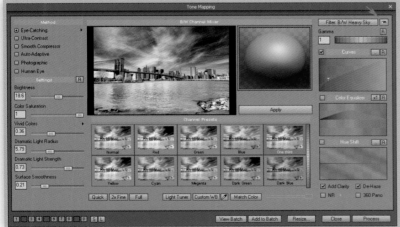

The **Filter: Color** button brings up a wide selection of monochrome filters from which you can choose (including sepia tones). You may click the **Eye** button to launch the orb-based **B/W Channel** mixer. If the orb scares you, try one of these thumbnail presets.

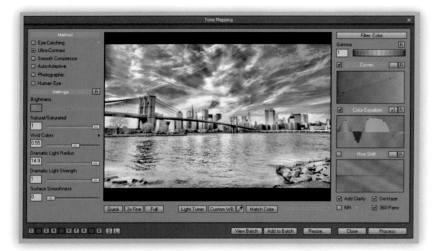

 The **Color Equalizer** can be used to amplify or subdue tones for either artistic or pragmatic effects. Here I was just having fun to show the effect; however, using this tool can minimize chromatic aberration by isolating and desaturating certain areas of the spectrum. It takes some experimentation to find the setting that will work for your specific lens, but once you find it, save it! (Step 2 in this section shows you how to save it.)

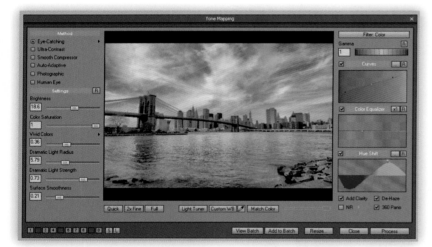

 **Hue Shift** can likewise be employed for subtle fixes or, as shown here, for dramatic duotone-style effects.

 The **3D Filter** buttons (lower-left in window) are specifically for tone mapping images with big skies or people in the scene. At left, the **3D Filter** for the sky is off. At right it is on. Give this and the **Skin** filter a shot with your own images to see which effect you prefer.

Checking **Add Clarity** and **De-Haze** (lower-right) should minimize the fuzzy haze that is oftentimes seen in tone-mapped images. Clicking the **NR** button activates **Noise Reduction**, and clicking the right-pointing arrow launches the **Wavelet Noise Reduction** window to adjust the settings. Checking **Simulate T-M** emulates tone mapping. The X and Y dials navigate the preview. The slider controls the noise reduction amount. Checking **Compare Before/After** splits the view to show the effect.

With so many sliders, adjustments, and options, how do you keep track of your tweaks? Simple! With samples! Just click on the image at any time and a pop-up sample window will appear. Experiment away. All it takes is a single click back on the sample view to make those settings active.

 When you are using **Eye Catching** or **Ultra-Contrast**, notice the little paintbrush icon beneath the image. This is also called a **Light Brush**.

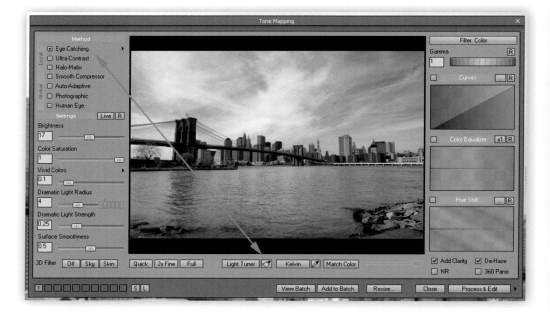

This paintbrush allows you to paint on, or erase, the active tone map settings into various areas of your image. The **All to High** and **All to Low** buttons allow you to prefill the whole image and paint the effect in or erase it from certain areas. **Remove All** resets the window to the original settings. **Cancel** crashes the window without applying the effect, and **OK** applies the effect. I have painted on **Ultra-Contrast** effects to the left half of this image, indicated by the two red arrows.

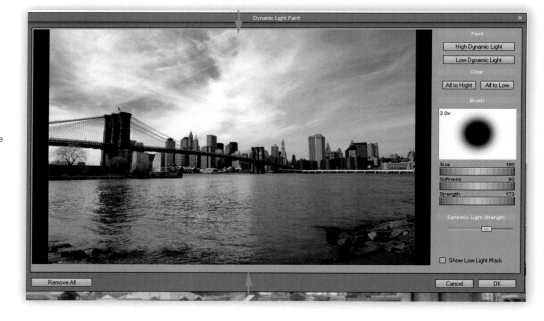

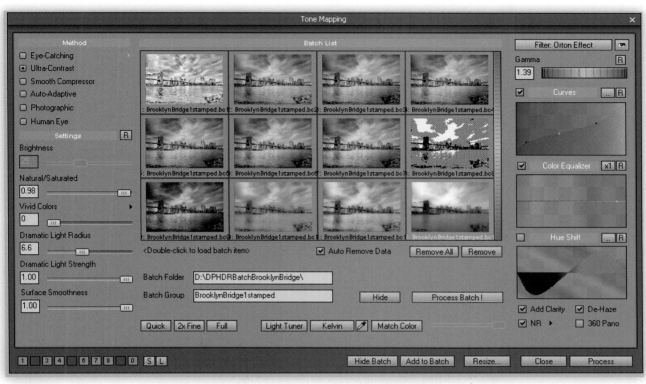

**18**

With so many possible ways to tone map in DPHDR, it's great they've added a batch processor. Click **Add to Batch** (at bottom of window) to queue images into the processor. Select a destination folder and away you go. Click **Process Batch!** to start processing. Click **Hide** to go back to the main tone mapping window.

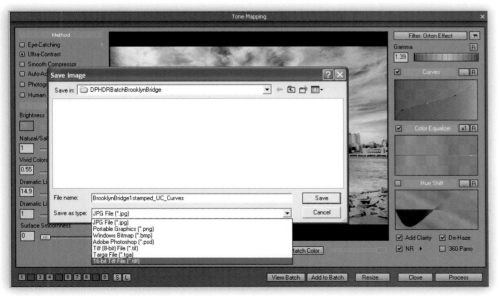

**19**

If you just want to save one tone-mapped output image, click **Process and Save** and route to a save location. Give your output image a descriptive file name for both the subject and the tone map style and select a file type— I always save as 16-bit TIFFs for maximum image quality.

## Little Planet via Process and Edit

If you've noticed, there's a small arrow next to Process and Save that converts this button to Process and Edit. When Process and Edit is selected, DPHDR will create your tone-mapped image and launch into Mediachance's Photo-Bee image editing software. There's your normal stuff in Photo-Bee—resize, crop, and so on—but there's also the really fun Little Planet command. This takes your tone-mapped landscapes and cityscapes and turns them into polar projections that look like tiny little worlds.

As you can see, before I tone-mapped this shot taken from the top of the Arc de Triomphe, I copied and flipped the image to make a wider, mirrored HDR source image. You do have to make sure the horizon is perfectly equal on both the right and left sides of the frame for best results, whether you want to mirror your world or not. Click Process and Edit to launch Photo-Bee.

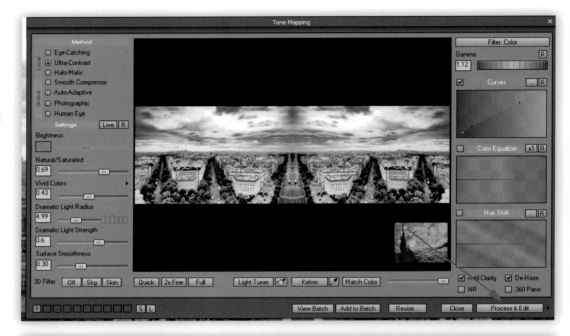

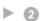

Adjust > Little Planet launches the Little Planet interface.

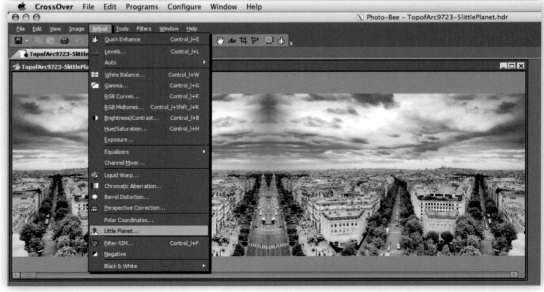

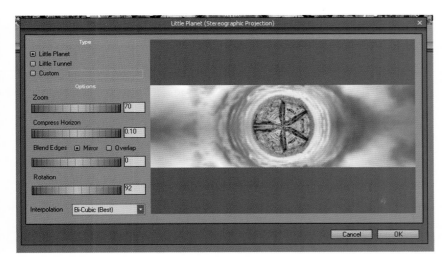

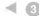

Most of the time, you'll want **Little Planet** checked, but give **Little Tunnel** a try as well. And **Custom** allows you to adjust the stereoscopic projections anywhere between the two poles for different effects. **Zoom** will scale your "planet" up or down at the center of the frame, and **Compress Horizon** adjusts the vertical scale of the sky—whether it is literally or figuratively a sky. Under the **Blend Edges** control, either **Mirror** or **Overlap** may be the better option depending on your scene; give them both a shot and experiment with the dial to nail down your blend point. And **Rotation**, obviously, spins the planet around the center of the image. Once you've made your adjustments, click **OK** to bring it back into **Photo-Bee**, save it as a TIFF or JPEG, and you've made your own little HDR world.

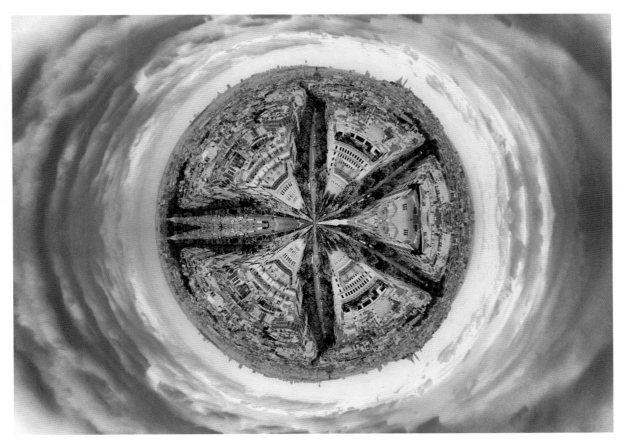

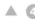

I cropped the sides of the image to make a squarer frame, and here's my Parisian little planet! And that was a whirlwind tour of the amazingly featured tone mapping window of Dynamic Photo HDR!

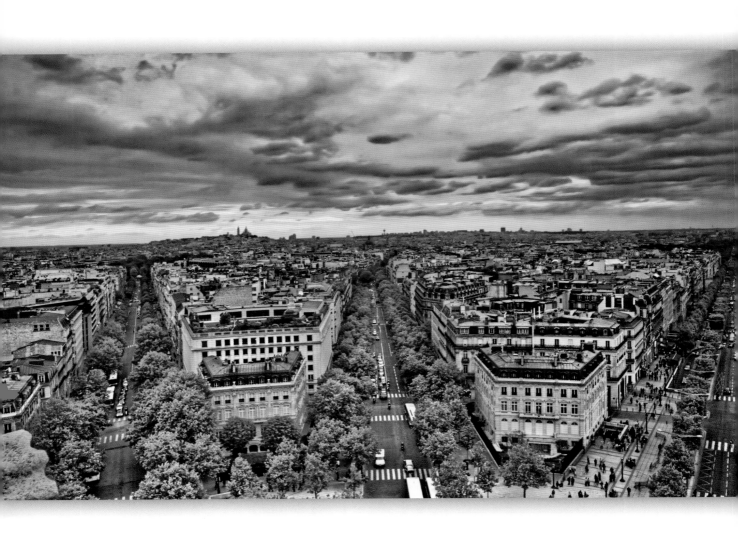

# 9
## Post Tone Mapping Image Optimization

Every photographic image will benefit from a degree of output-specific optimization—and this includes tone-mapped low dynamic range output images from high dynamic range images. In this chapter we will look at both global and local adjustments of LDR output images in low-bit image-editing programs. Our two main goals are polishing and showcasing the tone mapping process along with avoiding some common—but easily fixed—problems you may encounter after tone mapping. I advocate always saving the tone-mapped image as a 16-bit TIFF to have the highest-quality original to optimize for both print and Web sharing.

## Post-Tone Map Tutorials that Make No Sense to Us

I've lost count of the number of tutorials on high dynamic range imaging that leave me baffled once I am beyond the tone map step because of all the localized layer masking, pasting, erasing, and other old-school exposure blending steps involved. It's not that I get lost or confused with the processes, and it's not that layer masking and selective revealing of different source image pixels is exactly rocket science. It's just that it is an arduous, old-fashioned process. Why bother with source image merging and 32-bit tone mapping at all if you simply wanted to manually blend image layers with airbrushes in Photoshop? It doesn't make a lot of sense to me! We *will* briefly explore a style of a manually built adjustment layer, but don't worry—this is almost all global. There's not a lot of airbrushing or outline tracing to get us frustrated along the way.

For RAW-style global adjustments, we will use Adobe Camera Raw 6 (ACR) since it is bundled with Adobe Photoshop CS5. Keep in mind that Adobe Lightroom, Apple's Aperture, and a couple of other programs can also be used for nondestructive RAW-style image optimization—and therefore, you may simply adjust the workflow tips to each program. We'll put the final touches on our images in Adobe Photoshop CS5—and many (but not all) of the tips and tricks from both ACR and CS5 can be translated to Adobe Photoshop Elements or other economical image editors with a little experimentation—if you are on a tight budget.

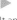

It amazes me to see HDR tutorials that end up utilizing traditional layers and masking to blend the tone-mapped output image with one or more of the original source images. Why even bother with tone mapping then?

We start with three issues than can cause trip-ups and disappointment even when your images need very little adjustments or post-processing optimization.

---

**WHICH WAY TO THE EXIF?**   If you haven't yet noticed, there might be some wacky stuff happening in your EXIF info. Maybe it gives the info for a single shot from the series, maybe it is showing 1/100 @ f/1 at ISO 100, or maybe it all is blank. There is no standard for how EXIF info is handled during HDR generation or tone mapping—yet. Still-image HDRI is currently at the toddler stage, but I'd like to see some uniformity in the handling and preservation of EXIF data to reflect both the merging and tone mapping processes. (This is why I suggest top-loading the folders and filenames with descriptors.) Once you are past the tone mapping stage, you can add your own keywords, captions, location, and such, as explained in chapter 4, but you probably can't easily add or append the camera data. ■

## Three Big Issues with Tone-Mapped Images

**PLAIN VANILLA IMAGE FILES—WITH A TWIST:**   Once your 32-bit high dynamic range image has been down-sampled to 8 or 16 bits via tone mapping, it is, for almost all intents and purposes, a plain vanilla image file—the same as if it were a single file straight from the camera. Yes, the multi-file merge to high-bit space to expand the dynamic range coupled with the tone mapping process to preserve and translate the extra luminance information is now represented in that 16-bit TIFF or 8-bit JPEG, but where do all the color values live? That's right: somewhere within the old-fashioned low dynamic range (0, 0, 0 to 255, 255, 255) limits.

And once it is opened in any flavor of Adobe Photoshop, or Lightroom, or Aperture, or Corel Paint Shop Photo Pro X2, or iPhoto, or Google Picasa, or any other low-bit image-editing program, it can be tweaked, cooked, and treated just like any straight-from-the-camera image with the full array of tools available in each program. Everything you've got in your bag of tricks for the digital darkroom can be thrown at your tone-mapped image—sharpening, blur, selective desaturation, cloning tools, artistic filters, type mask overlays—you name it, you've got it!

These files can be shared online or printed—at home or through a digital lab—just like every other photo on your hard drive. But there are three main issues with tone-mapped output photos from high dynamic range images that you should pay particular attention to: color profiles, histogram spread, and gamut warnings.

## Color Profiles

Every program handles color profiles slightly differently, but most allow you to assign a color profile to images either at the import stage or later as a drop-down menu command. Quite simply put: Make sure the tone-mapped image is assigned to the color profile space you normally work in. I'll reckon that more than 95% of the readers of this book will be working in Adobe RGB or sRGB color space and are achieving good print and monitor display results with their traditional images and their normal workflow—whether it's the ultra-scientific "eyeballing and dead-reckoning method", a system that

has been completely calibrated every step of the way, or somewhere in between.

So it's a simple matter of making sure your tone-mapped images aren't saddled with a Wide Gamut or ProPhoto color profile (or some other profile that's not Adobe RGB or sRGB—unless you usually work in these niche spaces). And here's the thing: Some of these other color spaces will look okay on your monitor—particularly in programs that natively support them—but you're likely to get major disappointing shifts when posting online or sending to a printing service.

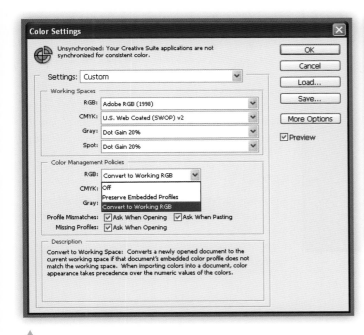

With Adobe Photoshop CS5, the easiest way to ensure that your photos open within your preferred color space is to set the **Edit > Color Settings** command to the working space of Adobe RGB (or sRGB if you prefer). Then select **Convert to Working RGB** under **Color Management Policies.**

It is also a good idea to check both of the boxes under embedded **Profile Mismatches** and the box for **Missing Profiles** (shown checked in the previous image) and you'll get a prompt to convert to the working RGB each and every time there's a conflict with color spaces. This method is particularly handy when copying and pasting from different files for montages, photo illustrations, and such.

Opening images through Adobe Camera Raw into Photoshop allows you to assign either of these profiles by clicking on the **Color Space and Image Size** info line under the ACR preview window.

Color management in Adobe Photoshop Elements is both simple and confusing. Under **Edit > Color Settings**, it appears to allow only sRGB, Adobe RGB, a choice of either sRGB or Adobe RGB, or no color management. The top button, **No Color Management**, discards embedded profiles. The second button, **Always Optimize Colors for Computer Screens**, converts the image to sRGB. **Always Optimize for Printing** converts the image to Adobe RGB space. **Allow Me to Choose** appears to offer two choices: sRGB or Adobe RGB.

So it appears at first glance that Elements only offers these two RGB profiles, but if you read the tiny type, it actually states that it will preserve embedded profiles, if supported, and both ProPhoto RBG and Wide Gamut RGB are actually supported! Don't get tripped up on this!

## Histogram Spread

Remember the photo of the buffalo in the blizzard way back in the introduction? I had to spread the histogram to normalize the exposure and make it appear less flat for presentation and printing purposes. Strangely, the same thing is often true of high dynamic range images after tone mapping. All those extra EVs of exposure get crunched down to the traditional bit depths, and depending on the particulars of the image and the tone mapping settings, it is not uncommon to have blacks that don't start until the 10s and 20s and whites that wander to the edge of detail perception in the 230s and 240s. Some people may actually like the ultra-flat, low-contrast feel of these shots, but for the rest of us it's a good idea to normalize the histogram before publishing on the Web or sending to a printer. And again, this can be done in Adobe Camera Raw, in any flavor of Photoshop, in Aperture, in Lightroom, and so on. It's a simple matter of tightening up the histogram via **Levels** or **Curves** controls to push the black and white points closer to where the usable data starts. And you'll want to do this yourself rather than leaving it to the mini-lab. Trust me on this one.

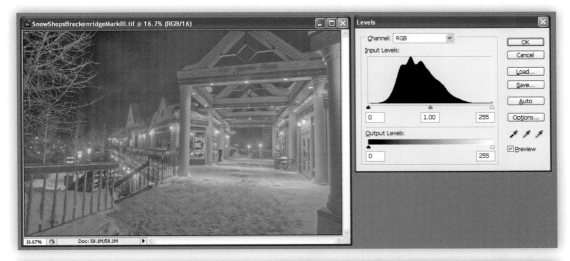

◄ **1**

I used FDRTools Compressor to tone map this image and am happy with the compression in regard to detail and luminance preservation; however, a quick look at the histogram shows that the tone mapping process fails to produce a definitive black and white point.

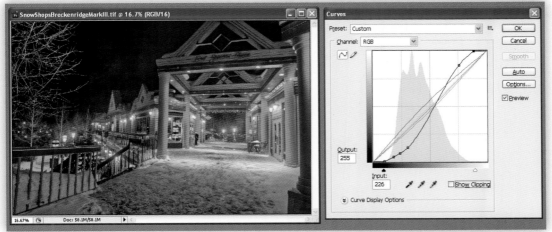

◄ **2**

I now switch to **Curves** for some fine-tuning. Not only do I define the black and white points and add a classic contrast-boosting S-curve, I also spread the channels out a touch to make truer neutrals and build midtone color depth.

But if you really want flat images without true blacks and whites, leave the histogram cramped in the middle and away from the black and white points. Be sure to tell the folks at your lab to print straight from the data, without adding any of their own decisions on snap, contrast, and overall brightness spread. In any event, it is always a good idea to find out what your digital image processor's preferred color space is and whether they offer custom profiles. Many high-end pro labs employ Adobe RGB as their preferred color space and may actually have several specific profiles available for download. The vast majority of mass-consumer digital kiosks such as those found in big-box warehouse clubs, pharmacies, and supermarkets work in sRGB because that is the default color space of most compact digicams—which represent the biggest percentage of their business. Plan accordingly and match your profile to the output device for optimum results!

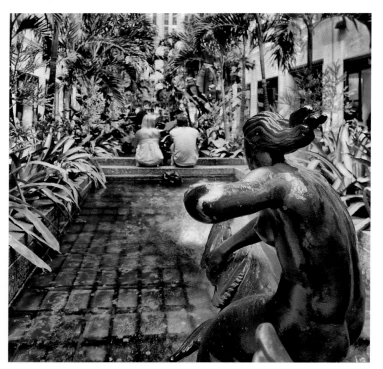

## Ultrasaturation, Hypervividity, and Gamut Warnings

Quite simply put, *gamut* is the range of colors that can be represented in a given color space. Your monitor is an additive color model (throw all the primary colors of light together equally and you get bright white: 255, 255, 255), while your prints are a subtractive color model (slop a ton of cyan, magenta, yellow, and black together and you'll get a dingy shade that's the print equivalent of 0, 0, 0). Even the best printers with multiple shades of the primary subtractive colors of cyan, magenta, yellow, and black will never be able to match the full range of colors on a decent computer screen because your monitor is direct light and a print is simply reflected light. (Bear in mind that it is as impossible to accurately illustrate this in book form as it is for you to turn to the next page and see a video how-to pop-up window since this book is, after all, based in a subtractive color model.) As with the data crunch from 32 bits back down to traditional bit space, some compromises may have to be made when preparing a tone-mapped image for print output.

◀ ①

Of the normal bit-space image editors I mention throughout this book, Adobe Photoshop CS5 offers the most robust set of options for exploring and discovering out-of-gamut colors—which can be quite a challenge for the HDR photographer who prefers the ultrasaturated, hypervivid style. Those eye-popping colors can often quickly fade to dingy and drab during printing.

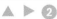 **2**

The option **View > Proof Setup > Custom** allows you to select your "soft-proof" profile from a huge list of CMYK profiles. Then select **View > Proof Colors** for a CMYK preview. I have my system set up to simulate my Epson 2200 printer on matte paper as the working CMYK.

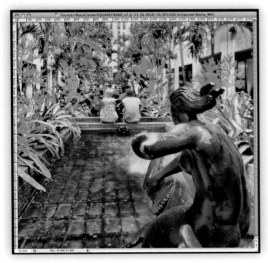

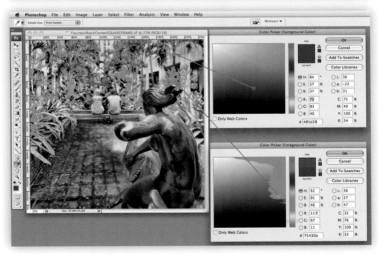

 **3**

The option **View > Gamut Warning** will gray out all the colors that can't be reproduced in the active CMYK profile space. This is helpful, although don't be fooled into thinking that your bright green will be substituted with gray!

 **4**

Now, click on the foreground color in the CS5 toolbar to bring up the **Color Picker**. Hold down your mouse button and scroll over the areas that are grayed out when showing the **Gamut Warning**. Any time you see the warning sign ⚠ this is an out-of-gamut color. Directly beneath this is the swap-out color that will be substituted. And the little cube? That indicates it is also not a Web-safe color and shows the browser swap-out color. Notice the gray areas in the lower **Color Picker** window? Selecting **View > Gamut Warning** will overlay the out-of-gamut colors with a gray tone when the **Color Picker** is the active command window.

Sometimes the color change is negligible, but sometimes it's a horrendous shift! In a nutshell, the print gamut depends on the color space of the source image and the rendering engine selected in your image editing program.[1] In practice, it is much more of an issue with printing than with online sharing.

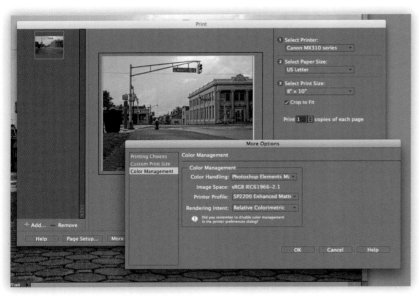

Adobe Photoshop Elements does not offer a gamut-warning function, so you are flying a little blind with what is in and out of print gamut. Elements actually does support a number of RGB color spaces, including Wide Gamut and ProPhoto RGB, and can handle 16-bit files created during the tone mapping step, but there's no CMYK space and no soft proofing. Next, let's look at a paper- and ink-saving workaround from the days of yore, which I've adapted for the digital age. This will work with any image-editing program and home printer and will help deal with printing the hyper-saturated style of tone-mapped images—regardless of gamut-warning and soft-proofing options.

---

[1] Entire books are dedicated to color management from start to finish, and I highly recommend Brad Hinkel's *Color Management in Digital Photography: Ten Easy Steps to True Colors in Photoshop* (Rocky Nook, 2007).

## Rekindling the Wet Darkroom Days: Digital Test Strips

Back in the time of the dinosaurs, computer screens were monochrome. I'm not even talking shades of gray here: each pixel was either black (off) or white (on). Photorealistic computer-based imaging was something from the sci-fi movies. We had to dodge pterodactyls on the way to our local photography shop to buy stinky chemicals and papers coated in silver halides, and we would burn hours upon hours in cave-like darkrooms working on the perfect print.

The materials for making a wet photographic print were expensive, and if you had your exposure and developing times and settings not quite right, it produced a costly mistake. And that's why test strips were a big part of the wet darkroom workflow.

A test strip is nothing more than a piece of photo paper cut into several long pieces. In this way, one piece of 8math" x 10" paper can become ten 1" x 8" test strips (or eight 1" x 10" strips, for that matter). And by picking a cross-section of the negative that covers most of the tonal range of the image, one single piece of photo paper could be used ten times over to fine-tune the exposure and developing times, with the only loss being a single sheet of photo paper instead of ten!

For reasons we cannot understand, in the digital age, the concept of test strips seems to have gone the way of the brontosaurus. Message boards are rife with photographers griping about burning through costly supplies of ink and printer paper in the quest for the perfect print. And more often than not, these frustrated printers are throwing away stacks of costly paper and milliliters of ink along the way.

Why not make digital test strips instead? Now, before you break out the paper cutter and

Create a new, blank document that matches the printable area of the selected paper and ensure that it is the same pixel dimensions as your desired print image—10″ x 8″ at 360 dpi in this example. Set the marquee tool's **Style** option to **Fixed Size** and choose **1″ x 2″** (or whatever size you want). Select and copy a section of the image that may present some problems and/or covers a good sampling of the overall tonal range of the scene. Paste it into the top-left corner of the new target document.

Repeat the preceding procedure with three other selections from the source image, pasting each below the previous one, until you've got a 1″ x 8″ column of source image samples in the target document. Then flatten the target image by selecting **Layers > Flatten Image**.

slice your Photo Quality Glossy paper into ribbons, hold on! Your printer probably can't feed slim strips through, so we do have to make some adjustments for the digital age. The end gain is the same, though: creating the perfect final print while minimizing ink and paper loss. And the cool thing about digital test strips is that you are not limited to a contiguous slice of the image. You can pick and choose areas of the image that will be the most potentially problematic with some simple selections and copy/pasting into a new test strip document. There are two ways to go about this: all at once, or by making adjustments after reviewing the previous test

strip print. But in this way, one piece of paper can be used to test, in an economical fashion, whether you want more contrast, less contrast, a saturation boost, out-of-gamut color shifts, and more.

At this point, you *can* send this target document to the printer to run your first test strip. If you're using this method, be sure to mark a tiny spot on the lower-right corner of the sheet before feeding it through the printer! Run it through the printer and inspect the results. If you are satisfied with the test strip result, go ahead and print the full document and hold onto your test strip page for your next print. But

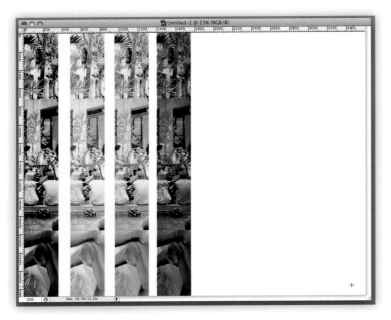

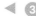

If you want to do it all at once, you can make several duplicates of the source file and tweak the contrast, saturation, color balance, or other image quality settings you want to dial in. Simply copy and paste several test strips at once and print them all simultaneously. And don't be afraid to test a couple of different images on the same piece of paper. In either case, it's a lot less wasteful than printing six or seven full-sized images that aren't up to snuff, isn't it?

if you are not satisfied with the test strip print, go back and tweak the source file for contrast, saturation, sharpness, color balance, and so on, and repeat the steps of copying and pasting into the test strip file—but don't start on the left margin this time. Align your new test strip column 1.5 inches from the left edge and delete the original left-margin column. Then run it through again and inspect the results. Keep repeating this with a half-inch margin between the columns until you run out of space on the page. And pay attention to that paper alignment dot! If you load the paper in differently, you will potentially overlap the previous test strip ink laydown, and then you're just back to wasting ink!

## Making Adobe Camera Raw 6 Your First-line Image Editor for Tone-Mapped Images

If you haven't noticed, this is a tough chapter to tackle in a linear fashion! Much of the advice about histogram spread and color profiles can be tackled and resolved in Adobe Camera Raw 6 before your tone-mapped image is even opened in Adobe Photoshop CS5. If you are wondering why I am talking about a RAW converter for non-RAW files, it's simple! Adobe Camera Raw can be configured to open TIFF and JPEG files and handle them as if they were straight-from-the-camera RAW images. (The data isn't quite as flexible as a true RAW file. There is no demosaicing, obviously, but the file data is treated very linearly by ACR with these pseudo-RAW files.) You have to change preferences once in Photoshop and twice in Bridge to make this happen. ACR and Lightroom run off the same engine, which is why these two programs are almost always updated in tandem. If you prefer the Lightroom interface, everything here translates easily to LR.

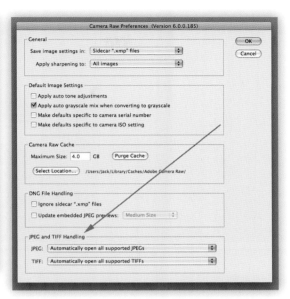

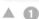

In Photoshop CS5 select **Edit > Preferences > File Handling** to launch the
file handling dialog box. Check the top option: **Prefer Adobe Camera Raw
for JPEG files.**

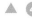

In Bridge, select **Adobe Bridge CS5 > Camera Raw Preferences**. (On a PC, this is
under **Edit > Camera Raw Preferences**.) Under **JPEG and TIFF Handling**, check both
boxes for **Always Open JPEG Files With Settings Using Camera Raw** and **Always Open
TIFF Files With Settings Using Camera Raw.**

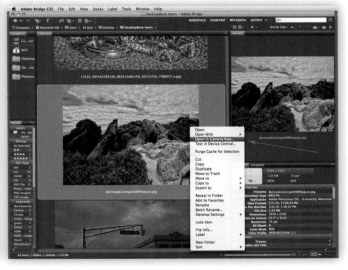

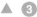

Once more in Bridge, select **Adobe Bridge CS5 > Preferences General** and check
the box labeled **Double-Click Edits Camera Raw Settings in Bridge.**

Right-clicking on the thumbnail in Bridge also brings up a
menu to launch your tone-mapped TIFFS and JPEGs into ACR.

▲  ⑤

Don't worry. Syncing up the preferences is the clunkiest part of this process. Now a double-click on a TIFF or JPEG (or tap **CMD/CTRL+R** or right-click and choose from the menu) in Bridge will launch it into ACR for global RAW-style editing.

**I CAN'T FIGURE OUT HOW TO LAUNCH ADOBE CAMERA RAW!** Go ahead. Search your hard drive for anything looking like the Adobe Camera Raw icon to launch ACR. I'll wait right here. Can't find it? Don't worry—it's there even if you can't see it. The only ways to launch the ACR interface are by double-clicking (CMD/CTRL+R works, too) on a supported and associated file type in Bridge (Camera Raw formats, and TIFFs and JPEGs via Edit > Camera Raw Preferences) or by double-clicking on a supported and associated Camera Raw file in a Finder folder, or via the Photoshop Open menu for a supported and associated file type. ■

▲ ▶ ⑥

A few adjustments to add snap and sharpness to an impossible shot that was tone mapped with a local operator and we're just about ready for final optimization for print and Web display! But now let's explore the ACR workflow more closely to see how we got from start to finish.

## Working Up Your Tone-Mapped File in Adobe Camera Raw

Let's check out a number of images to see how ACR can quickly make a tone-mapped image even stronger from both a creative and a technical perspective. At first glance, it looks great, but zoom in a little bit and you'll usually see some small technical issues—dust spots, chromatic aberrations, and such. It's easy to minimize a lot of the artifacting quickly in

ACR. From a creative perspective, it's a matter of personal taste to a large degree. We'll tackle the technical issues first. Always keep an eye on the histogram to get a feel for how each setting adjustment affects the image. And perhaps most important to note with ACR: **Cmd/Ctrl+Z** will undo the last step, but that's it. **Opt/Alt** will switch the **Cancel** button to a **Reset** button—which will bring you all the way to the beginning. So take it slow or you'll find yourself repeating work.

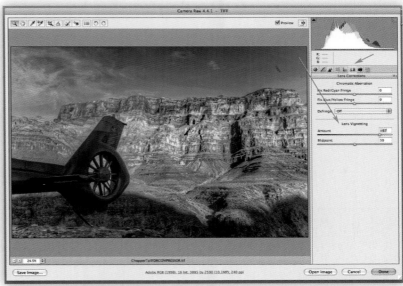

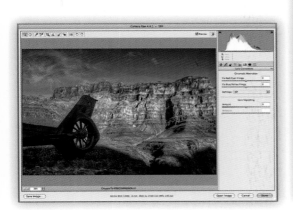

▲ ▶ ①
I launched the 16-bit tone-mapped TIFF into ACR via Bridge and clicked the **Lens Corrections** icon. I pushed up the **Lens Vignetting** setting to brighten up the corners of this wide-angle shot. If the corners of your shots look a little darker than everywhere else, give this a try.

Zooming in on the tail rotor, I notice chromatic aberration issues. I'll tackle these next. I click the **Lens Corrections** icon. By adjusting both the **Fix Red/Cyan Fringe** axis and the **Fix Blue/Yellow Fringe** axis, I have minimized chromatic aberration. There is still some fringing when viewed at magnification, but a lot less than when I started at the zero settings!

## ACR's Tools

ACR is primarily a global program, but there are a couple of useful local tools available. Click the **Basic** icon (it is the leftmost icon under the histogram) for this walk-through. From left, the tools are **Zoom**, **Hand**, **White Balance**, **Color Sampler**, **Targeted Adjustment** tool, **Crop**, **Straighten**, **Retouch**, **Redeye**, **Adjustment Brush**, **Graduated Filter**, **Preferences**, **Rotate CCW**, and **Rotate CW**.

**Zoom** and **Hand** are useful for examining the image closely when looking for chromatic aberration or dust spots. **Cmd/Ctrl** and **Opt/Alt** help toggle between these tools for zooming in, zooming out, and moving the image. **Preferences** launches the **Prefer** panel we saw a few pages ago, and the purpose of the **Rotate** tools is obvious.

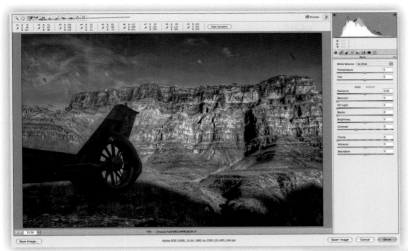

The **Color Sampler** tool gives the RGB readout for up to nine points in the image—to help avoid clipping and to find good numbers for neutrals or touchstone colors like the blue sky. Notice that the **White Balance** drop-down is currently set to **As Shot**, and along the top of the window sample #5 shows **RGB: 60, 63, 70**.

I selected the **White Balance** tool and then clicked on the spot associated with color sample #5. Notice that I did not select a white point—I was trying to set a neutral and I could have chosen highlight, midtone, or shadow areas for balancing. Your channel values won't always be exactly equal, but feel free to look anywhere in the tonal range for a new neutral. (Note that you don't have to have **Samplers** active to use the **White Balance** tool, but it does help.)

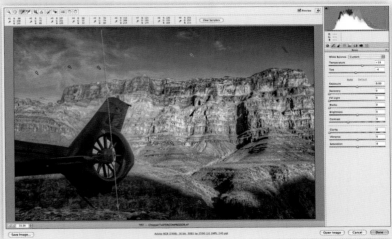

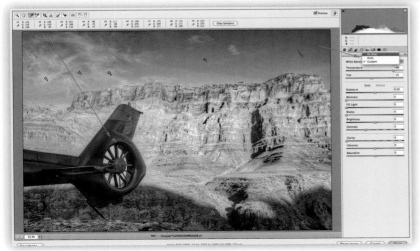

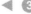

Sample #5 wasn't quite right. So I tried sample #2, and that wasn't right either—in fact, it was much more wrong. If you get frustrated with clicking around, move over to the **White Balance** drop-down and its two sliders. **As Shot** is your escape hatch for multiple undos with the **White Balance** tool. It brings it back to the original settings. **Auto** will attempt to discover the neutrals for you. And **Custom** allows you to push and pull the sliders for both **Temperature** and **Tint**.

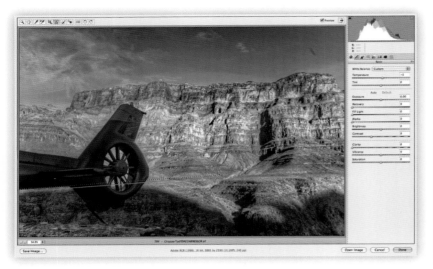

▲ ④

The **Crop** tool does just what its name indicates. It shaves pixels from the image to tighten composition, and can be set to different sizes and ratios via the drop-down. The **Straighten** tool is a specialized variation of the **Crop** tool. Instead of click-dragging the entire bounding box, simply pick a start and end point (such as an object's edge) that you'd like to be at right angles to the frame edge, and it auto-builds the biggest bounding crop box that fits within the pixel dimensions of the image. Say, for example, I wanted the tail of the chopper to define a parallel for the horizon; I click and drag along that line.

## IS A PERFECT NEUTRAL ALWAYS PERFECT?

Don't be afraid to add a sense of warmth or coolness to an image by keeping your neutral points not perfectly equal in each channel. The reason this helicopter tail in the Grand Canyon is challenging for both ACR and our eyes to balance is twofold. This chopper is not a perfectly neutral gray in real life—it is a blue gray at all times—but combine that with it being in the shade, and both ACR and our eyes want to balance it to a truer neutral. When we do this, it throws everything else off. So, in the end, all I did with the color temperature was nudge it to +5 for a subtle warmth boost. ■

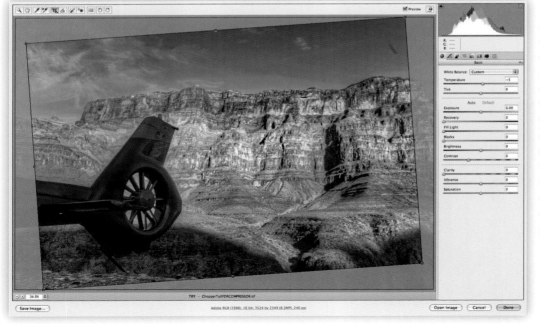

◀ ⑤

And I get a bounding box squared to that line. Next, I adjust the size of the crop box—and ACR will not let us go beyond the image edges, so we'll never wind up with white space. I am quite content with the angularity of this original composition—but for architectural and hard-lined landscapes, this is a great tool. The **Straighten** tool inherits **Crop** tool settings so you can easily straighten and crop to square, 16:9, or any custom ratio or pixel size.

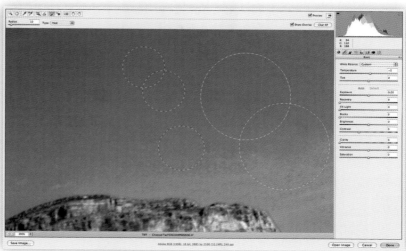

 **6**

I can't imagine there are many tone-mapped images where redeye is an issue, so I am skipping this tool. But the **Retouch** tool is very useful. The user experience is very different from the **Clone Stamp** tool in Photoshop, and it does take a little practice to become comfortable with it.

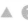 **7**

Select a **Radius** by using the slider or typing in a value, and select either **Clone** or **Heal** as the retouch method. Clicking or click-dragging on a spot on the image defines the area to be retouched. After a moment, a green-dashed circle pops up. This green circle defines the sampling source, while the red-dashed circle shows the radius of the retouching operation. That's all simple enough, isn't it? In this image you can see there is an active retouching operation in progress, along with three black-dashed circles which show where we previously retouched the sky (the top two of these are overlapping).

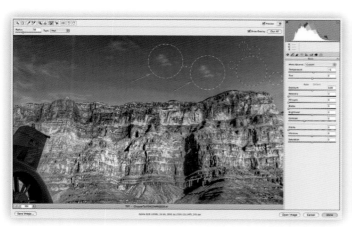 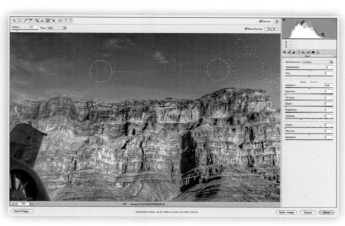

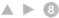 **8**

But I can resize both the source and the destination circles of the active set by grabbing an edge of either circle. And both the source and destination circle can be relocated. Notice how I have copied some clouds from one location to another in the active circles in the first of these two images? Now, compare the differences between the first and second screen shots. This is a powerful retouching tool, but it does take some practice!

### Three Cool New Tools Added to ACR Since the First Edition

We're going to leave the Grand Canyon and head to Waimea Canyon on Kauai to check out three cool new tools in Adobe Camera Raw: the Targeted Adjustment tool, the Adjustment Brush, and the Graduated Filter.

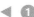

The Targeted Adjustment tool is a cool on-image editor that samples data from the image and makes on-the-fly adjustments. Touch a spot on the image and you can push and pull the controls for parametric curves or any of the Hue, Saturation, and Luminance (HSL) adjustments (including Grayscale). In this example, I am going to click on the bright tropical greens inside the highlighted circle and boost the Luminance by pushing to the right on the image, as shown with the horizontal red arrow. Pushing to the left would decrease the luminance. When Parametric Curves is selected, *up* and *down* are the directions to push to tweak the curve.

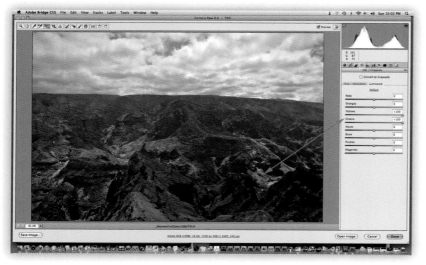

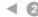

As you can see, my on-image adjustments pushed the yellow and green Luminance sliders to maximum. If the Targeted Adjustment tool is the active tool, you can also employ it for on-image editing of Curves or making HSL/Grayscale adjustments by clicking on that tab.

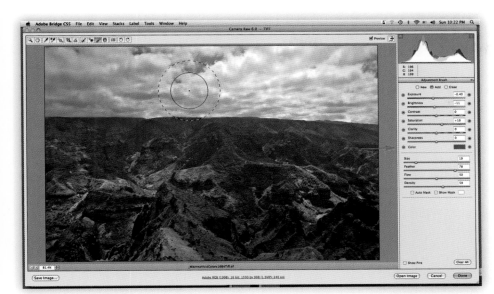

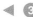 **3**

The **Adjustment Brush** allows for localized editing with an adjustable size and hardness brush. Note the **Color** option. As you can see, I have painted over the left part of the sky in this shot, and with a negative exposure value and the color setting, it is darkening and making the sky a touch more blue. You can also select White/None as the color by clicking on the color patch, which keeps the adjustments neutral.

 **4**

The **Graduated Filter** has similar options as the **Adjustment Brush** but applies them as a gradient fill to the image. It can be applied at any angle to the image, and multiple gradients can be applied to the image, but the individual gradient is always a straight line effect, which does limit its usefulness for complex compositions.

Now we're going to leave the canyons and head to the Red Mill in Clinton, New Jersey, for some further experimentation with ACR.

## Tone Curve and Basic Exposure Adjustment Settings in ACR

A composition in red, green, and blue is a good way to get a feel for many of the general image quality adjustments in Adobe Camera Raw. Pay special attention to the histogram in the following screen shots.

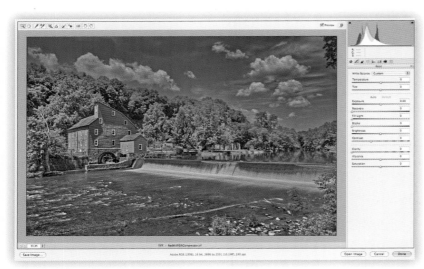

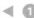 **1**

Again, tone mapping takes us almost to home plate. All I need to do in Adobe Camera Raw is a little bit of sweetening to make this tone-mapped scene even stronger for sharing online and in print. Remember from the introduction that you can click the arrows above the histogram to show black and white clip. Right now, it is not an issue, and I want to keep it that way!

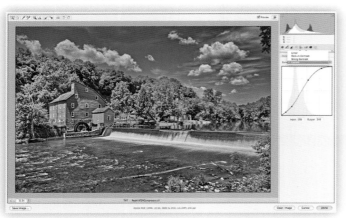 

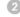  **2**

Some may prefer to work in the **Basic** setting first, while others may want to experiment with the **Tone Curve** as the first step. Before doing anything else, I usually throw in a custom S-curve to add contrast from the **Point** tab. (The **Parametric** tab also allows for curve manipulation, although it is slider based without direct input on the curve.) We can always revisit the **Tone Curve** to boost or diminish snap after experimenting with the **Basic** adjustments. I liked this custom curve, so I clicked back over to the **Basic** adjustments for some tweaks. Click the **Targeted Adjustment** tool for on-image **Curves** editing.

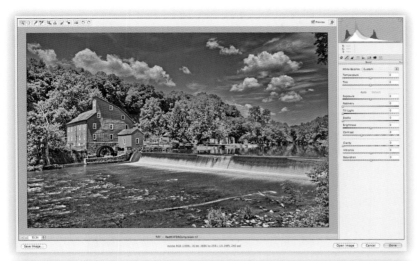

There are a number of different sliders here. Each slider does something to the image. Pay attention to the visual clues in each slider. Pushing **Exposure**, **Brightness**, or **Fill Light** to the right pushes values closer to the high end of the histogram, while pushing **Recovery** and **Blacks** to the right darkens the image. **Contrast** and **Clarity** add snap to the image, and **Vibrance** and **Saturation** boost colors. And no, these are not completely redundant sliders! Each control impacts the image differently. Go ahead. Pick a colorful image, and experiment with pushing and pulling each setting to minimum and maximum. I'll wait right here. **White Balance** was covered earlier, so I skip that here, but notice that it too has a visual indicator of the effect on the slider bar.

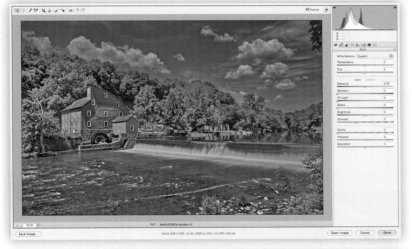

When I was experimenting with the sliders, I deactivated the custom **Tone Curve** setting and built similar contrast snap and white point by using the **Exposure**, **Recovery**, **Blacks**, **Brightness**, and **Contrast** sliders. (Did I mention that this chapter was very difficult to write linearly?) At this point, I could now revisit the curve for some fine-tuned tweaking, if I wanted. See, it's a matter of what works for you and the image—sometimes working this way is better, other times, the alternate route is easier. Just don't get too wrapped up in set-in-stone "workflows".

▶ ⑤

And don't go overboard in ACR and make your tone-mapped image look like this! Your tone-mapped 16-bit TIFF packs a lot of information, and ACR can push and pull this data all over the place, just like the tone map operators we've already explored. There may be times when one setting needs to be cranked very high, but if all of them need to be pushed, explore your tone map workflow first!

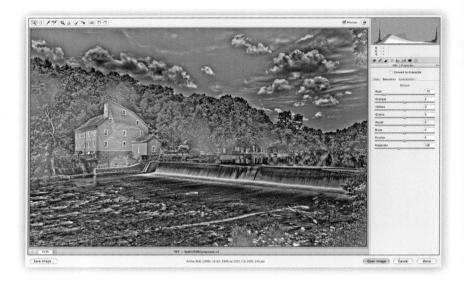

Let's take a look at a different shot for a moment to explore the difference between **Vibrance** and **Saturation**. This is a picture of John Douglas, who represented Guyana in the 1996 Atlanta Olympics. And it is a great HDR shot for exploring these settings.

▶ ①

Notice that the zero setting is centered. Moving to the left decreases the effect, while moving to the right boosts the effect. Both **Vibrance** and **Saturation** control color intensity, but only **Vibrance** affects the RGB primary colors, while **Saturation** has a universal effect. Skin tones are never exclusively primary colors, so we can boost or diminish **Vibrance** with less of an impact on the people in the frame.

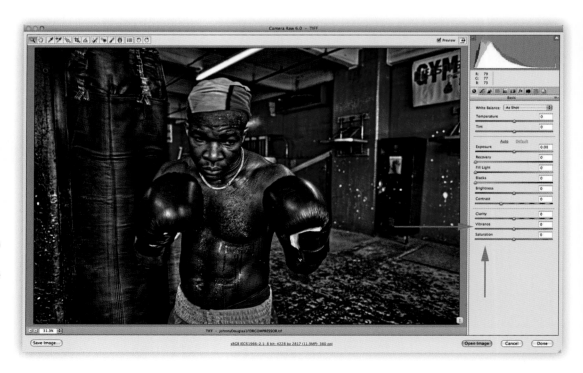

▲ ▶ **2**

Compare the skin tones in these two images with **Vibrance** tweaks and the next two examples that have **Saturation** tweaks.

▶ ▶ **3**

The **Saturation** slider affects all colors equally. If neither **Vibrance** nor **Saturation** does the trick, there is a way to adjust the **Hue**, **Saturation**, and **Luminosity** of tons of different color ranges individually—which we'll get to shortly.

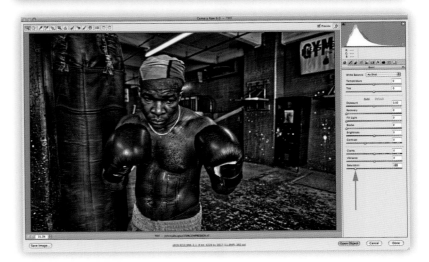

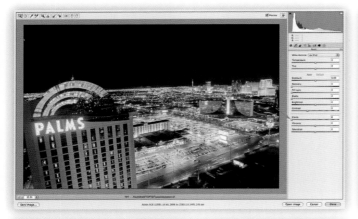

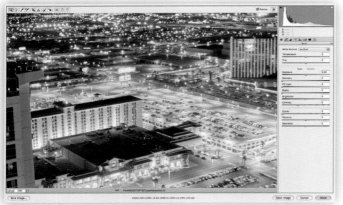
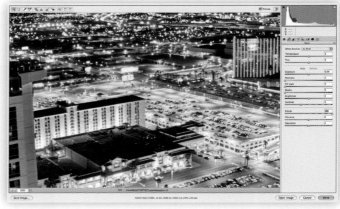

Here's a good view into how **Clarity** works. **Clarity** is a flavor of sharpening that looks at local contrast. It boosts overall snap and is good at cutting through some of that typical tone mapping haze we often see. But be careful! **Clarity** can oftentimes increase halo effects. I cranked it here to maximum for illustrative purposes, but you'll want to temper your settings a bit more. The top shots show the before/after effect on the whole image, while the lower shots show the effect at 100% pixel view of a section of the image.

**HOW IS THIS A "WORKFLOW" WHEN WE KEEP JUMPING FROM IMAGE-TO-IMAGE?** Not every image needs the identical cookie-cutter settings applied to it. Sometimes all an image needs is a little exposure or vibrance boost, and other times it may need some other subtle work. Tone mapping should usually do the heavy lifting—with both global and local operators—with ACR and Photoshop doing just a little bit of sweetening. So, we're jumping to various images that are used to illustrate the effects of the available settings. That's all. Don't worry; I'll cover some advanced Photoshop image fixes shortly. ∎

## Noise and Sharpening

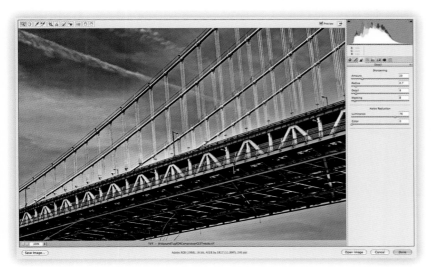

In ACR, use the **Sharpening** and **Noise Reduction** tools (accessed from the **Detail** icon) sparingly, if at all. Local operators, in particular, have a sharpening effect by their contrast-boosting nature. And tone-mapped images from a source series that captured the full dynamic range of the scene gain noise reduction by picking the best pixels from the range. Although at higher ISOs (even with the HDRI workflow noise reduction built-in bonus feature) you may want to throw some smoothing at the image. Be sure to zoom in to 100%—otherwise you will not see any preview. But notice how clean the pixels are, even in the shadows in this low ISO image.

## The Hue, Saturation, and Luminance Sliders

The **HSL/Grayscale** button offers **Hue**, **Saturation**, and **Luminance** controls in both color and grayscale for Reds, Oranges, Yellows, Greens, Aquas, Blues, Purples, and Magentas. You can also click the **Targeted Adjustment** tool for on-image Curves editing when in the **HSL/Grayscale** tab to select by touching the colors you want to target.

We see almost every color under the sun in this image!

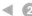 **2**

**Hue** is good for shifting a pesky color cast one way or the other. But I'm going to reset the hues to just where they originally were by clicking **Default**, because in this case **Hue** was right on.

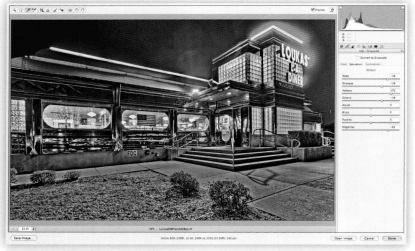

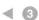 **3**

Unlike the **Vibrance** and **Saturation** sliders in the basic setting, the **HSL** sliders allow you to isolate wavelengths for saturation adjustments. Notice that I cranked up the warm tones to exaggerate the casting and light blooms outside this classic diner.

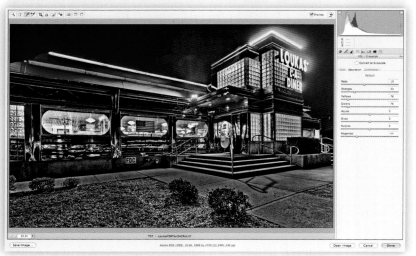

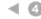 **4**

And here's an inverse effect where the **Oranges**, **Yellows**, and **Greens** have been desaturated to minimize color casting on the sidewalk and steps.

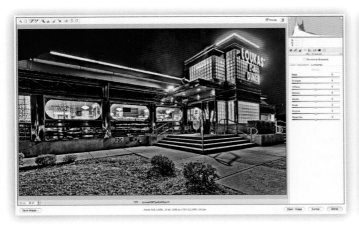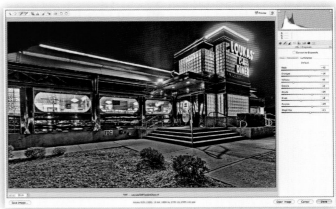

▲ ▶ ⑤

Look at the position of the sliders on the left and right images. Can you see where the
**Luminance** has been boosted and decreased?

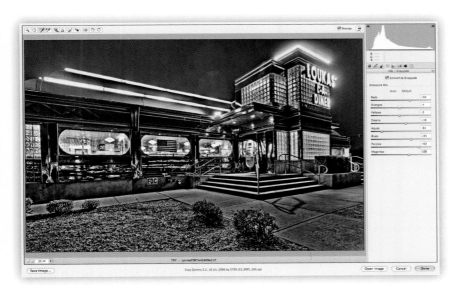

▲ ⑥

You can check the **Convert to Grayscale** box to blend your tone-mapped image into a custom
grayscale image.

## Saving and Loading Presets

While there is something to be said for manu-
ally toning and adjusting each photograph by
hand, there are times when it comes in handy to
be able to load in baseline settings for conver-
sion and "developing". The far right icon allows
you to save and load image settings, among
other things. Don't worry if it appears empty at
first—you've got to save at least one preset to
get yourself started.

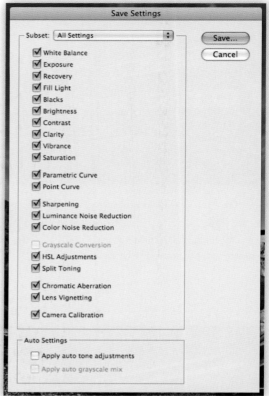

A prompt box with lots of check boxes allows you to choose
which settings to save.

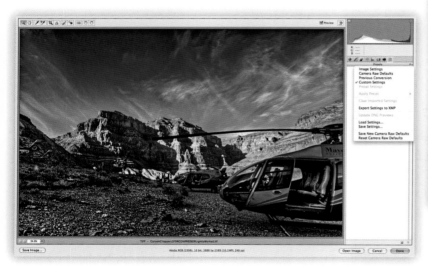

In addition to saving and loading personalized settings, the **Previous Conversion**, **Image Settings**,
and **Camera Raw Defaults** can be quickly applied via the **Presets** menu. Click **Save Settings** to save
the current conversion settings.

Save the settings somewhere
safe!

## Some Final Tweaks with Photoshop

Adobe Camera Raw and related RAW-style
programs are powerful and graceful, but for the
sheer number of functions and possibilities, it
is tough to beat Photoshop all the time—par-
ticularly for local adjustments. Please keep in
mind that this is not meant to be the compre-
hensive, exhaustive series of tips and tricks in
Photoshop CS5—just a handful of my favorite
fixes for tetchy situations.

## Dealing with Those Pesky HDRtifacts When Something Moves

In digital imaging, artifacts are pesky little pixels that are related to a problem or weakness in the digital process somewhere along the line and degrade overall image quality. In the HDR process, I use the term *HDRtifact* to describe the hard-edged feel to pixel areas where something moved in the source image. Sometimes it is subtle and small enough to blend right into the textures, but sometimes it is just downright ugly. It is easier to smooth away small HDRtifacts than big ones, any day of the week!

Sometimes it is as simple as using the clone tool or healing brush—when dealing with a texture or pattern in clouds or water ripples, for example. But when the HDRtifacting is along a detailed edge of a moving object, the clone tool isn't always the best choice. We might not necessarily want to eradicate the edges—but just soften and smooth away the hardness.

Here is where the **Smudge** and **Sharpen** tools can be used together to blend in those hard HDRtifact edges.

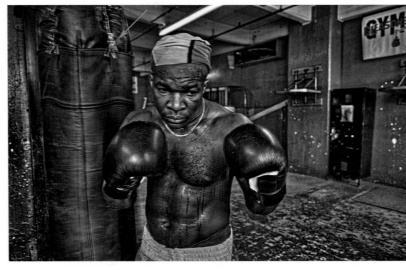

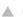 **1**

Take a quick look at this tone-mapped shot, which you've seen earlier in the book. Does anything jump out at you? My eye is drawn immediately to the blue casting on the chains of the punching bag.

 **2**

Zooming in, we see that not only is there a strange tone map blue artifact, but also some of those typical hard-edged pixels where things moved during capture. I can't really clone it away because then there would be nothing holding the punching bag up. So I've got to get creative!

 **3**

I click on the **Smudge** tool, select a small brush size, and gently click and drag over the hard edges, which smoothes them out without completely destroying the good visual information.

But it won't look quite right until I run over the area with the **Sharpen** tool to rebuild some "grain" (you can see where I've already sharpened here above the brush circle). If your hard-edged artifacts aren't significantly discolored, you can stop at this point. This smudge and sharpen trick will help clean up hard spots in moving water, cloud edges, highway light ribbons, and more.

But we still see that strange, tone-mapped blue cast. I use the lasso with 11-pixel feathering to make a loose selection around the blue area.

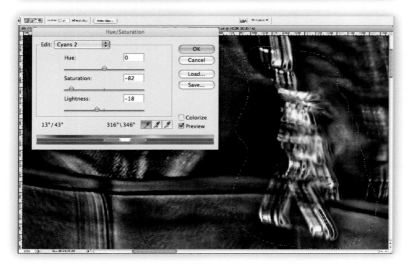

Selecting **Image > Adjustments > Hue/Saturation** should allow me to fix this problem. I need to go a little more extreme than I'd like to fix this, but I'll take the undersaturated results in this instance instead of the nasty blue casting.

## Healing and Cloning in Photoshop Instead of ACR

Get rid of the idea that the Healing Brush tool is better than the Clone Stamp tool, or vice versa. Depending on the nuances of what you are trying to accomplish, one may do better than the other—sometimes. Other times, it may be reversed. If you simply cannot get the hang of the Retouch tool in ACR, get to know these two blemish-fixers in Photoshop.

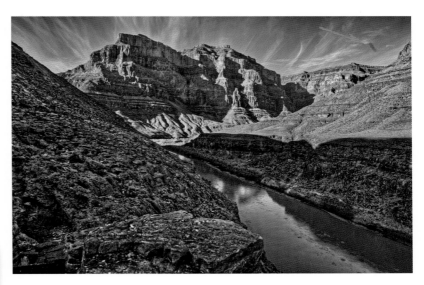

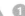 
Here is another view of the Grand Canyon, with yet another smudge in the sky. What did I get on my sensor that day!

I zoom in on the image, select a Healing Brush size, and check Proximity Match to clean up a sensor smudge in big broad patches such as the sky.

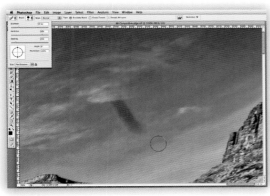

I then paint over the area of the smudge, being sure to completely cover the smudge.

▲ ❹ 
The smudge *mostly* disappears into the background now.

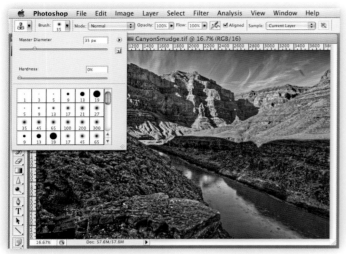

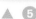 ⑤

If you don't like what the healing brush does, give the **Clone** tool a try. Select a brush diameter that isn't too small or too big for the size of the smudge.

▲ ⑥

Use **Opt/Alt+click** on a spot for the **Clone** tool to sample replacement pixels. I chose a spot just to the right of the smudge in this example. The crosshairs show where the sample pixels are being drawn from.

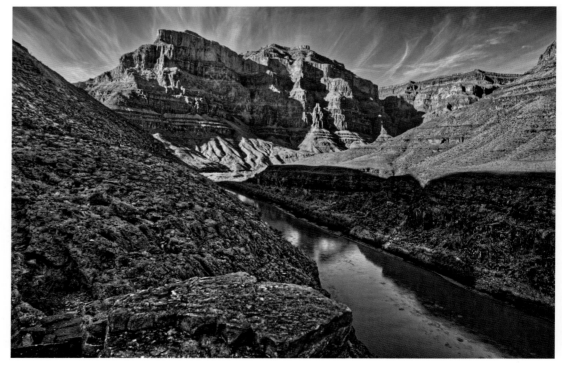

▲ ⑦

Click on a portion of the smudge, and continue until the smudge is gone!

## The Ultra-Subtle Sweetening Layer in Photoshop CS3

Tone-mapped images, particularly ones with an emphasis on detail and texture, can present a challenge for subtle final adjustments such as sharpening, subtle contrast shifts, and other nuanced final touches—even when using the built-in adjustment layers or fading the effect (Edit > Fade [last operation]). It may feel a little convoluted at first, but once you see the subtle way in which this sweetening layer can "finish" your image, you might add it to your workflow for your trophy shots. This works so well for subtle sweetening because it isolates the luminance information and applies adjustments primarily to edges and contours, with minimum impact on chromaticity (if you want to get technical about it).

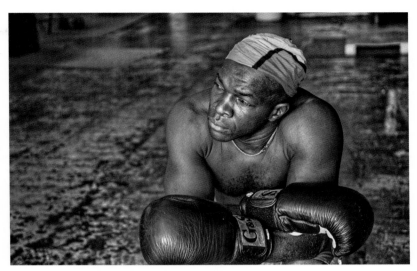

Here's a shot that's at the "just about there" stage after tone mapping and ACR global adjustments, and now it is in Photoshop for final touches before printing or posting to photo sharing sites.

Selecting **Image > Duplicate** makes an identical copy of the image. Click **OK** on the pop-up box.

◀ ③

Image > Mode > Lab Color converts the duplicate to Lab color space.

◀ ④

Window > Channels will open the Channels palette.

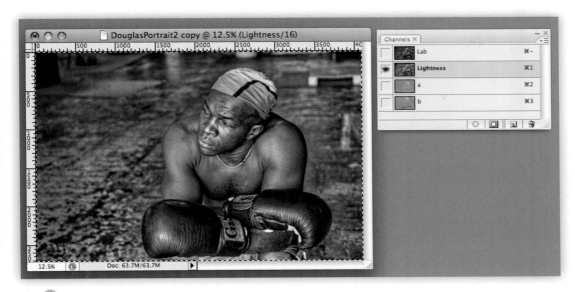

▲ ⑤

Click on the **Lightness** channel to isolate it. Choose **Select > All** or hit **Cmd/Ctrl+A** to select the entire **Lightness** channel. Copy the **Lightness** channel by selecting **Edit > Copy** or by typing **Cmd/Ctrl+C**.

◄ ⑥

Click back on your original image, which is still in RGB space, and paste the **Lightness** channel onto your RGB image. You can now discard your duplicate.

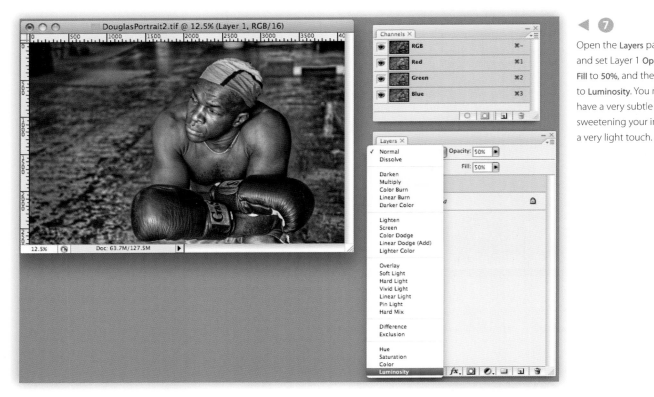

◄ 7

Open the **Layers** palette and set Layer 1 **Opacity** and **Fill** to **50%**, and the mode to **Luminosity**. You now have a very subtle mask for sweetening your image with a very light touch.

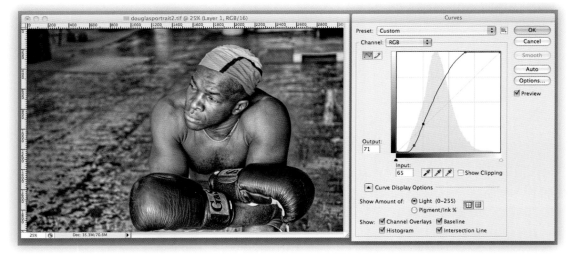

◄ 8

A hard S-curve on the sweetening mask layer accentuates even more detail.

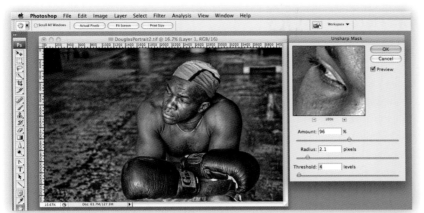

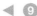

Experiment with various **Unsharp Mask** settings on this sweetening layer. Certain images may benefit from some very interesting combinations of the three sliders to crisp up edges without sharpening the noise.

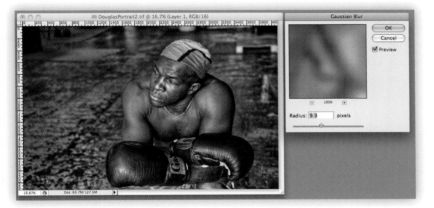

Going the opposite way, the sweetening layer can be used to soft-focus the image by applying the **Gaussian Blur** filter.

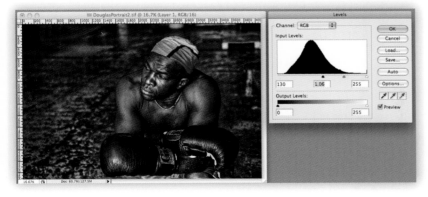

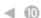

**Levels** can build density on the sweetening layer. Notice how compressed and clipped the black point is and how it impacts the image?

Don't stop here, and don't rely just on my tips and tricks. Experiment with your tone-mapped photos and you'll discover cool tricks and styles that work for you!

# Epilogue

## Where Do We Go from Here?

Where do we go from here? Quite simply, everywhere! Take the tips and tricks you've learned in *Practical HDRI* and apply them to everything in your own photographic background. My mission in writing this book was simple: to give you the technical and aesthetic know-how needed to take your high dynamic range imaging to the next level as swiftly and as painlessly as possible. I truly hope you feel I've succeeded in reaching this goal.

I've been as concise and simple as possible in teaching you the new workflows and lexicon of high dynamic range imaging. I'll admit it—there is a lot that could trip you up along the way, but all it takes is a little bit of the *proper* kind of practice and experimentation to really make your HDR photography fly.

There's no CD of *my* images for you to experiment with. The next steps are up to you. Go out and find your own amazing and impossible scenes to capture in the HDR style. Remember—a great output image starts with great source photos. This book has laid your foundation, and now it is up to you!

Photography is a journey that never ends. There will always be something new to learn, a new way to see the same scene for the hundredth time, and new techniques to master.

Everyone learns at their own pace. Don't get frustrated if your first few experiments with HDRI aren't perfect—it's all part of the process. Use the practice and experimentation techniques described in *Practical HDRI* to launch your own journey into this exciting new arena.

Challenge yourself. Frequently push yourself outside of your photographic comfort zone. Sometimes you'll fail, but other times you *will* succeed. There are heaps and gigabytes of experimental shots on my harddrives that will never see the light of day—except perhaps

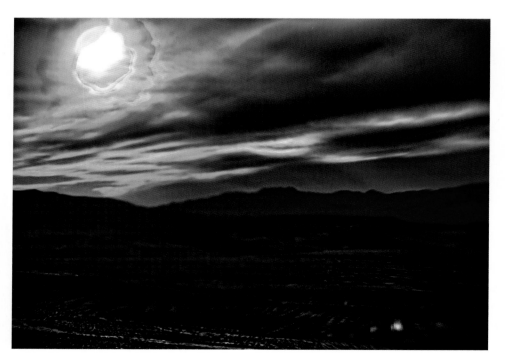

Between Las Vegas and the Grand Canyon, I gambled and got lucky. This is a six-shot merger from an unlocked Lensbaby 3G, handheld, from a moving helicopter. Common sense would dictate that all I was really doing was wasting some card space. But Lady Luck was on my side and I nailed it! There's no reward without risk.

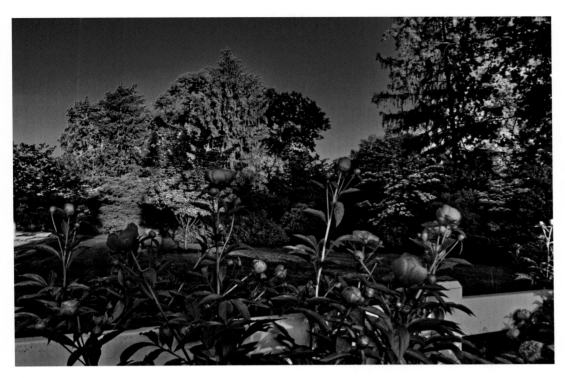

This pastoral scene was captured with a specialized DSLR that captures wavelengths into both the UV and IR spectrum. The total wavelength sensitivity of this camera is 350-1000 nm, compared to the 400-700 nm range that the human eye can see (and most filtered sensors). So, here I have an expanded dynamic range coupled with an extended spectrum image. Really—anything goes with HDR photography. Have fun with it and experiment!

as examples of what not to do! But these experimental missteps *can* breed successes unto themselves or learning opportunities to be applied to the next shoot. Start with simple static compositions to get a feel for the process and programs. Then push the boundaries by incorporating or eradicating moving objects into your compositions. And then from there, chart your own course—discover your own ways to push the envelope.

Search the web and you will discover some truly amazing examples of high dynamic range imaging with tone-mapped results, ranging from seamless to surreal and everything in between.

Photographers are taking the HDRI process and applying it to their own visions in amazingly creative ways. Not a week goes by when I don't discover some impressive new style, technique, or simply a rock-solid portfolio online. In truth, we've just scratched the surface of possible photographic usages in this short volume. There is an entire subculture of photographers capturing virtual reality environments in the HDR style. And many photographers are now combining HDRI with time-lapse photography for stunning animated tone-mapped moving pictures.

Take what you've learned here and run with it! How can you push the bounds of

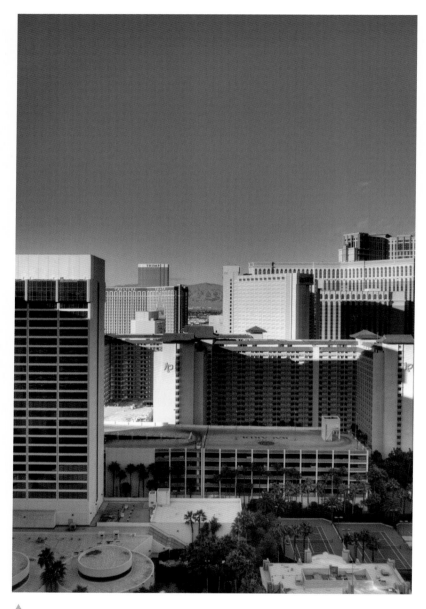

At the other end of the pendulum's swing, many photographers simply want or need seamless photorealism for documentary purposes—and this high dynamic range image is a much truer representation of the back of the Vegas Strip than would be possible with any single-source image with clipped values at one end or the other.

photography? How will you make HDRI your own?

High dynamic range imaging continues to be one of the most interesting and exciting evolutions in digital imaging, and the processes behind the programs are only going to improve over time. Huge strides are being made in regard to in-camera HDRI, and I predict we'll see a consumer camera writing OpenEXR, or perhaps Unified Color BEF HDR files before the third edition of this book is published!

Competition fuels creativity and functionality when it comes to programming. The HDR merge and map upgrades and 32-bit feature set of Photoshop CS5 really kicks things up a notch. And let's not overlook HDR Photostudio's 32-bit toolkit. Keep your eyes open for the next killer, beta HDR application—whether it comes from a big established company with an army of PR reps, or a small-shop startup where the owner/programmer personally responds to helpdesk emails.

High dynamic range imaging isn't the exclusive province of any photographic subculture—almost every style of photographer can benefit from understanding when and how to employ HDRI techniques, so go out and find your HDR eye!

In conjunction with the second edition of *Practical HDRI,* I've launched a Vimeo Channel at http://vimeo.com/channels/hdrphotography where I'll be posting videos about the stories behind many HDR shots in this book, additional screencast workflows, software update comparision videos and more. Additionally, I've started a Vimeo HDR group at http://vimeo.com/groups/hdrphoto where readers can share their own narrated slideshows, share their own HDR stories, and discuss anything else related to HDR photography. I also invite all fans and friends of *Practical HDRI* to visit

▲

This 5-shot HDR image inside the Basilique Notre-Dame de Montréal succinctly summarizes so much about the current potential of HDR photography, both in-camera, and in processing. Shot handheld with the Pentax K-7 and merged in Adobe Photoshop CS5 for deghosting and alignment, this is an image that simply isn't possible to create without a rich set of HDRI tools and skills. This image is especially meaningful to me as it was shot last July, just after we'd committed to a timeline for the second edition of this book. My wife and I didn't know it at the time, but there were actually three of us on this weekend escape to Montreal. By late August, when I shot the San Francisco and Hawaii images scattered throughout this edition, we knew there was a little one along for the ride. And as I put the finishing touches on the manuscript for the second edition of *Practical HDRI*, we were just a few weeks away from welcoming our first child into the world! (And here in early June as I give one last look at the layout before this edition ships to the printer, our beautiful daughter Avery Rose is now eight weeks old.) Visit **http://vimeo.com/channels/hdrphotography** for a narrated slideshow where I discuss the backstory of this and many other images in this book.

**www.facebook.com/HDRPhotography** and join they group I launched while working on the updates for the second edition, to share your photos, get feedback on workflows, or just to say "hi!" Feel free to join in the conversations on these forums and message boards. And if you have any questions or comments, are interested in archival prints of any of the photos displayed in this book, or simply want to drop me a personal note, you can email me at practicalhdri@gmail.com

Thanks for reading this book, and I wish you the best of luck on your HDRI journey!

— Jack Howard, July 2010

# Index